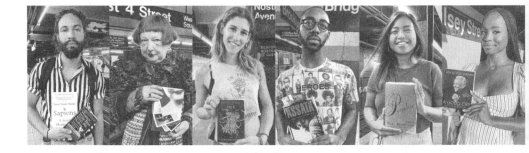

Stories from the Underground

Simon & Schuster

New York London Toronto Sydney New Delhi

Between the Lines

Uli Beutter Cohen

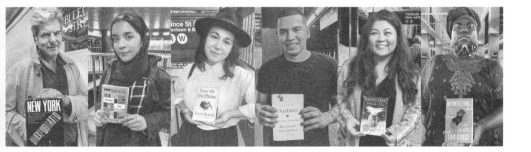

Simon & Schuster
1230 Avenue of the Americas
New York, NY 10020

First Simon & Schuster hardcover edition October 2021

SIMON & SCHUSTER and colophon are registered
trademarks of Simon & Schuster, Inc.

For information about special discounts for bulk purchases,
please contact Simon & Schuster Special Sales at
1-866-506-1949 or business@simonandschuster.com.

The Simon & Schuster Speakers Bureau can bring authors
to your live event. For more information or to book an event,
contact the Simon & Schuster Speakers Bureau at 1-866-248-3049
or visit our website at www.simonspeakers.com.

Interior design by Lewelin Polanco

Manufactured in the United States of America

10 9 8 7 6 5 4 3 2 1

Library of Congress Cataloging-in-Publication Data

Names: Beutter Cohen, Uli, author.
Title: Between the lines : stories from the underground / Uli Beutter Cohen.
Description: First Simon & Schuster hardcover edition. | New York :
 Simon & Schuster, 2021. | Includes bibliographical references.
Identifiers: LCCN 2021002944 (print) | LCCN 2021002945 (ebook) |
 ISBN 9781982145675 (hardback) | ISBN 9781982145699 (ebook)
Subjects: LCSH: New York (N.Y.)—Biography—Anecdotes. | Commuters—
 New York (State)—New York—Interviews. | City and town life—New York (State)—
 New York—Anecdotes. | Books and reading—New York (State)—New York—
 Anecdotes. Subways—New York (State)—New York.
Classification: LCC F128.56 .C64 2021 (print) | LCC F128.56 (ebook) |
 DDC 974.7—dc23
LC record available at https://lccn.loc.gov/2021002944
LC ebook record available at https://lccn.loc.gov/2021002945

ISBN 978-1-9821-4567-5
ISBN 978-1-9821-4569-9 (ebook)

For my family,
all of you.

Contents

Introduction

To write about the entirety of New York City is an impossible thing to do. The city is too grand yet too personal, too elusive yet too concrete. When we talk about the city, we can't just describe a place and its people, a dream and its destination. When we talk about New York, we have to talk about the world, which gathers here to find itself. The place that singularly illuminated for me what connects us on this journey, is the underground.

I arrived in New York City in 2013 and felt like I was late to the party. Many of my friends were lifelong New Yorkers who had already lived through the best and the worst of times. Others I knew attempted to move here and left after a few years, defeated. What sparked my curiosity was the promise of extraordinary stories. I couldn't wait to meet the people who called themselves New Yorkers and whose sheer existence in such an unpredictable and relentless place seemed to hold some kind of secret. After I landed in a Brooklyn sublet with no air-conditioning during a particularly hot summer, I had a hunch that my boundless enthusiasm would not last forever. I needed to observe the city with fresh eyes while I had the chance. I signed up for workshops and classes, went to parties and events, joined and formed artist groups, and spent every free moment walking through all corners of the city, ferociously inhaling its newness. However, my approach quickly proved to be too broad and therefore quite futile. People didn't have time! Neighborhoods were changing overnight! As soon as I felt familiar with someone or someplace, they had already moved on. But between destinations, something caught my eye. The subway. It connected the dots.

Unlike the streets aboveground, the subway slowly, if ever, changes.

It's the city's beating heart that never stops. It's also one of the few places where the ever-rushing inhabitants of New York City have to stand still—if you can get on a train to begin with. Countless times I swiped my MetroCard at the Clinton–Washington Avenues station only to find out that it was empty yet again, which often caused me to miss my train. At the vending machine, I faced the innocent but profoundly existential question of whether I wanted to add value or time to my card—a choice that could really stop me in my tracks if I let it. During rush hour, I squeezed into a funny shape to avoid being thrust face-forward into a stranger's armpit. Feet stepped on other feet. Eyes avoided other eyes. Hands felt for a spot on the handrail that wasn't warm or wet. At every station, more people packed their bodies into nonexistent spaces, creating a tight, involuntary group hug. As a small-town girl from Germany who had spent a decade on the West Coast living at a more leisurely pace, I was immensely frustrated and equally fascinated by the subway. When I discussed the G train's erratic behavior in one of my artist groups, it hit me. Since I believed in the "finding-clarity-in-chaos" theory, was the subway a portal to a side of the city where I would find something extraordinary? I decided to follow my instinct and started to ride the subway whenever I could, at all hours of the day, with no destination in mind.

On a cold winter morning, I rode the B train over the Manhattan Bridge. I stood by a window because I loved seeing the East River and the Statue of Liberty, with her torch gleaming in the sunlight. The train was fairly empty. It was one of those days where it was so quiet, you'd think you were the only person in the city if you closed your eyes. As usual, I looked up and around, unlike others, who were sleeping or busy with their phones. Unexpectedly, my gaze met that of a young woman at the other end of the train. Our eye contact lasted much longer than subway etiquette allowed. It was uncomfortable and it also felt like an invitation. I decided to go over to her and, since she held a book in her hands, ask what she was reading. Hana told me she was a sci-fi fan, which explained *Catching Fire* by Suzanne Collins, and that she was on her way to a rehearsal at the dance company Alvin Ailey. Spontaneously, I jotted down our conversation and asked if I could take Hana's picture to commemorate the moment. She agreed. We only rode one stop together, but I felt electrified. I had caught a glimpse into another world.

After talking to Hana, the subway became my unofficial office and my second living room. I surrendered to its oceanic flow, and with every ride I understood the city, its layout, and its boroughs a little bit better. I felt how the collective mood of the city would shift based on current events, and I started to see who I shared space with. The subway carried people from all seven continents, of all ages and backgrounds. Enemy nations gently touched knees on rows of plastic seats. This diversity wasn't restricted to the commuters—it also extended to the literature they held in their hands. I saw people with bestselling novels, experimental poetry collections, self-help books brimming with sticky notes, provocative memoirs, and well-loved classics. When I asked about their choice of book, each reader had their own story, too—stories I began to document. The conversations lasted longer and grew deeper. I put more care into my photography and asked more questions. I started to understand the importance of storytelling by the people for the people, and that local stories, much like local food, create a different connection to your home. Slowly but steadily, my experiment evolved into a place for community.

Over the last seven years, Subway Book Review has become many things to many people. Some say it's a movement. Some say it's a social media project. To me, it's a documentation of who we are and where we are going.

The more I talk to readers in the underground—unquestionably some of the most imaginative and empathetic people—the more I realize that books are a reflection of our identities and souls. Books reflect everything we are and everything we wish we could be. At Broadway–Lafayette station I met Verena, who read *No One Tells You This*, and talked about living a meaningful life as a child-free woman. At Columbus Circle, Saima told me that *They Say, I Say* helped her to address hurtful confrontations about her hijab. Larry shared his experience as a foster kid in Queens with me during a conversation about *Becoming*. Emmanuel read *De perfil* and described what it felt like to be a Mexican immigrant in today's America.

I also started to connect the dots aboveground. *M Train* by Patti Smith and a chicken coop sighting in the middle of Brooklyn brought a grieving photographer named Ellie peace after her mother's passing. Her story made me want to find the person behind the chicken coop. It took a few months, but eventually I sat down with Gregory Anderson, the man who had built not one but several chicken coops all over the city in response

to 9/11. Some conversations I had a chance to revisit, like the one with Kamau Ware, who became one of my closest friends over our shared love for public spaces. Others were fleeting. I'll never forget the day in 2018 when I randomly saw Ta-Nehisi Coates on the 6 train, reading *Ill Fares the Land* by Tony Judt. We only rode one stop together, but his generosity filled me up as if we had sat down for one hour. Other people, like Jacques Aboaf and Ashley Levine, I ran into multiple times in different parts of town. Each conversation opened up a chapter about dreams, fears, hopes, and secrets. Each encounter seemed less like happenstance and more like an intentional opportunity to broaden my horizons.

Like the city itself, I've had to evolve and adapt over the years. The arrival of the internet service on subways in 2017 meant fewer commuters with printed books in tow. Sometimes I saw a promising-looking tote bag and was delighted when someone revealed their current read. In addition to talking to strangers, I also started to ask interesting people to meet me at their favorite subway station. In 2020, when the pandemic and white supremacists turned our lives upside down, I interviewed people over the phone, like Waris Ahluwalia and Jamel Shabazz, or met them outside at a distance, like Wendy Goodman. But even as we experienced the unfathomable, we shared our journeys and we felt close.

Between the Lines is a collection of some my favorite encounters. Each one has shown me that our connections are endless. I've talked to people in all five boroughs. I've ridden every train line end to end. I've laughed, cried, and hugged more strangers than I can count, but of course not all conversations have been easy. Some hit my blind spots, and some hurt my soul. I've heard personal accounts of loss, discrimination, hate, and other threats that many people face daily and desperately wish to escape from. Each book built a bridge, not just for the readers but also for me, leading into other lives and possibilities. Each story gave me the chance to learn and unlearn what I thought about my place in the world. After talking to over a thousand people, I've come to realize that these conversations aren't about one person's knowledge or lack thereof. The point is to share each other's reality and truth for a moment.

This book is my attempt to capture some of these moments. I can't depict the experiences of eight million New Yorkers, and I don't pretend to have done that here. Inevitably, by the time you read this, some people

portrayed in *Between the Lines* will have changed jobs, moved away, or seen their stars fall or rise higher. Such is the life of a New Yorker. No matter where you find yourself holding this book, I hope their stories and ideas inspire you to live boldly. We are in dire need of people who are committed to moving us forward. For this to happen, it is necessary to see that the world belongs to you only as much as you are willing to belong to the world.

In *The Peregrine*, a book I picked up because it came highly recommended by one of my favorite documentarians, Werner Herzog, a line reads: "The hardest thing of all to see is what is really there." How lucky we are to find a moment where we can see each other clearly. Where we can meet people we don't know, and go places we've never been to through their stories. Our world is changing at lightning speed. This is the time to remember that we are meant to be a wonder for each other.

I often think about what astrophysicist Moiya McTier said about this to me at 81st Street station in front of a mural of our solar system. She summed up perfectly what the underground had been whispering into my ear for years. On the cosmic scale of the universe, an individual life matters very little. It can be missed in the blink of an eye. But on Earth, every thought and every action matters. Right here, right now, you make all the difference.

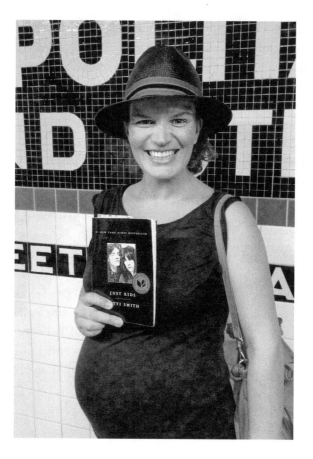

Julie Helquist

Just Kids
by Patti Smith

Just Kids is about Patti Smith's arrival in New York City, where she meets her soul mate Robert Mapplethorpe. They are lovers at first, but as their relationship grows, they become friends and kindred spirits instead. After they share an important part of their lives with each other, Robert sets out on a path where Patti can't follow him. Her writing is so captivating, and with the glasses of youth everything is new to her. She's inexperienced

but you can feel the raw power that will inform the woman she will become. I think it's so cool that Patti can still tune into that side of herself later in life. I hope there's always a part of me that's open to grow.

Do you have words you live by?

There's a quote I really like that's often falsely attributed to Ursula K. Le Guin. It says, "The creative adult is the child who survived." I think it's true that our curiosity and our appetite for life have to be preserved at all costs.

Metropolitan Avenue/Lorimer Street station
Brooklyn, 2014

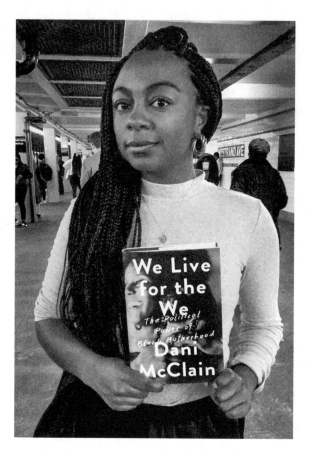

Jazmine Hughes

We Live for the We: The Political Power of
Black Motherhood by Dani McClain

I moved to New York during Hurricane Sandy, and it was an intense moment to arrive. Everybody was rightfully stressed out and I was like, "Let's take my mattress off the truck, Dad." My first job was at *New York* magazine and I was so overeager, I kept asking for things to do during the storm. Now that I think about it, I arrived in the middle of one of the city's biggest stories and my first inclination was to report it, which is

representative of what my life has turned out to be. I've lived here for eight years, and for the first four years, I almost single-handedly kept up the dollar-slice pizza economy. Now I do $4 and $5 slices.

Who do you think is an iconic New Yorker?

Brian Lehrer, the kids who hustle on the train, and Joey Chestnut, the thirteen-year champion of Nathan's hot-dog-eating contest, are definitely emblematic of New York—and so is every woman who has ever carried a stroller down the subway stairs. Give them Olympic medals!

What does this book say about Black motherhood?

Any motherhood is one of protection, but Black mothers have to triple down because their child is under siege from the moment they're born. Imagine looking at your baby every day, knowing that they can go out into the world and never come back to you. I think Black motherhood involves more world building.

Are you doing any kind of world building for yourself?

My entire life has been in pursuit of power, and now I'm finally widening my definition of what that means. When I first moved to New York, power meant wearing a suit, getting paid lots of money, and being your own boss. Now I know that it comes in many different forms. Magazines and newspapers are incredible vessels of power, and when I realized that I could tell stories and speak to people, I was like, "This is all I want to do." I think New York has given me the strength to build exactly the world I want to live in.

Nostrand Avenue station
Brooklyn, 2019

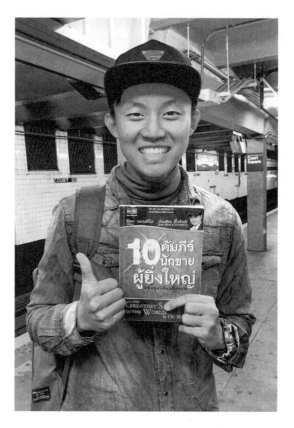

Poph Kanchanavasutha

*The Greatest Salesman
in the World* by Og Mandino

This is my first time on the subway ever. I'm in New York to study and have only been here for two weeks. I heard that subway rides take a while, so I brought a book. [*Laughs.*] *The Greatest Salesman in the World* is about rich guys, their habits, their stories, and how you can become like them. I'm reading the book to improve my language skills. Each page is

written in English and in Thai. The instructions say to reread every chapter for thirty days before moving on to the next one. That means it will take me 300 days to read this book. I hope I finish it before I go back to Thailand.

Court Square station
Queens, 2015

Douglas Ross

The Rise and Fall of a
Theater Geek by Seth Rudetsky

S o far this book seems to be about a young theater geek and his first trip to New York City. I just picked it up and have to confess that I know the author. He's the husband of my ex-boyfriend and we've been friends for at least ten years. I'm here to visit them, and they told me about a new bookstore in their neighborhood, but they said nothing about his book being sold there. Of course I bought it to support him.

Is this your first trip to New York City?

Oh, definitely not. [*Laughs.*] The first time I came to New York was in the late '60s and I've loved it since then. I actually calculated it recently and I think I've been here well over 200 times. I remember my first trip vividly. I came here with my mom and my sister and we went to see the Statue of Liberty and Radio City Music Hall. Everybody should come to New York at least once in their lifetime.

C Train
Manhattan, 2017

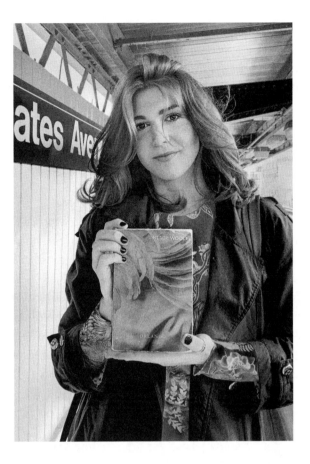

Diana Schlossberg

Orlando: A Biography
by Virginia Woolf

My name is Jacob Diana Schlossberg, but for casual acquaintances and people I work with I'm Diana Schlossberg. Once I moved from Chicago to New York City, I saw reflections of myself everywhere. There are some experiences of seeing yourself in New York that feel very joyful and there are some moments when seeing yourself is scary. Part of me feels like I left Chicago to come out as nonbinary, but after my move I

realized that I'm still in this body, regardless of the city I'm in. It's like when you look for an apartment and you see pictures of a beautiful, bright place thanks to a good staging company. Then you move in and you're like, "Wait, it's really dark, what's going on here?" I thought I was going to come to New York and immediately turn into a beautiful apartment. [*Laughs.*] Instead, I still have to work on myself, just like I would on any other piece of art that exists in this city.

How did you arrive at Diana?

My mother has a deep love for Diana, Princess of Wales. Whenever Lady Diana cut her hair, my mom would get the same haircut. It's an affinity I've inherited. Diana's star sign is Cancer. She was the most nurturing person and articulated herself beautifully in this world. I try to act in her image. My twenty-first birthday was Princess Diana themed. I asked everybody to dress up as a different Lady Di, and nobody was allowed to wear her wedding dress but me. I bought a vintage gown and wore a ten-foot train in a tiny East Village apartment. It was a very special night. That was the first time I allowed myself to put on a gown—not a dress, but a real gown—and I felt all these feelings awaken, like the Little Mermaid. [*Laughs.*] I would say that birthday and reading *Orlando* by Virginia Woolf have fueled my transition more than anything.

Tell me everything about Orlando!

Orlando is a lord in England and he lives for 500 years—I watched the Sally Potter film with Tilda Swinton in high school before I discovered this book. What I value about the story is that it shows Orlando's radical change of sex. One day, Orlando wakes up and is a woman. For a long time, what stopped me from pursuing my transition was that I genuinely thought, "Okay, maybe one day I will wake up and be exactly who I want to be." Any kind of transition is in fact not sudden. It's an extremely hard and long process. I think we get to have multiple arrivals in New York, because the city brings us closer to ourselves in a cyclical way. The two things I've fallen in love with most so far are my reflection in the window of a building and my shadow on the sidewalk.

If you and Lady Di could hang out, where would you go?

First, we would go to Central Park. We would do my typical loop, starting at the 79th Street entrance on the west side, and from there we'd do that really pretty walk past the Delacorte Theater and Belvedere Castle until we would find ourselves at Bethesda Fountain—a woman who was once a gay man and the Princess of Wales. Next, we'd probably take a picture together in the men's room, or something really fun like that, and then we would go to the ballet and see *Swan Lake*. Honestly, after that I would be good. That would be my day.

Gates Avenue station
Brooklyn, 2020

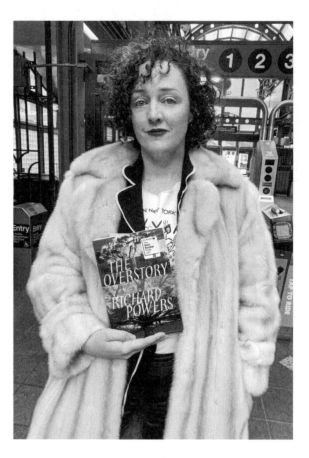

Glynnis MacNicol

The Overstory
by Richard Powers

T his city is an intense experiment in existence. In other parts of the country there's a sense of wanting to create a buffer between yourself and other people. In New York, from the moment you walk out the door, you respond to everything that's happening around you and I love that very much. An entire lifetime can exist in a day in New York, and some days it's smooth sailing, some days it smashes you up against the rocks.

I've been a walker my whole life and moving around freely as a woman means a lot to me. I love that I can get a $2 coffee at a food cart and then walk across Central Park to get a $20 martini at Bemelmans—and both can be accomplished in my pajamas and a vintage fur coat. [*Laughs.*]

Is there a place that makes you feel awestruck?

A walk through Central Park will make me feel better no matter what. That park is a miracle. I once wrote a poem about it, which was my first published piece in the *New York Times*. To carve out this enormous square, on the most valuable real estate on the planet, that's accessible to everyone, and entirely devoted to grass and trees, is glorious. *The Overstory* is a novel about different trees and the people who build their lives around them. We often understand trees as what we can see aboveground, but much like with the rest of life, the real story is in the understory.

Has a particular tree ever caught your eye?

I'm partial to the trees that line the sidewalks and corrupt the cement around them. They will not be tamed! [*Laughs.*] Reading this book made me think differently about what we consider intelligent life-forms. The tree in the opening chapter escapes a disease known as chestnut blight, which wiped out the chestnut population on the East Coast in the early twentieth century. It's powerful to be reminded that, much like humans, nature and trees also experience pandemics. Immediately after I finished the book, I signed up to volunteer in Central Park. There's mulching, flower planting, and weeding to do. I really like being a caretaker for something whose lifespan is hopefully longer than my own.

**72nd Street station
Manhattan, 2020**

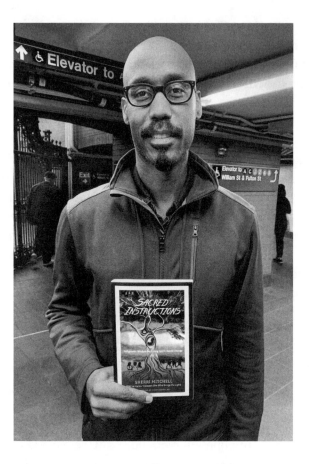

Ijendu Obasi

*Sacred Instructions: Indigenous Wisdom for
Living Spirit-Based Change* by Sherri Mitchell

In Igbo tradition the palm tree is a sacred symbol of strength. Many people don't know that you can actually only grow one species of palm, the needle palm, successfully here in New York. I moved to the city five years ago, and since then I've bought property in my home state, Alabama, where I'm planning to create a palm tree arboretum.

That sounds so satisfying, to plant your favorite tree on your home soil.

The craziest thing is that my property is in a place called Africatown. The last shipment of Africans to the New World started it after the Civil War. Questlove from the Roots traced his ancestry to one of the founders of Africatown. It used to be self-sustaining and had its own language, grocery stores, schools, everything. Sadly, there isn't a lot going on now. The city of Mobile rezoned the land to heavy industrialism and now there are oil farms, paper mills, and a tar sands pipeline. But people still live there and have pride in their community.

Where do you spend your time in New York City?

I work for the city's Parks Department. We have 550 community gardens in the five boroughs, and I support gardens in the South Bronx and Upper Manhattan. We have meditative gardens, ornamental gardens, and some are strictly for food production. It's not a cookie-cutter program like in other cities. [*Laughs.*]

This book you're reading has a gorgeous tree on its cover.

I love trees because they show us that we are one human family. The premise of *Sacred Instructions* is that, in order for us to have any hope for a good future, we have to honor the ancestors who gave us their wisdom. Sherri Mitchell was born and raised on the Penobscot Indian reservation. She shows how Indigenous ways can change our behavior. There's an amazing chart in the book that lists Indigenous versus Western values, like setting communal versus individual goals and valuing elders versus glorifying youth. I really believe that we're not here to outshine everyone else. Those of us who can tell the truth from the counterfeit are going to band together, and we're going to usher in a new age.

Fulton Street station
Manhattan, 2020

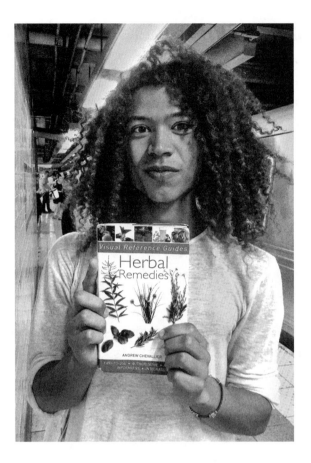

Macon McGinnis

Herbal Remedies
by Andrew Chevallier

I'm an herbalist and just came back from a vacation. I'm reading this book to refresh my memory. [*Laughs.*] It's a visual reference guide about herbs, how they can be used for healing, and where they can be found. In this day and age, pharmaceuticals take precedence. I would like to empower people to consider natural healing. There's so much wisdom and beauty in connecting with the ancient power of nature and its medicine.

What made you want to become an herbalist?

Divine guidance, I guess. I have an innate obsession with nature and the symbolism of plants, animals, minerals, and all other kingdoms.

14th Street/8th Avenue station
Manhattan, 2015

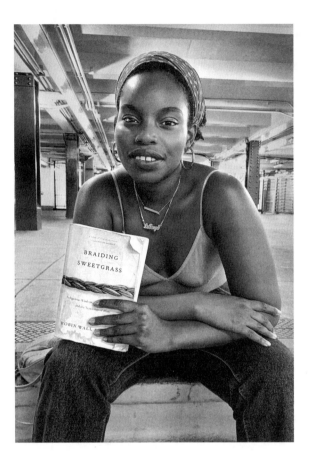

LaTonya Yvette

Braiding Sweetgrass
by Robin Wall Kimmerer

S omeone tried to cut down a tree in our shared backyard in Brooklyn recently. Apparently, my landlord had given them permission, but I went *off* so they didn't end up doing it. [*Laughs.*] Can you imagine? They felt they had the right to cut down a tree that has been here longer than they have been alive!

I tried to fight for a tree once, but I lost. What kind of tree is yours?

It's an ailanthus tree, the tree of heaven. The book *A Tree Grows in Brooklyn* is about the ailanthus tree. It's pretty common, but it signifies so much, because it has a very long lifespan. The one in our backyard is gigantic and around fifty years old. I said to my neighbor, "You don't own the relationship to this earth. You don't get to remove something from this land without people noticing it." We live near Brooklyn Hospital, and thousands of people died a few blocks away during the pandemic. It made me feel like we have to hold on to what we have.

There's a big difference between stewardship and ownership.

I fell in love with *Braiding Sweetgrass* by Robin Wall Kimmerer and I've already read it twice. It makes you think about what you're receiving from an environment—including a tree or a plant—and how you show gratitude and give back. And it brings into focus that we actually don't own anything. Often when I speak to white people, they talk about owning property. I started to think that I needed to be part of that conversation too. This book puts into perspective that even if your name is on a mortgage, you don't actually own the land. You occupy a space, you don't own a space. It's complicated, because there are also many arguments to be made for Black equity. I think the fact we can all agree on is that anyone who thinks that they lose something when someone else gains an inch is psycho. [*Laughs.*]

Agreed! Do you have a special way to connect with the land around you?

This summer, I spent a lot of time biking and lying in the grass. A huge part of me wants to start a garden. It might be on a fire escape or in a real yard, we'll see. I want to be present with what I'm growing. Even if it's just in a small, little pot.

**Clinton–Washington Avenues station
Brooklyn, 2020**

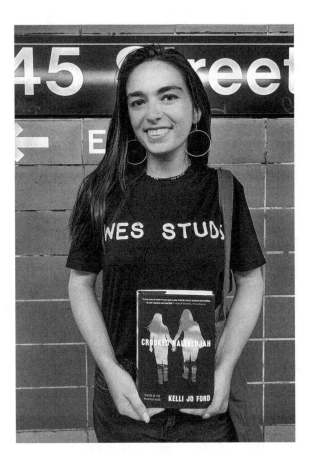

Shea Vassar

Crooked Hallelujah by Kelli Jo Ford

I'm growing heritage corn in pots on my stoop for the very first time this year. I'm a citizen of the Cherokee nation of Oklahoma, and my tribe has a seed bank where you can get heritage seeds, including flowers and vegetables. My corn is a descendant of the plants my ancestors brought with them on the Trail of Tears. It's called Cherokee White Eagle corn and it's beautiful. I often sit on the stoop and hang out with my corn while drinking my morning coffee.

How does it feel to grow Cherokee heirloom seeds in New York City?

It's weird to be a Native person in an urbanized city. I've had a really hard time reconnecting with the land. Having my hands in the soil and spending time with something that I'm able to grow and nourish is a new experience for me. Being Cherokee can be hard because people don't understand that we still exist, and the thing that's often misunderstood about Native belonging is your blood quantum. I don't define myself by a fraction. If your great-grandmother was Cherokee, then you are, too. New York has one of the largest Indigenous populations in the country, but many people don't even know that we are on Lenape land. Many people think that land was bought, given, or that it doesn't belong to anyone, which is not true. Native communities feel so connected to the land because we know that it's our duty to protect Mother Earth.

Have you always felt close to your tribe?

No, I wasn't raised by my Native mom, and growing up I was taught that the Native part of me wasn't important. As I got older, I started to reconnect with my kin by going to my tribe's museum in Oklahoma and reading lots of books. *Crooked Hallelujah* is about growing up in a community where a little bit of Cherokee presence is left in the shadow of megachurches and smaller country congregations whose über-religious attitude erases a lot of our culture. You look at what people have to sacrifice to survive and ask how we can make it to a point where the next generation doesn't have to sacrifice as much. There's also nostalgia for tradition in the book, and though it's not ever explicitly stated, you see it in the actions of all women. There is growth in each matriarchal line and in each family tree in this story.

Do you see yourself in the book?

I see myself in the youngest character, Reney. She has a goldfish that her mom's boyfriend won for her at the fair. Reney finds out that the goldfish will only grow as big as its container, so she puts it in a large pond where it can meet its full potential. Things like the seed bank, where I was able to get my corn, are so important, because we are not taught to put our happiness

and our fulfillment first. It's more about survival and assimilation to survive. As a kid, I always wanted to see sunsets and dance barefoot in rainstorms, and honestly, I'm still like that. In the morning, I'll throw on a T-shirt, shorts, and wear no shoes to go check the mail. People say, "You do that in New York?" But I can wash my feet later. [*Laughs.*] I like having my feet on the land.

45th Street station
Brooklyn, 2020

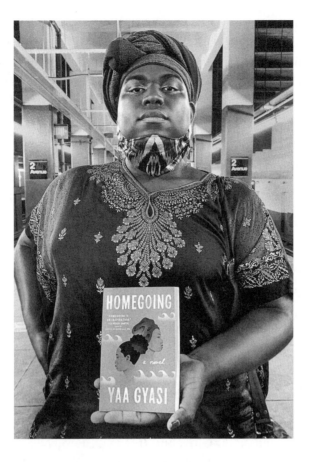

Qween Jean

Homegoing
by Yaa Gyasi

I'm a Caribbean goddess who was raised by two Haitian grandmothers in Port-au-Prince and Jacmel. Those women gave me the will to live and they gave me purpose by reminding me of where I come from and what makes me special. What makes me special is my culture, my skin, and my native tongue. I can never lose that. When I think of matriarchs, I think of the Black queens who have continually birthed, raised, and educated the

American community at large. My grandmothers were powerful business-women whose success was not attached to a man. They provided for their family and they fed their community on weekends. My mother, Emirene, taught me to be independent and that we cannot wait for a man to give us anything. We cannot wait for a man to define our virtue, victory, or purpose. We have to find that for ourselves.

What do you do in New York City?

I am seated in the Black trans liberation movement, I'm a costume designer, and I'm a storyteller. We transform through clothes and create whole worlds and new language through the vessel of clothing. What someone wears defines who that person is, whether it's a sneaker, a leather jacket, a hair clip, or a wrap dress. When someone is adorned, they are complete. When they are adorned, they can step out into the world. I have a lot of textiles and I often wrap them up into a crown. These fabrics are painted, embroidered, and produced by women of my community. It is an honor to be crowned with the cloth of my ancestors.

Homegoing, which you are holding in your hands, is all about ancestors.

I will go on record to say that this work is seated next to Toni Morrison, Maya Angelou, and Nikki Giovanni. It is a masterpiece and hella Black, hella feminine, and hella powerful. [*Laughs.*] People say that time is relative, but when I read this book, I am like, "Child, time is precious, time is essential." This young, visionary writer has been able to tap into something that we've been trying to resolve for hundreds of years. As a young Black trans goddess, the women in this book are women I know. These women have raised me, yet we never get to hear about them. We see them on the street, we see them at the bus stop, but we don't know who they really are. Yaa Gyasi has allowed us a way into their hearts. Black matriarchs exist. She is seated next to them and affirms them.

Every person has to journey into who they are. But some journeys are much more scrutinized and life-threatening than others.

Oh, absolutely. I've always known who I am, that was not a new discovery for me. What's new is the acceptance of other people and their affirmation. That's the part of my journey I didn't know could be possible. When I wore heels to school or if I borrowed a skirt, I was met with opposition instead of praise. That truly made me afraid. Instead of showing my full self, I was the person others wanted me to be, someone more palatable, more socially acceptable. All the while, Qween was being underfed and underserved. A lot of trans youth deal with that burden, and sometimes we feel that if we were gone, it would be easier. I am here to say that this is not the case. We are enough. We are beautiful. We are powerful. Transition is not a burden—it is an opportunity to finally get to live. We have to face our dementors and say, "You do not have power over me." This is my reigning season. I shall be triumphant and victorious.

2nd Avenue station
Manhattan, 2020

Samuel María Gómez

*Women Who Run with the Wolves: Myths and Stories of
the Wild Woman Archetype* by Clarissa Pinkola Estés

What's not to admire about women! I think one of the coolest things about women is their ability to channel masculine *and* feminine energy. A woman can wear a red dress with heels and command the attention of a room or she can throw on sweatpants to garden some flowers. I want to bring that ability into my own life. Right now, I'm actually wearing a pair of women's jeans. I found them at a shop that was closing and it's all

they had left [*laughs*]. They were a dollar, so what was I supposed to do? I got them tailored at the waist and they fit pretty nicely. I've been rocking them all summer.

Welcome to the sisterhood. We appreciate you.

I know that I have my limitations as a man, but I've always felt a close kinship with women, starting with my mother, my aunts, sisters, girlfriends, lovers, and friends. I tend to connect deeply with women and I'd like to understand them more. *Women Who Run with the Wolves* came highly recommended. A Mestiza Latina woman wrote this book, and since I'm Latinx, I'm leaning in that direction. It's about the existence of spirit and our ability to tap into it. To wear what lives inside of you on your outside really is a process. It takes time.

Do you think the identity of a Latinx man is changing?

It's an interesting time to be a Latinx man. I'd say, specific to my people, we're not popping out as many babies anymore. I'm one of eight and so far I have no children. That's a big shift. I also think that there's a growing awareness of our bloodlines and our relationship to women. Our culture is still very patriarchal, but being a "good man" is also no longer only defined by going to work and paying the bills. It's about sustaining yourself emotionally, nurturing your mental health, being there for others, being patient, loving, and vulnerable. You could say that my generation of men is experiencing the "Industrial Revolution" of being in touch with our emotions. [*Laughs.*] I think the next generation will totally get it and figure it out. We're dealing with all that misogynistic stuff that we learned from our dads and are building a bridge between what we've been taught and what is right. It's a beautiful and messed-up place to be.

14th Street/8th Avenue station
Manhattan, 2019

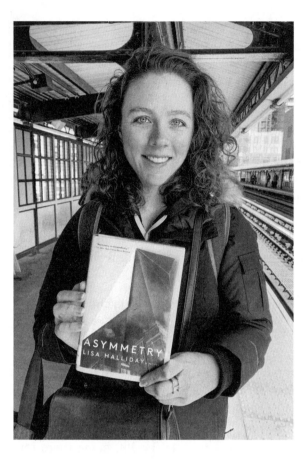

Mary Rhymer

Asymmetry
by Lisa Halliday

E veryone knows my mom. When I drive her car, people wave at me because they think I'm her. The car is also covered in big hippie flower stickers, which might have something to do with it. My mom is our town librarian and my parents live across the street from the library. Our cat Louie has been going to work with my mom every day for seventeen years. My mom doesn't remember this, but growing up, my sister and I had

to read every night and log the page counts and titles of the books we read. In the morning, we'd get ready and then sit on the porch for ten minutes before we left for school, and my mom would read to us until the bus came. This routine went on for six years.

That sounds intense! Did those routines affect you in any kind of way?

I don't enjoy the task of reading, but I still enjoy a good book. [*Laughs.*] I got *Asymmetry* at the library and I've renewed it twice already, that's how slow of a reader I am. It's set in New York, and the first story is linear and about a young woman who has an affair with a famous, older writer. That one I sped right through because it felt more relatable. The second story is taking me longer because it feels less familiar to me. It's about a young Iraqi Kurdish man from Bay Ridge who gets locked into a holding area at the airport on his way to visit his brother. It's not surprising that these two stories could take place at the same time in New York.

Did you take something from your hometown with you when you moved here?

When I was a kid, my mom said, "I want you to try to be the kindest person in the world." I think about that a lot and for a while I really tried. But since living in New York for ten years, and starting a business, and doing too many favors for free, I've learned that you need to be a little tough in the city. I'd say, "Be the kindest person in the world, within reason."

**Court Square station
Queens, 2020**

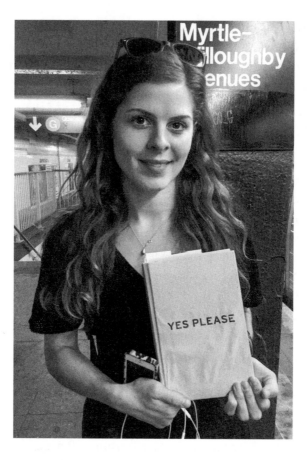

Brittany Saisselin

Yes Please
by Amy Poehler

I love reading stories by inspiring women, and *Yes Please* has definitely made me laugh out loud a few times. I read *Bossypants* by Tina Fey before this one, and I think women who aren't afraid to laugh at themselves are the best. I'm almost thirty and I work in a male-dominated environment. It's refreshing to hear how other women handle it. Amy talks

about how women often say "sorry" after asking a question or making a statement, especially when working with men. I think we should never apologize for speaking our mind!

Myrtle–Willoughby Avenues station
Brooklyn, 2015

Marz Lovejoy

Rabbit: The Autobiography of Ms. Pat
by Patricia Williams with Jeannine Amber

My grandmother Alyce brought me to New York City for the first time when she came here on a business trip. She's gregarious, loving, and a Gemini—she keeps you on your toes! I was nine years old and fell in love with the city instantly. As the years passed, I started modeling and I'd come here to do campaigns. Then Myspace popped up and suddenly I had friends in the city. I remember coming here with my mom and dad for a huge Ralph Lauren campaign. We stayed in a very nice hotel and we went to Dylan's Candy Bar and took the ferry to see the Statue of Liberty. My mom saved all my modeling money, which meant I could take care of myself when I turned eighteen. When you're a kid, you never know what little seeds are being planted.

Is Ms. Pat planting any seeds with you?

Yes, Ms. Pat is great! She's a comedian and *Rabbit* is her memoir. She grew up in the inner city of Atlanta and she had two young kids by age fifteen. I love that Patricia Williams made it happen for herself and that she had a story to tell, about what it's like to be a Black woman. We have to get back to the basics. If you have a story, tell it. You'll find people who will help you shine it up. Ms. Pat has definitely inspired me to put my story on the page. I'm thankful for that.

Phone interview, 2020

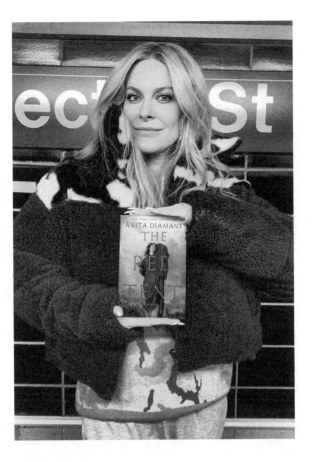

Leah McSweeney

The Red Tent
by Anita Diamant

I'm just a woman trying to figure things out. [*Laughs.*] Right now, I'm in a strange place because my grandma recently passed away. Grandparents are so amazing because they have unconditional love, they don't judge you, and they have wisdom our parents can't give us because they're stressed out all the time. My grandmother had a lot of dreams, and she broke a lot of boundaries. She grew up in the West Village as an only child

and had eight children. I think she really longed for a family, so she created one for herself. My grandmother is gone but my mother is her legacy, I'm her legacy, and my daughter is my legacy.

Do men think differently about the legacy they leave behind?

Of course! There's always a difference with men and women. Men care more about the things they've accomplished. For me, it's all about the people I have a direct impact on. It's not about how many businesses I've created or how much money I've made. How many people will be heartbroken and devastated when I leave the earth? That's what matters. I was actually thinking about this yesterday—running my brand Married to the Mob for sixteen years has been an uphill battle, but ultimately it works because of the relationships I've built. I totally believe that it's our karmic duty to use our success in a positive way and to spread it back around.

Behind every strong woman is another strong woman.

If you think about it historically, the way women have survived all over the world—and I'm not a freaking history major but this is true—has been because they were together. I think that's why people love shows like *The Real Housewives of New York City*, which is about sisterhood in the end. Of course, when you put six women together, interesting things will happen [*laughs*] but you're also going to see how powerful it is when women form relationships with each other. That is how women have survived, forever. Believe it or not, *The Red Tent* was given to me by a woman I don't know, who was like, "Oh, your name is Leah. I think you'd really like this book. It's about the four wives of Jacob, one of their names is Leah, too." I like it. It's about the women dealing with each other, midwifery, and menstruation. Spoiler alert: They go into a tent, hence the title.

Wait, they had a period tent?

Yes, think about it! They didn't have tampons and pads. They had to go bleed onto the dirt! But there were beautiful traditions around menstruation, and it was meaningful. I'm personally very connected to my period. Even

though it's annoying, it's a beautiful thing, but I'm also never going to tell another woman how to feel about it. Women should have the freedom to be whoever they want and to do whatever they want.

What's the best advice you've ever gotten from another woman?

Back in the day, I was assisting a stylist who told me, "Be careful how you treat people on your way to the top, because you're going to see them on your way back down." I'll never forget that. Isn't that so good?

Rector Street station
Manhattan, 2020

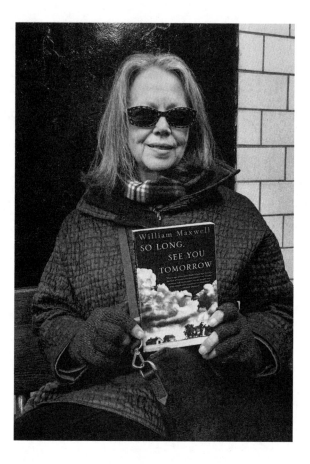

Margaret McInerny

So Long, See You Tomorrow
by William Maxwell

T he author of this book, William Maxwell, was the fiction editor of
the *New Yorker* for a long time. The story starts with a murder and
the narrator leads you through his childhood, the death of his mother, and
how he meets the son of the killer. Maxwell gives you all of this informa-
tion right at the beginning, so I'm not spoiling anything. [*Laughs.*] His
reminiscence of his mother's death is heartbreaking. I don't know if I feel

that way because I just lost someone. Last fall, my husband and my son-in-law passed away within six weeks of each other. They both had cancer. I still feel very raw, and Maxwell's description of loss perfectly captures my emotions. My daughter, Nora, really got the double whammy, losing her father and shortly thereafter her husband. I'm in New York to visit and support Nora while she is running the half marathon this weekend. Someone once said, "Grief is the presence of absence." This is very true.

York Street station
Brooklyn, 2015

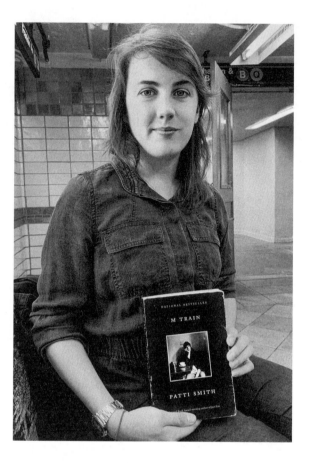

Ellie Musgrave

M Train
by Patti Smith

The lamp company I work for has been in business since '83. The shop is in Bushwick and is full of metal parts, lampshades, decades' worth of paper files and minutiae collecting dust. I've been working as a photographer on and off and I wanted a part-time job that didn't detract from my creative pursuits.

I imagine that light matters to you as a photographer.

Oh, light is the essence of photography! The word *photo* is derived from *phos*, which is Greek for "light." A lot of people have gone out of their way to use photography in their books, and I don't think anybody has done it quite like Patti Smith. The style of her photography and the style of her writing are so obviously from the same mind. In both, there is room for speculation and imagination. Patti Smith really is a wonder.

What makes Patti Smith a wonder?

I think she *is* New York. She's had her hand in so many people's lives and she's had such a huge impact as the godmother of punk. In the opening of *M Train*, she talks about walking around on New Year's Eve and feeling out of place, watching everything she loves change. She acknowledges that she's part of a bygone era, but still, so many people feel connected to her because she stands for the eternal story of coming to New York, which is a timeless tale.

How would you describe your relationship with New York?

Right now we are not quite on the rocks, but maybe on the dunes where the sand gets spiky and you don't want to walk barefoot. [*Laughs.*] I struggle with what it means to be an artist in the city, and I also lost my mom about a year ago. She was a huge Patti Smith fan. Being able to read *M Train* after she passed away is such a blessing, because it's about loss and grief. Unlike in *Just Kids*, in *M Train* Patti Smith is just like everybody else. She's in her apartment, watching detective stories on TV late at night with her hairless cats. While my mom was in hospice we'd watch *The West Wing* and eat chocolate ice cream together. Patti Smith embodies past lives in so many ways and people think of her as an icon. But she's also a human being and, just like everybody else, she's grappling with what that means.

What are you photographing these days?

I have a few days off this week and I'm thinking about going to Dead Horse Bay to take pictures. There's an old abandoned airfield and a bunch

of dilapidated buildings that, at first glance, look kind of sad, but I think there's a lot of wonder and possibility in that. I like to look for the odd and unusual. The other day, I found a chicken coop on a little plot of land on Dean Street in Crown Heights. There was a machine that you could put a quarter in, turn a crank, and a bit of chicken feed would come out. I didn't have my camera on me, so I have to go back and photograph that at some point. Imagine, you're in Brooklyn and suddenly there are chickens.

**Prospect Park station
Brooklyn, 2020**

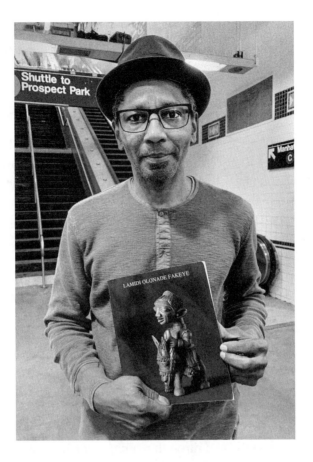

Gregory Anderson

Lamidi Ọlọnade Fakẹyẹ: A Retrospective
Exhibition and Autobiography

I love chickens. I've built around a dozen chicken coops in different
community gardens in New York. There's a chicken for every part of
your life. A Rhode Island Red will give you some of the tastiest eggs you
can find. If you need companionship, the Bantam chicken is there for you.
I personally love the Silkie. Their feathers are just beautiful. I grew up
down South, first gardening with my grandmother and then helping out my

cousin Buster Brown Bishop on the family farm in Selma, Alabama. My cousin gave me my first job on the farm, which was to feed the chickens, because they are the easiest animals to take care of.

That's amazing. Why did you start building chicken coops in Brooklyn?

At the end of 2001, after the World Trade Center came down, I decided that I needed to get back to my roots. We lost so many people physically, but we also lost the city mentally. I wanted to give my kids the experience of being around small animals because it changes your priorities. I met Mr. Lenny, the steward of a community garden on Dean Street and a caretaker for the whole block, the first winter we spent in our house in Brooklyn. He taught me the tricks of urban farming and showed me that farmers are scientists and historians. Unfortunately, he passed away in 2004. Me and the block association president decided to renovate the garden and to name it Walt L. Shamel, which was Mr. Lenny's real name. That garden is still there today and there are still chickens in it. Our community gardens are important because they are our town squares and help us to reaccess our ancestors' knowledge.

How do you access your ancestors' knowledge?

I do it by learning skills and through reading, which allows me to disconnect from my current situation and go backward or forward into a more positive experience. This book is about Lamidi Ọlọnade Fakẹyẹ. He comes from a famous family of wood carvers that go back to the fifteenth century and he is one of a few ancient African artists that we can name. That in and of itself is amazing. I grew up in the '60s, and *National Geographic* was one of the most popular magazines around because it allowed people like myself to travel the world without leaving our living room. I would see stories about artists like Rembrandt in *Nat Geo*, but when I read a story about African art, it never had a name attached to it. That hurt me to the core of my soul. It made me feel like Africa had nothing to offer, which is a lie—the Cubist movement was developed from African art. It took me over thirty years, but I did find Fakẹyẹ.

How did you find Fakẹyẹ?

My wife gave me wood-carving tools from Pearl Paint as a gift. I found a loose piece of wood in Prospect Park that spoke to me and carved a mask from it. I ended up in an art show at a church in Fort Greene with that piece, and Chief Isaac Olugbemiga Komolafe was part of the same show. I met him and studied under him for about four years. Turns out that he's from Yorubaland and Fakẹyẹ's cousin. That's how I found Fakẹyẹ after all those years. This book means a lot to me because it brought an end to my childhood search for the history of my people. A lot of people get their DNA tested to find out exactly where in Africa they are from. I love that idea, but personally, I feel the right to claim all of Africa as my family. The oldest bones came from Africa, so I claim that I am an ancestor of Lucy. And since Lucy is not only connected to Africa, but also to the rest of the world, I claim everyone as my family.

We need to love and respect each other—and the chicken.

Yes, we do. There is a whole story behind the Leghorn, which is the Corn Flakes chicken. I'll tell you about it another time. And the egg! You don't have to consume the chicken, because the egg is the perfect food. It's very nutritious, and just think about all the pastries and sweets you can make with eggs. The egg is a whole other story.

Franklin Avenue station
Brooklyn, 2020

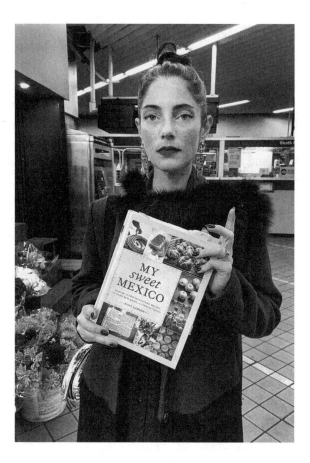

Maayan Zilberman

My Sweet Mexico
by Fany Gerson

When I started my candy company, I wanted to make candy with
meaning and its own personality. Over the years, I've made crystals,
amulets, medusas, panthers, and a giant boulder adorned with candy gem-
stone rings. My inspiration is a dream I had when I was a child where I
buried precious possessions like my cassette tapes in the ground only to
return later and find that they had turned into candy. I used to listen to music

on my headphones and feel like it only belonged to me. For me, candy is the same thing—your private, fleeting experience. I was born in the '70s on a kibbutz in Israel where everyone shared everything. I found candy to be *so* mysterious and didn't eat much sugar then. It wasn't until we moved to Canada and I saw kids on the playground with their Smarties that I got curious about candy.

Does Fany Gerson, the author of this book, make you curious?

Absolutely! Fany Gerson is a pastry chef, and *My Sweet Mexico* is the most gorgeous cookbook I've ever seen. Fany is Mexican, and she traveled all over Mexico to visit homes, local bakeries, and century-old convents to document their traditional techniques. Sugar and sweets are spiritually important in Mexico. Reading about it made me think about the use of sugar in the United States. If you put lots of sugar in products to drive business, there isn't a lot of room for spirituality anymore. I love seeing how sugar is treated around the world when I travel. In Rwanda, I went to a bakery and their sprinkles had a color palette that you can't find anywhere else because of the natural, local ingredients. It was beautiful.

What defines your local experience in New York?

When I moved here as a fifteen-year-old, I was obsessed with Lil' Kim. I listened to Hot97 on my Walkman and dreamed about meeting the women who sang about empowerment and confidence, which sounded possible to me as a small-town girl. [*Laughs.*] To me, the "New York woman" is loyal, witty, and a hustler in the classiest way. The New York man knows where to get the best pizza and the barber down the street is his friend. That's Mister New York.

Clark Street station
Brooklyn, 2020

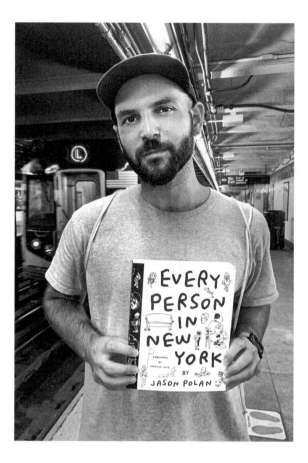

Nicolas Heller

Every Person in New York
by Jason Polan

I'm New York Nico. Most people know me for profiling the kind of New York City I love, whether that's street characters, businesses, or current events. The only time I got out of New York was when I went to college in Boston to study film. I thought I was going to be the next Hype Williams. [*Laughs.*] After college, I landed in Los Angeles and it was the worst six months of my life. I biked everywhere because I didn't have a driver's

license, and I shared a room with someone I found on Craigslist. Once I moved back to New York, I felt defeated.

What got you into the New York Nico spirit?

When I was down in the dumps, I went to Union Square Park to sit and reflect. I noticed a tall dude with a sign that said "The 6-Foot-7-Inch Jew Will Freestyle Rap for You." I'd seen him around for years but I was always too shy to talk to him. At that point I thought, "Why not?" I ended up making a documentary about Te'Devan and people were stoked on it. Then I filmed a Spider-Man who rode people around the East Village in a rickshaw; Big Mike at Astor Place Hairstylists; Tiger Hood, who plays golf with milk cartons; and Nelson Molina, a former Department of Sanitation employee who started a museum in a garage full of trash.

Why do you think we love these people so much?

There's no one in the world like the Green Lady, Charlie da Wolf, or Luca Two Times. They make us happy and the world more entertaining. I'm drawn to old-school New Yorkers, whether they're twelve or eighty years old. This book, *Every Person in New York*, is by the late Jason Polan. It still feels crazy to say that. Jason passed away from cancer at age thirty-seven. He was the sweetest one-of-a-kind guy, and every time I saw him, he had his notebook in his hand. One of my favorite illustrations he did is of a security guard dancing to Michael Jackson. If someone walked away, Jason didn't continue the drawing, so a lot of them feel unfinished, which I think is great.

This book is chaotic, like New York itself. I mean that in the best of ways.

It's funny, I didn't like Jason's style at first and was like, "Why is this guy getting so much shine?" Because of this book, I understand how brilliant he was. You can't just look at one of his sketches. You have to look at every person in context to each other. I love that. I always want to be there for the city and for the little guy, because they're the best. They are what makes New York New York. Once they're gone, we're not going to have another one of them.

Graham Avenue station
Brooklyn, 2020

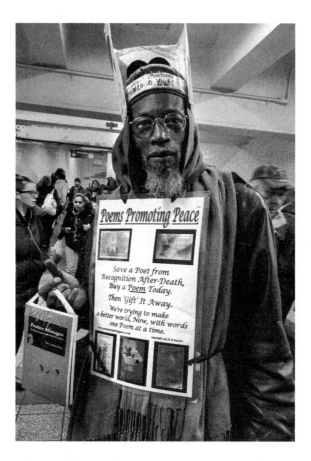

Marc Anthony Butcher

Positive Messages
by Marc Anthony Butcher

Thousands of people pass me by and they don't stop to speak to me. I was hoping my sign would disarm them, but people still think I'm crazy or homeless. I'm a philosophical person promoting peace because heartbreak is a terrible disease, and I write poems and books about having healthier relationships in your life. I've been here for a long time. The *New York Times* featured me a few times, once in an article about roller-skating.

My theory is that roller-skating on a regular basis will prevent senility and dementia. It's a theory. Only the public can decide if they want to challenge it. In the meantime, I'm here. And if any of my messages move someone in a positive way, then my existence will serve a purpose.

Metropolitan Avenue/Lorimer Street station
Brooklyn, 2018

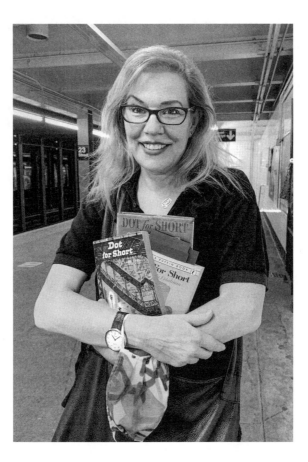

Debbie Millman

Dot for Short
by Frieda Friedman

I was on a quest to re-create my childhood library, and *Dot for Short* is one of my favorite books. The version I was looking for has illustrations by Mary Stevens in it and I couldn't find it anywhere. I would scour all sorts of flea markets and bookstores, and they'd always tell me it was out of print. One year, I was looking as I always did and found this copy, which was reprinted in '88. I feel single-handedly responsible for the republishing

of this book, because I went into every single bookstore in the United States and asked for it. [*Laughs.*]

Why did you want multiple copies of *Dot for Short*?

I don't know, but I love this story so much. Dot is a New Yorker who lives on 3rd Avenue, facing the elevated train. She is a short little girl who wants to be more than she is, and she becomes a hero. That's all I ever wanted when I was a kid. I'm a native New Yorker and in '83 I moved to Chelsea, which is when my quest to find *Dot for Short* began. I think I wanted to remake my childhood on my own terms. I did the same thing with some of my toys and dolls.

New York makes me feel smaller and bigger at the same time. It's perfect.

In New York, I feel like I fit in anywhere and everywhere. My office was in the Empire State Building for twelve years and I felt like we were working in the castle of New York, because we were. In the early '90s, I worked at the Brooklyn Academy of Music, and that was a special space to me. Now I work at the School of Visual Arts and that's a really great institution to be a part of. New York is a magical town that is very tolerant of misfits.

Misfits often become legends.

That's the thing about Dot. She feels like a misfit and then ultimately she is appreciated for it. A lot of people live in New York because they feel like they don't quite fit in anywhere. I think misfits are the ones who make a difference. They tend to be risk-takers and they're willing to try anything. That's a good quality to inhabit, especially in New York City.

23rd Street station
Manhattan, 2020

Roxane Gay

The Age of Innocence by Edith Wharton

I love Edith Wharton. *The Age of Innocence* is my favorite novel and I have read it probably seven or eight times. I mostly pick it up when I want to be reassured that beautiful writing exists. Edith Wharton is so good at cultural commentary and she has a real contempt for the wealthy class she was part of. Like many places, New York City is very stratified in terms of class because it's a megalopolis with a small surface area. You're always going to encounter people from all walks of life, but many times the people who live in the "better neighborhoods" don't think about the people in the outer boroughs who make their lives possible.

Have you ever felt contempt for being associated with a certain class?

I'm definitely associated with a certain social standing, but I don't know if *contempt* is the right word. I grew up middle-class, but I can't privilege my way out of racism. As an adult I have certainly made some money, but I also still have student loans that I can't pay off anytime soon. It's a fine balance. People will always make assumptions about your level of wealth and it may not be accurate. That can be frustrating, but it's not the end of the world. I'm going to be at home watching Bravo today, contrary to people's expectations.

People like to flaunt their stuff in New York. There's a legacy to it.

My wife, Debbie [Millman], and I go back and forth between Los Angeles and New York, and there are some aspects of New York I just don't understand,

like the need to be seen. Partly because I'm an introvert and partly because I'm from the Midwest. Also, I'm old. [*Laughs.*] Almost every moment I spend in New York is full of tension because everyone is a fast mover and I am not. As a fat Black woman, the world does not want me to exist in public. It's important, but it can be challenging to believe that I have the right to take up space given that people love to tell me otherwise. Many tend to stay away from discomfort. I'm very interested in discomfort. I find the lack of a resolution frustrating, but it has texture. The moment I love most in the book is when Newland Archer and Countess Ellen Olenska are almost touching, but not quite, and there's an unbearable tension between them. I just love to think about that moment.

Is there a moment you particularly enjoy in New York City?

When I'm with Debbie, a born-and-raised New Yorker, I see the city through her eyes and we have so many lovely adventures. Through her, I see that art is everywhere, not only in galleries and museums. She has an eye for seeing unexpected, beautiful things in a fire hydrant or on the walls of an alley. The way she sees the city is remarkable.

How we see our surroundings makes all the difference.

Countess Olenska is a stranger in a strange land and a woman without a country because she divorces her abusive husband. I totally get that feeling of being a person without a country and looking for a way to fit in. Oftentimes when we don't accept other people, it's because they embody something that we resent or hate in ourselves. I don't want to sound too idealistic, nor do I want to sound too simplistic, because nothing is as easy as saying, "If we all love ourselves the world's problems will be solved." But if we were more generous with ourselves and would accept the best and worst parts of ourselves, I do think life would be easier.

**23rd Street station
Manhattan, 2020**

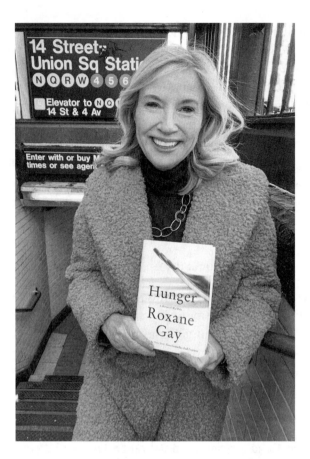

Nancy Bass Wyden

Hunger
by Roxane Gay

I'm going to a small dinner gathering in honor of Roxane Gay tonight that's hosted by PEN America. I'm a memoir junkie and I love that *Hunger* is so forthright and raw. I really appreciate Roxane's honesty about the shame of keeping secrets and a woman's struggle with body image and self-worth. She writes that food can be a fortress to protect yourself from people who want to hurt you. We all grapple with vulnerability in our lives,

and for me, reading is a great source of comfort. It's a good thing to have a paperback in your pocket at all times. [*Laughs.*]

You're the owner of the Strand bookstore. What is it like to protect that kind of legacy?

I was basically born in the stacks at the Strand. It has been in my family for almost a hundred years. It was my grandfather's, my father's, and now the honor has been passed on to me. My place of refuge is the Rare Book Room. For me, owning a rare book is a chance to own a piece of history, and much like the Strand, I am devoted to the printed word.

14th Street–Union Square station
Manhattan, 2017

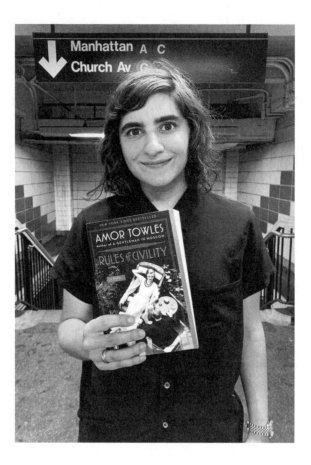

Marguerite Zabar Mariscal

Rules of Civility by Amor Towles

*R*ules of Civility transports you to an homage of New York in a really cinematic way. While reading it, I also watched *Taxi Driver*, *Do the Right Thing*, and *Rear Window*. The book is about a young woman with high society, Great Gatsby–like aspirations. Looking into the title I found out that George Washington apparently had 110 rules of civility. A lot of them are outdated, but some are still interesting. Rule 107 is, "If others talk at the table, be attentive but talk not with meat in your mouth."

Order Number: 263929

07/28/22 at 02:10 PM
Cashier: Gus

. .

Tuna Salad Sandwich
+ Bubbler Drink
+ No Meal Upgrade
+ Chips

. .

. .

Total 12.93

er Checked By _____

Do you have rules of civility?

Something I've been saying at work lately is that you shouldn't treat people the way *you* want to be treated. You should treat people the way *they* want to be treated. I'm the CEO of Momofuku, and my family owns Zabar's on the Upper West Side. I never thought I would work in this industry, because my grandfather Stanley always said that being in hospitality is not a great idea. You always work on holidays and the hours are long.

I'm very jealous that you're part of the Zabar family and I am not.

My grandfather has pretty much spent his whole life between 80th and 81st streets, and the majority of the Zabar family lives within ten blocks of each other, so it's a lot [*laughs*], but I consider myself lucky to see so many family members on a consistent basis. Dave Chang [the founder of Momofuku] says that the line between my family and the business seems to be a very fine line. Me, my brother, and all of my cousins have worked at Zabar's at some point. Everyone starts as a cashier or behind the strudel counter—I never worked the strudel counter, my brother did. Zabar's has been around for over eighty years and I think that's because it is entirely itself. When you're in the store, it feels the way it always has, and that's hard to do in New York.

Hoyt–Schermerhorn Streets station
Brooklyn, 2020

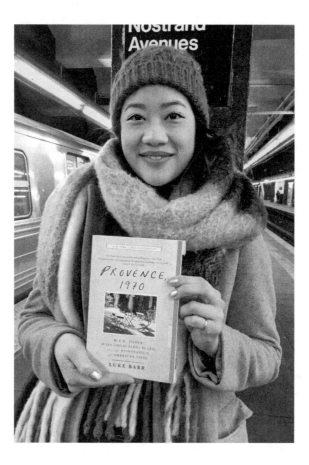

Coralie Kwok

Provence, 1970
by Luke Barr

My book club is reading *Provence, 1970* and it's a story about pioneers in American food, like Julia Child, James Beard, and M. F. K. Fisher, who fell in love with France and the value of eating around the table. They brought this concept to the United States at a time when people here were into microwave food. I'm French and grew up in Paris—I do not have a microwave. [*Laughs.*] You can do everything with a stove! I love throwing

something like a boeuf bourguignon into a cocotte. You don't have to do much and it tastes and smells amazing. I often have friends over and cook a three-course meal for them, including a cheese platter and a dessert. You can't have a meal without cheese.

Bedford–Nostrand Avenues station
Brooklyn, 2018

Christa Beutter

Di Palo's Guide to the Essential Foods of Italy
by Lou Di Palo with Rachel Wharton

I'm visiting from Germany and wanted to buy some great food for a party I'm attending tonight. I randomly stopped by Di Palo's in Little Italy, which is where I came across this book. It's written by Lou, the owner, and the foreword is by Martin Scorsese, which I think is special. The Di Palo family founded their *latteria* in New York over a hundred years ago. Lou told me that Scorsese bought milk at Di Palo's for his family when he was a young boy.

Did you find something for your party?

Yes, I found a special cheese, called stracchino, and grissini, which are thin breadsticks. My family would eat those two things on vacations in Italy. It was our tradition for many years. I believe family and food belong together—it's the essence of life!

F Train
Manhattan, 2015

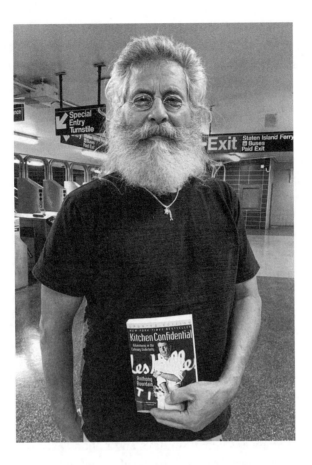

Jody Scaravella

Kitchen Confidential
by Anthony Bourdain

I own a restaurant on Staten Island where different grandmothers cook every night. Originally, we started with Italian nonnas who made food from their regions. I realized there were big differences and that got me thinking. Now you can also find Yumi from Japan and Xena from Syria cooking their specialties at the Enoteca Maria. When I first had the idea, people told me, "You can't do that, because people want to know there will

be ravioli on Thursdays." But I like surprises. [*Laughs.*] I wanted to have a space where women who carry their culture forward can cook whatever they like. Fourteen years ago, I put an ad in the daily paper *America Oggi*, which is very popular among Italians, and here we are now.

What have you learned from the different nonnas in your kitchen?

Yumi taught me that Japanese food is not just sushi and really broadened my perspective with her rice, noodle, and vegetable dishes. I also learned that they use a lot of Scotch bonnets and spices in Nigerian cooking. I always tell whoever's in the kitchen to cook authentically and not to worry about making it for Americans. You're never going to get everybody to like it, no matter what you do. [*Laughs.*] I want it to be real. My mother and grandmother put pignoli nuts and raisins in the meatballs. Sicily was under Arab rule for a time and that's why you have dried fruit mixed in with the meat. The closer you get to the border of any country, you start to see the influence of the neighboring countries on the local food.

I remember my Transylvanian grandmother rolling plum dumplings in sugar and cinnamon.

I remember the eels in the sink flopping around. [*Laughs.*] I grew up in Brooklyn and we always spent Sundays and holidays at my grandmother's house, a few blocks away. Women are the glue that hold the family together. They keep traditions alive and commiserate with you. I noticed that families start to break apart when women pass away. I know it happened for me. The driving force behind the idea to invite all these grandmothers to cook in the restaurant was probably just me trying to comfort myself. Because after my mom passed away, I really felt orphaned. I think I was trying to re-create that feeling of being at home.

What were you doing before the *enoteca*?

I was at the MTA for twenty-five years and there was an overlap of eight years where I was running the restaurant while working for the MTA. They hired me as a mechanic, but I have this quirk with numbers so they put me

in charge of forecasting and I basically had to guess which trains would need repairs a year out. It was challenging, but I was wired for it. [*Laughs.*] I had a little office in the MTA Coney Island Yard, one of the largest train yards in the world. It was great. Now they have high-tech trains running on a low-tech system. You know how that goes.

We love to hate the MTA! You have Anthony Bourdain with you today, bless his soul.

I really admire how Anthony Bourdain showed us different cultures through food. I rarely have time to read a book, but when I started *Kitchen Confidential*, I couldn't put it down. I love Bourdain for sharing all his trips across the planet and I feel like we're kindred spirits. He was down-to-earth, unpretentious, and just loved being around people. He would drink with them, smoke with them, do hallucinogens with them, and then he'd relax in a hammock, extolling the virtues of a tea he enjoyed. His absence is a tragic loss.

Do you have any virtues Bourdain would have appreciated?

Don't do anything for money. I always get laughed at for saying that, but if money is your driving force, you're going to lose. You start to think, "What can I do to make money?" instead of, "What can I do to make people happy?" If you do what you love, the money will come.

St. George Terminal
Staten Island, 2020

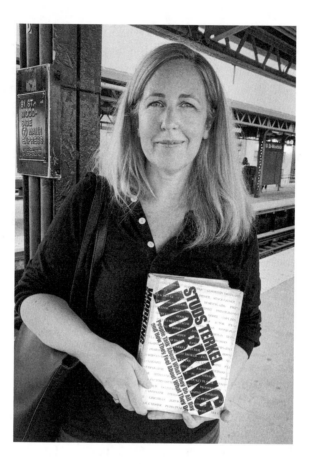

Laurie Woolever

*Working: People Talk About What They Do All Day and
How They Feel About What They Do* by Studs Terkel

W hen I first wanted to be a writer, I didn't know anything well enough to write about, so I thought, "Let me learn through my work." I've since worked as a food writer and a private cook; I went to culinary school, assisted the now-disgraced Mario Batali, and did a lot of catering before I became an editor at *Art Culinaire* and then *Wine Spectator*. After all that I

got married, had a baby, and wanted to change my life. That's how I ended up working for Anthony Bourdain for ten years.

I miss him, and I never met him. What defined the Bourdain universe?

For me, it was his sense of collaboration. I'm not a team player—the idea of group projects in school terrified me. Through Tony I saw that collaboration makes something bigger and better. He knew his strengths and when a project would be better served by somebody else. He did have a hand in every aspect of his work, but he also really trusted the people around him and was happiest working with a friend.

Why are we so defined by our work?

New York is not a leisure town. How much you work, where you work, and how much money you make is a badge of honor. People who have too much leisure time are sometimes looked at with a little skepticism. [*Laughs.*] This book, *Working*, is an oral history, which I love so much. Studs Terkel conducted interviews about people's work, if they liked it or had other ambitions. You can hear from a sanitation truck driver, a sex worker, and a factory owner. The nature of work has changed a lot but talking about what we do is universal. When you get into a cab, nine times out of ten, you're going to talk to the taxi driver about what they did in the country they used to live in, or what their kids do, or what you do. We're always in each other's business.

If you and Tony could go anywhere right now, where would you go?

There was a nondescript dive bar, the Coliseum, across the street from Tony's apartment that he loved. I'd be very happy to go there for a plate of chicken wings to shoot the shit.

61st Street–Woodside station
Queens, 2020

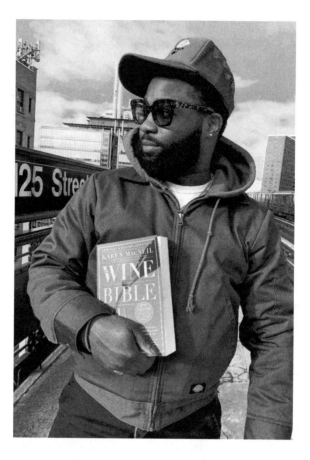

Marquis Williams

The Wine Bible
by Karen MacNeil

I'm from Harlem, I'm thirty-two years old, and I got my start as a stock boy at a wine shop on the Upper West Side. I've worked at wine shops all over the city, always filling in shifts everywhere. I moved up to shipper, then I became a salesperson, a manager, and then a buyer. Now I run my own wine club called Highly Recommended and I have my own wine coming out.

Why do we love wine so much?

I love it because wine is community-based. I love the togetherness I feel when I'm with the winemakers. They're often with their family and friends and there are always smiles and food going around. I also love that wine is a field where you can never know everything. *The Wine Bible* is a very good reference point. Karen MacNeil tells you everything you need to know. It's an easy but informative read, no matter what level you're on. She's not using vernacular that only wine people know and she doesn't go over your head. I think that's how wine is supposed to be. I really appreciate this book.

Wine, like literature, can be seen as kind of an elitist thing.

Yeah, but I think wine is super casual, fun, and there shouldn't be any stigma around it. I try my best to let people know that it's okay if they like sweet wine, and I also try to broaden their palates. People tell me, "I would never drink wine, but you make it approachable and you speak my language." That's what life's about, trying new things and exploring your mind.

What is a fun fact about wine that most people won't know?

There are five million bubbles in a champagne bottle. Champagne is one of my favorite categories and I will read anything I can about it. I'm called the Riesling Don and the Champagne King. I could drink those two for the rest of my life and be happy.

**125th Street station
Manhattan, 2021**

Britta Plug

When Watched: Stories
by Leopoldine Core

The other day I randomly stopped into a bookstore to look for short stories, something light. I picked up *When Watched* and went on to enjoy my day by having lunch at Angelica Kitchen. The waiter asked if I knew the author, Leopoldine Core. He told me that she eats at the restaurant all the time, and that in fact I was sitting in her seat. I felt like I was in the

right place at the right time reading exactly the right book. I felt so close to Leopoldine and her stories that I kept looking for clues to see if she left any hidden answers in the restaurant for me.

14th Street–Union Square station
Manhattan, 2017

Camille Becerra

Save Me the Plums: My Gourmet
Memoir by Ruth Reichl

I've been a chef in downtown Manhattan and in Brooklyn for many years. I got my start at Angelica Kitchen, which sadly has since been closed. It was vegan with heavy macrobiotic philosophies. They were very community-focused, and half an hour before closing, they would pack up whatever food was left over, and all these young artists from the East Village would line up to get their little box of food at the end of the night. It was

a really wonderful place to learn how to cook. When I started, the whole food scene was made of male chefs.

What kind of food do you like to make?

I'm very much into vegetarian cooking and I like to get my produce from the farmers' market at Union Square. I think that a vegetarian kitchen often feels safer to a female chef. A gentler way of eating translates to the back of the house, too.

Is Ruth Reichl's book nourishing you?

I have always looked up to Ruth Reichl and I was obsessed with *Gourmet* magazine, where she was the editor in chief. I just started reading *Save Me the Plums*, and it's great to read about the city through her lens. There was this restaurant in the '70s that was run by hippies in SoHo called Food, and Ruth Reichl used to bake there. It sounds very punk rock. [*Laughs.*] I love to stroll down memory lane. In this book, you really see how Ruth stepped out of the norm by writing about old-school restaurants. Even though they weren't the most elegant or didn't have the best service, she understood that their food was important, so she went out of her way to visit them, critique them, and make them notable. The people she photographed and wrote about were real and personable, yet they were in magazines. As a young girl from New Jersey who is Puerto Rican, that was powerful. Ruth showed me that the most beautiful food is made with love and care. I will always remember that.

Prince Street station
Manhattan, 2020

Samhita Mukhopadhyay

Bengali Harlem and the Lost Histories of
South Asian America by Vivek Bald

I'm about as New York as they come. [*Laughs.*] I am a feminist, a journalist, and currently the executive editor at *Teen Vogue*. I was born at Beth Israel on 16th Street and 1st Avenue and practically raised at my parents' Hindu temple at 94th and Madison. It's in an old brownstone that's been there since the late '60s. It's a somber, quiet place that always smells like flowers and incense. My mother ran the choir for many years, and we would

spend every Sunday at the temple. The only time my brother and I would leave was to run out and get pizza.

How would you describe the mythology of the temple that is Condé Nast?

I didn't go to school for journalism—I have a master's in transnational feminist theory—so I'm a bit of a media outsider. Obviously I've seen *The Devil Wears Prada* and it was pretty cool to walk into a place that everyone talks about. [*Laughs.*] Some things are true, it definitely is very fashion-forward, but you also ask yourself, "Are the people working there creating the culture, or are the people who are talking about it creating the culture?"

I love magazines. I used to make a lot of vision boards. They came in very handy.

Magazines are powerful. They're a place of aspiration but they are also a readily updated historical document. Making history visible is majorly important. In *Bengali Harlem*, Vivek Bald shares the stories of Muslim Bengali immigrants who came to the United States in the early 1900s. This is the profound, deep, unwritten history of our spiritual aunts and uncles. We don't know that they were here before the early '70s. We don't know that Punjabi migrant workers helped to build the transcontinental railroad in the late 1800s. We don't know that they were not allowed to be in the photographs like the Chinese workers.

It's so sad that we can't rely on gatekeepers to create visibility.

Honestly, the constant process of writing ourselves into history is exhausting, and I sometimes wonder if anybody wants to read about it. But we are proof of our ancestors' dreams and my history is as much part of the fabric of this country as everybody else's. There's always something else under the layer of the stories we've been told.

**96th Street station
Manhattan, 2020**

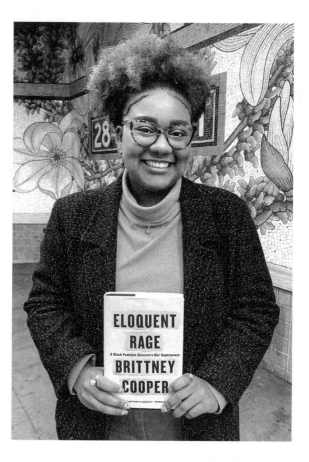

Naydeline Mejia

*Eloquent Rage: A Black Feminist Discovers
Her Superpower* by Brittney Cooper

B rittney Cooper is an incredible writer and cultural critic. She says that
we can rediscover our power through our anger. What a message! She
very clearly says that the stereotype of "the angry Black woman" is used to
put us down and an attempt to make non-Black people fearful of us. Cooper
takes back that stereotype, reworks it, and says, "Yes, I am angry, but my
anger is powerful and can be used to create positive change."

How are racism, discrimination, and prejudice different from each other?

There's a common misconception that anyone can be racist, but that's not true because racism has to do with power. You can be discriminatory, and you can be prejudiced, but if you don't hold power in society, you technically can't be racist. Prejudice is thoughts or beliefs that you have toward another group of people, and discrimination is the action that results from that prejudice. Every white person is not racist, but every white person has the potential to be racist because they hold the most systemic power in our society.

Thank you. That's the best breakdown ever. Are you angry?

I hold a lot of anger, but I don't express it as much as I would like to. I don't think Black anger is taken very seriously in this country, and when people of color express anger, it's treated like an overreaction. But it is something I always think about and carry with me. If you were constantly seen and treated as a threat to society, wouldn't you be angry, too?

28th Street station
Manhattan, 2020

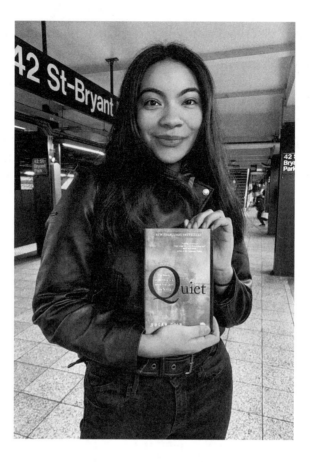

Natalie Falcon

*Quiet: The Power of Introverts in a World
That Can't Stop Talking* by Susan Cain

I'm trying to figure out if I'm an introvert or an extrovert. I like being alone and I recharge from being alone, but I also feel happy when I'm with other people. I hope to learn more about introversion from Susan Cain because she redefines it, which is amazing. When we think of introverts, we often think of them as inferior or lacking. I'm quiet, but that doesn't mean I don't have a lot to say. *Quiet* begins with an anecdote about Rosa

Parks and how she started a whole revolution with just one word. She said "no" when she was told to give up her seat on the bus. Her delivery was powerful. It was a quiet fortitude.

Quiet fortitude. I love that.

We never hear someone described as "quiet and strong." When I was younger, my parents would say, "Oh, she's just a shy little girl." Why is it bad that I'm quiet? What if I just don't like making pointless conversation? Someone wrote "small talk equals small thoughts" on a mirror in the public library and I completely agree. I would rather think and not talk at all. [*Laughs.*] Why should I work so hard? I'm totally okay the way I am.

42nd Street–Bryant Park station
Manhattan, 2020

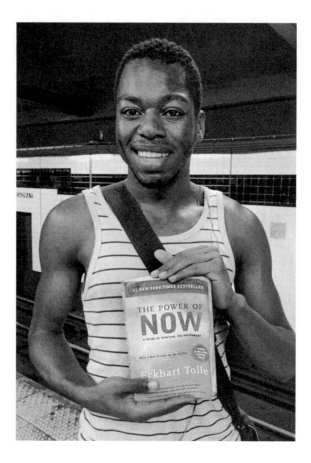

Dontàe Lewis

The Power of Now
by Eckhart Tolle

I've been reading this book for the last four years. Eckhart Tolle speaks about enlightenment, breaking down the ego, and reducing self-identification. He wants to remind people that they are connected to everything and everyone. It's a struggle. It's almost like my mind doesn't want to face the fact that everything I think I know and identify with is false.

[*Laughs.*] We're more than our jobs, our cars, and our apartments. Knowing this, I feel that I will be okay. I'm learning that I don't *have* to have an external identity. It's important to find my internal identity first.

Broadway–Lafayette Street station
Manhattan, 2015

Lakshmi Subramanian

The Folded Clock: A Diary
by Heidi Julavits

T*he Folded Clock* is a series of anecdotes that recount seemingly trivial moments in the author's life in detail. I relate to how Heidi Julavits describes these moments and how she connects to them. There is one story I just read that's about a yard sale. Heidi finds an item that she really wants, but someone else tries to take it before she does. Heidi becomes obsessive and decides that she *must* have it. Usually, she is the kind of person who backs down, but not this time!

Are you someone who backs down?

I am the type of person who usually backs down. Well, actually, I'm moving and created an insane schedule to get it done. I forced my roommates to comply and we ended up getting a new apartment within one week. I guess that's the most recent time I didn't back down.

Myrtle–Willoughby Avenues station
Brooklyn, 2015

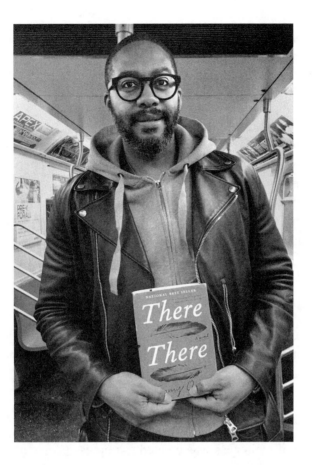

Mitchell S. Jackson

There There
by Tommy Orange

When I moved to New York City I intentionally did not buy a TV because I wanted to reinvent myself as a reader. I grew up in Portland, Oregon, at a time when gangs and crack hit the Black community, and I ended up selling drugs on and off until I was in my midtwenties. Because of that, I went to prison for a little while. When I got out, I started writing. I've been in New York for seventeen years now.

I lived in Portland. For hippies and hipsters it's definitely been deemed okay to do all kinds of drugs.

People say that I grew up in the whitest city in America, but I didn't know that, because my community was Black. I didn't see how segregated we were. For a white hipster, Portland is heaven. You get your microbrew, go to nice restaurants, and everybody looks like you. But the Black people who live in the community keep getting pushed to the periphery. I remember going to a meeting with the mayor where the chief of police and other city officials discussed the crimes of the week. All of the crimes were drawn on a map, and it was where the Black people had moved. I was like, "Oh shit, they can control this. They can actually place crime where they want it to be."

How did you feel as a person affected by that crime placement?

In a sense I felt empowered because I was at the table, but I also felt a lack of power to effect any change. Still, I felt enlightened, and it made me think about other tactics that are used in America to this day.

What other tactics did you come across?

That the idea of whiteness was created to oppress people and that we are experiencing the decisions of people who were in power thirty years ago, especially when it comes to city planning. Historically, the prosperity of certain groups has been seen as threatening. Take Black Wall Street in Tulsa, Oklahoma. They had their own economy and a bunch of prominent leaders. They survived without outside influence because they shared resources among themselves. And then outsiders came through and burned it down.

In terms of people in power, who are you really interested in right now?

I'm interested to see what people do with their moment. What happens when the attention turns to you? How do you handle it? What do you say?

What do you write? What do you not write? I'm really interested in Marlon James and Tommy Orange and what they do next.

Tommy Orange wrote *There There*, which is essential reading.

Yes, *There There* shows the state of contemporary Native America and it makes the struggle and the violence against Indigenous people visible. I love the book's interlude and that it offers historical context while implicating the reader. The United States has been perfecting genocide for ages and this book sheds light on our lack of access to Native history. We learn the United States' perspective in America and we never hear the opposite. But I'm an optimistic realist. The white man is on his last leg and he realizes that. That's what we're feeling all over the world, his desperation.

What fills you with hope while we're suffering from that desperation?

I was just in a barbershop and my barber was playing *The Love Below* by Outkast. I used to love Dre and Snoop, but their ethos does not stand up to time. Some of the stuff they're saying hurts my ears now. [*Laughs.*] When I listen to Outkast, I still agree with their words. That gives me hope, that you can make something powerful and timeless because it's about love.

C Train
Manhattan, 2019

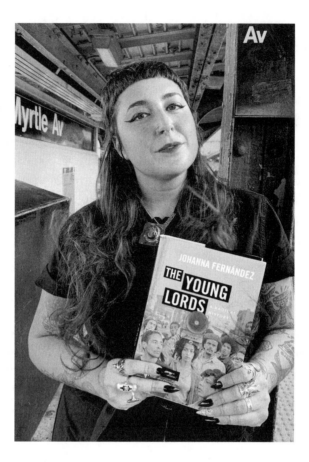

Regan de Loggans

The Young Lords: A Radical History
by Johanna Fernández

The last time I felt in my power was when I went fishing. I love fishing. It's not just a way of providing food—fishing is important because I am Mississippi Choctaw. The name of our tribe is People of the Rivers. We used to navigate the Mississippi River with all of its smaller creeks and brooks. The last time I went fishing, I caught a huge fish with the help of some Indigenous friends. We sat down, cooked it, and ate with our fingers.

We smiled at each other while fish juice dripped down our wrists, and we licked our fingers while giggling. I hadn't felt a moment of connection with the land and water like that in such a long time.

Thank you for taking us there. What brought you to New York City?

I came to Mannahatta when I was seventeen for the same reason as many people: to participate in resource extraction and to further my career. I grew up in the South and felt like I was not understood there as a queer Indigenous person. Mind you, I have now changed how I feel about the South. In the past, I saw it as my enemy. I now see the South as my home.

What made you change your mind about the South?

It can be pretty easy to shit on the South with its Confederate flags and backward ideas. I was humbled by an ex-girlfriend who said, "That land is still your home and it is worthy of your attention." That resonated deeply with me. In Mannahatta, there is just as much work to be done and it took me a long time to find my community, which is ridiculous considering that Mannahatta has the largest urban Indigenous population in all of the occupied United States. Once I found my people through the Indigenous Kinship Collective, it transformed the way I interact with the city completely. Now I see it as my duty to provide a service to the city. Johanna Fernández wrote this book, *The Young Lords*, which is an awesome gateway to it.

Who are the Young Lords? Tell me everything about them!

The Young Lords ground my own ideologies of anti-colonialism and anti-capitalism. They were based in Chicago and New York City and were a political organization predominantly led by Puerto Rican youth, fashioned after the Black Panther Party. They confronted race and class inequality and they provided health care, education, housing, and food without any reliance or dependency on the settler state or the government—and they did it so successfully that they were targeted and strategically destroyed by the FBI.

How do we address that we're on land that's not our land?

As an Indigenous person, I advocate for white people to get off our land and of course people don't love hearing that. Nonetheless, it's the reality. I also advocate for being an accomplice and letting Indigenous and Black people lead the way. When we call for mutual aid or community care, participate, but let those actions be led by people of color. Listen to us, as the authorities. Be willing to be wrong and to get corrected.

All of us need all the corrections we can get these days, don't we?

Absolutely. People don't like being wrong because we're trained to be afraid of it, but none of us are born progressive. We get educated to become progressive and radical. If someone corrects you, it's because they care and are making an effort to offer you community. That's powerful. Personally, I think it's a relatively easy process. You just have to relinquish your ego. [*Laughs.*] I say get corrected and get in touch with dirt and water. Those are the most powerful things you can do.

Myrtle Avenue–Broadway station
Brooklyn, 2020

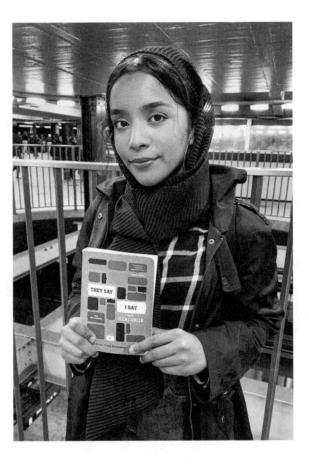

Saima Afrin

They Say, I Say
by Gerald Graff and Cathy Birkenstein

B eing able to make a good argument is important and this book helps
me so much with that. I'm reading it for class, but it's really good for
life in general. On the train and on the street, people often say things about
my hijab to me. I was walking home from school one day and a group of
girls bullied me. I get this all the time, but when it happens, I still feel hurt
and like a deer in headlights. I'm usually able to gather my thoughts and

respond. Not all people have the same knowledge, and it's important to educate others when what they're saying just isn't true.

What did you say to the girls who were bullying you?

I told them that I'm a very kind person and that I understand where they're coming from, but that what they're thinking is not the whole story. Even if just one person can change their mind. It will spread eventually. Just talking about myself as a person helps a lot, but often the people who say hateful things are a lot older than me and talking to them requires a lot more courage because I never know what they're capable of.

Where do you get your courage from?

Wearing the hijab makes me feel like I stand out in the crowd and I really like that. My identity is clear. A lot of my power also comes from my mom. She raised me to respect other people, even in painful situations. Being welcoming of others is a gift.

**59th Street–Columbus Circle station
Manhattan, 2019**

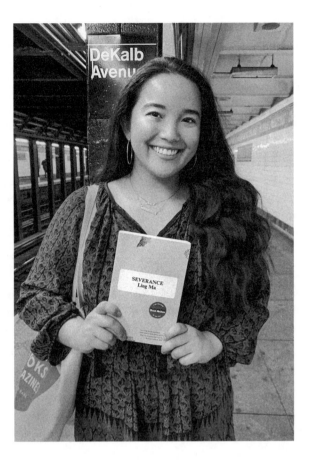

Alex Zafran

Severance
by Ling Ma

T he only thing in life that I feel truly good about is my relationships.
 [*Laughs.*] Otherwise, I feel like I'm not tied to any specific cultural
background and sometimes I feel defined by the things that I consume
in the absence of it, to be honest. Our society puts such an emphasis on
people's achievements and accumulations, but when I think about starting
my adult life and career, I feel a little apathetic and defeatist. *Severance*

describes that feeling perfectly. The main character, Candace Chen, works for a company that manufactures Bibles. The publisher wants to put gemstones on the cover of a new edition, and the production of it poisons the lungs of Chinese workers. A lot of people want to believe that if you know better, you can do better. In *Severance*, Candace is between a rock and a hard place all the time.

The glorification of capitalism might be a trick that's been played on us!

A hundred percent. Ling Ma uses a pandemic disease to show that people carry out routines while they're literally half dead and dying. Candace keeps going to work when the city is decimated, and she's comforted by living in her monotonous routine. It's dispiriting, but I also see myself in it. Today I had a job interview with a company that I feel pretty excited about. Ironically, they offer end-of-life planning. When you write your will, you're also prompted to give money to a nonprofit. To prepare for my interview, I tried to make my own will, and the idea of dealing with my digital footprint is terrifying. I would love to live in total denial. [*Laughs.*]

**DeKalb Avenue station
Brooklyn, 2020**

Kelie Bowman

1Q84
by Haruki Murakami

N PR reported recently that long books are popular now. People want to invest their time in reading. What I love about *1Q84* is that it tells two opposing stories and that it's set in two different realities—one of which is potentially an illusion. The characters can tell which reality they're in by how many Moons are in the sky. All Murakami characters are soulful but banal. There's depth to them, but they are not dramatized. I love Murakami. Lately I've been looking at the sky because I think I might be in a two-Moon reality.

G Train
Brooklyn, 2014

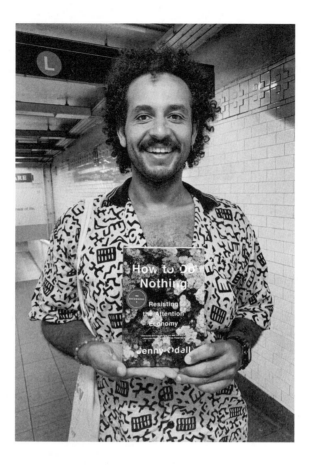

Kareem Rahma

How to Do Nothing: Resisting the
Attention Economy by Jenny Odell

My mom wants me to be a good Muslim son, so she sends me articles and one of them said, "George Bush and his daughters have converted to Islam." I didn't even have to click it to know that it was 100 percent not real. These people were playing to her most intense desires and it was working so well! I trained my mom to spot fake news and now she verifies articles with a trusted news source.

All problems are solved by the time the Bush family converts to Islam.

Instead, we got Sinéad O'Connor, the Irish singer. Who we really needed was the Bush family! We could hold a religious draft, or we could call it pivoting, which would be very New Age. "Oh, I was Catholic, but I pivoted to Islam. I'm just seeing how it goes." Personally, I don't know anything anymore and I think that's great. I always planned ahead and tried to set myself up for the future, but now I'm not like that anymore. I would have never predicted anything that happened over the last years. Now my mantra is "Do what's right, right now."

Does this book help you to live in harmony with your new mantra?

I got *How to Do Nothing* because I get uncomfortable when I do "nothing." I thought it would be a step-by-step guide, but Jenny Odell really talks about resisting the attention economy and the idea of refusal, which is super threatening to modern society. When Rosa Parks refused to get up, that was a plan of attack. That was forward momentum. I'm interested in this because I'm a capitalist, but I don't want to be one. It's miserable! We work for twelve hours a day because we've been trained to monetize our hustle and we've become insatiable. It will never ever be enough. And if *it* is never enough, then *we* are never enough. A quote in this book says, "Stupid fools are those who are never satisfied with what they possess and only lament what they cannot have." You know what? I'm a stupid fool. I have everything I need, yet I am not satisfied. And you know what? A lot of joy comes from slowing down and just being nice to people. Have a conversation with the guy at the deli you've seen every day for the past three years and have never talked to. That's your neighbor. Resist running into the store, finding what you need, and leaving. Stand there for ten minutes and just be part of the store. That stuff spreads joy.

14th Street–Union Square station
Manhattan, 2019

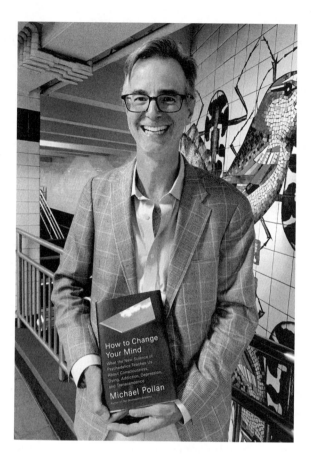

John Donohue

How to Change Your Mind
by Michael Pollan

I'm interested in how the mind works and the way in which we perceive things, which is what Michael Pollan talks about in this book. He covers the history of psychedelics, gets into the cultural aspects of them, and talks about how the self changes through various experiences. I like to draw and it really changes how I experience the world. From what I've read in the book, if you take certain substances, you dissolve your sense of self and

enter into another realm. My practice is to draw something every morning and every night, which feels equally transformative. In the mornings, I draw a toy duck.

You draw the same duck every morning?

It's the same duck on a tricycle, but it's like a zen thing because I see it at a slightly different time, in a slightly different light, and it changes. I've been drawing the duck in the morning for two years and my dish rack every night for about four years. It's akin to a musician practicing scales, I guess. It keeps me sharp and the dish rack reminds me of my kids. I see them every day, but do I actually "see" them? Not if I'm not paying attention. Now I notice how everything around me is changing. This morning the duck came out very Picasso-like.

You just became America's dream dad.

I come from a big Irish family and this doesn't come naturally to me. [*Laughs.*] I have to try to revise my thinking. If I'm anxious or scared about something, I'll say, "Oh, let's have courage" and I'll add little self-helpy, sometimes profound exclamation to the drawing of the duck. I wrote, "The start may not be as pretty as you want it to be, but it's a start" next to the Picasso duck. Since I started doing this, I think I've become more loving and I appreciate life more. I'm waiting for it to wear off, but it hasn't yet.

Jay Street–MetroTech station
Brooklyn, 2019

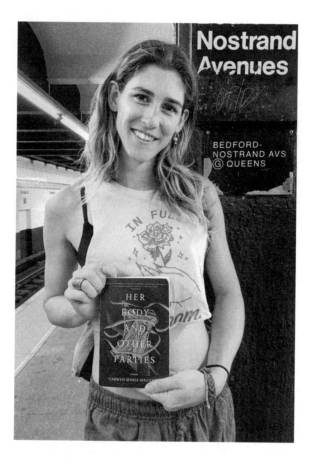

Daphne Always

Her Body and Other Parties
by Carmen Maria Machado

I was at a five-day festival on a mountain not too long ago. I made a new friend, a lovely sister who lives on the other side of the country, their name is Rheal. We hit it off and talked about bodies, sisterhood, and all that stuff. There was a dance floor called the Stone Circle. It was bigger than the hallway of this subway station and surrounded by thick twelve-foot-tall slabs of stone. It was a Friday night on the mountain at twilight.

Rachel Noon was DJing and there were smoke machines and lasers, and it was really trippy. One, because I was tripping on acid, and two, because the clouds were moving with the lights from the sun, and the fog machine clouds were moving with the lasers. It was very surreal. My acid kicked in and I said to Rheal, "I want to give before I take, I want to offer something." And they said, "Bitch, you *are* the offering." That blitzed my freaking head. So I went down to the river behind my tent, I started talking to it, and we just did the work. The river listened and then it said, "You can sit on this rock for as long as you want but stop apologizing so much for everything." After that, I went back up and had one of the best nights ever. A couple weeks later, a package arrived in the mail and it was this book, *Her Body and Other Parties* by Carmen Maria Machado. Rheal had sent it to me.

I don't want to leave the image of that mountain, but do tell me, what do you think of the book?

The book is enchanting, disturbing, thought-provoking, and also very sweet in its own way. It starts with scary stories from childhood, retold for an adult audience. They all have women at the center and look at mundane details that many cis women, trans women, and nonbinary femmes share in their experiences. Carmen Maria Machado doesn't give us the answers. She gives us room for our imagination and our anxieties to play out, which I love. Language can enliven or flatten things for us. I want to remember that I am many beings.

How many beings are you these days?

Let's see. I'm a performer. I'm Sasha Velour's dog sitter and Vanya Velour is my dog child. What else. I'm a Cancer. I give really good massages. I guess I forgot the obvious one [*laughs*], I'm a transgender woman. That one has fallen toward the bottom of the list, but there's not really a ranking system. My identities all coexist and inform each other, don't they?

Bedford–Nostrand Avenues station
Brooklyn, 2019

Waris Ahluwalia

The Wisdom of Insecurity by Alan Watts

I am Waris and I was born twice. The first time was in the foothills of the Himalayas and the second time was when I arrived in New York City at age five. My first birth was in a land of tradition and my second birth was in a city that looks forward and doesn't hold on to the past as much. I exist in the middle, where the warm front meets the cold front and you get a storm. Some would beg to differ, but to me New York is the greatest city in the world. There might be prettier, more interesting, and more international cities, but as a totality, New York City is the greatest.

You're Sikh, you're a New Yorker, you're a designer, you're an actor, you have a tea line and the House of Waris—what holds it all together?

At the center of it all is the search for a better understanding of my time and role here. I'm trying to make sense of why I was born into this species, which is the worst species on the planet. [*Laughs.*] We have our beautiful moments, but we seem to be committed to being our own asteroid. My search is for a way out, but part of me thinks we don't stand a chance, because we're not up against a mythical force. We're up against what we see in the mirror.

Are any books helping you with the feeling of being up against yourself?

I read Alan Watts, Pema Chödrön, and other scholars of the Four Noble Truths. The thing I get from all of them is that we've never been in control

of our lives. We're in flux, but we try to hold on. I grew up with that idea in the Sikh faith, which talks about not having attachments. We're constantly shifting, constantly moving, always in progress, always in the state of becoming. Watts says, "We live in a time of unusual insecurity." The book was published in 1951 and it still applies today, because we always live in a time of unusual insecurity.

Can we find a way to live with that insecurity?

I don't think we're savvy enough. We always look for the quickest solution and that has led to climate, health, and social justice crises. Profit over people isn't a new idea, but when Milton Friedman said that it was okay for businesses to only worry about their shareholders, much of the planetary destruction really began. Do we have time to get to the root of the problem? Do we have time to heal? No, we've got to get to work, pay our bills, and get the kids to school. This is all connected and integrated. I understand we're trying to be positive here. [*Laughs.*] To me what I'm saying is positive. We'll never be able to fix it if we don't fully embrace the problem.

After our apocalyptic destruction, will New York still be the greatest city in the world?

A hundred percent. New York City will look so pretty with all the green growth against the concrete.

Phone interview, 2020

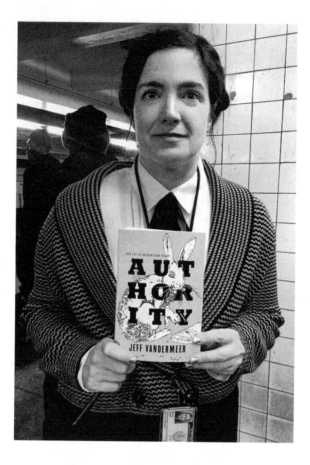

Nora Lynch

Authority
by Jeff VanderMeer

*A*uthority reminds me of Tarkovsky, the Russian filmmaker who made *Stalker* and the original *Solaris*, but his sci-fi was more meditative. This is the second book in the Southern Reach Trilogy and it's about a mysterious area that has emerged and is supposed to be a pristine wilderness. It's called Area X. The idea is that mankind has done so much damage to nature that nature is asserting itself in a malevolent way. The government

keeps sending expeditions into Area X and the people they send in come back slightly off or completely changed. Sci-fi writing requires so much imagination, I find it really impressive. I work for the government at the Department of Education. Maybe there's a metaphysical thing going on, me being a government worker who reads sci-fi on the subway.

Hoyt–Schermerhorn Streets station
Brooklyn, 2018

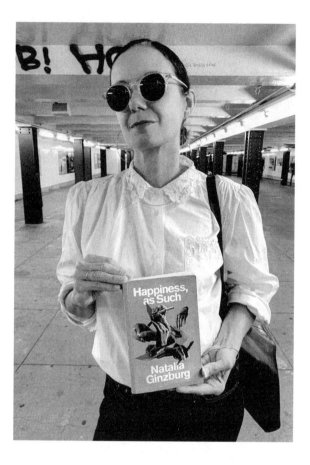

Eva Munz

Happiness, as Such by Natalia Ginzburg

I'm German European and I say that because I grew up in Germany, France, and Italy. I work as a journalist and fiction writer, and I'm culturally and geographically promiscuous.

How do you describe your relationship with authority?

It's complicated. I try not to follow anyone blindly, because I'm German and the orders Germans followed led to the Holocaust, a cruel disaster. As

for my personal life, I grew up with anti-authoritarian parents and I could do pretty much what I wanted if I could present my parents with the right reasons. My father is from Romania. He fled his home as a child during World War II and Romania was later led by an authoritarian tyrant, Nicolae Ceaușescu. So my father taught me to question everything, especially authority.

Books can help us to question authority.

Of course, books show us variations of all the big questions. Every book is about our search for happiness, meaning, love, and community in one way or another. If we want to survive as a species, these questions need to be thought about, read about, and talked about. I mean, look at this amazing cover of *Happiness, as Such* by Natalia Ginzburg. Doesn't it make you curious? Ginzburg's writing is sparse and unsentimental, which makes it very powerful. Her book is a series of letters between several women and a man who fled the Nazis. I don't love the title *Happiness, as Such*, but it captures the position of the mother addressing her disappeared son. She believes that happiness is fleeting and questions if it exists at all.

Do you think happiness exists?

Oh yes! The happy stuff gets me through the day. For me, conflict and happiness are not opposites. I derive great pleasure from intellectual conflict. Harmony does not necessarily make me happy. I always loved the fiery discussions my family had at the dinner table. Being daring and bold can make you very happy.

Clinton–Washington Avenues station
Brooklyn, 2019

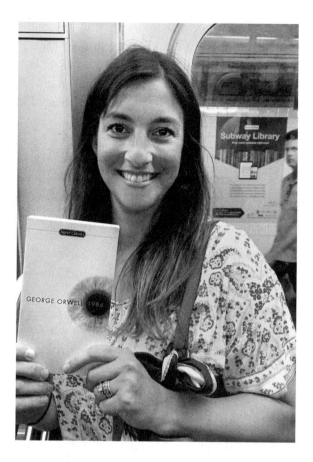

Kristin Vita LaFlare

1984
by George Orwell

I just got tickets to see the *1984* play on Broadway, so I thought I better read the book. I hear that the play is really immersive—people throw up in the theater and feel the whole gamut of emotions. It's good to catch up on classics, especially when they're relevant again.

Who is Big Brother?

I don't know! Is it Google? Alexa? Russia? What I do know is that we need to pay attention and not just play with our phones! Our Google Home started talking without being prompted the other day and it freaked me out. I consider myself a nobody, yet someone wants all my data and information. For what? To send me ads? It's so creepy that we don't have any privacy anymore.

Is reading *1984* reassuring or is it making things worse?

This book is a wake-up call. It puts me in a panic to think about who is actually in control, and the older I get, the more I realize that I have to actively try not to be terrified every day. It's good to have an understanding of the bigger picture and it's good to see a therapist. I'm also drinking a lot of wine and I'm trying to keep a sense of humor about the fact that the world is ending. [*Laughs.*]

L Train
Manhattan, 2017

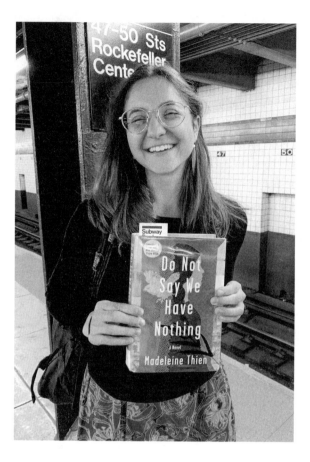

Elise Wien

Do Not Say We Have Nothing
by Madeleine Thien

T his book travels through various time periods in China, which I love. The prose is really flowery at times—I usually like it a little more sparse—but it does enough to keep me going. I read a lot of plays, I'm a playwright, and plays are always fast-moving because it's all dialogue and stage direction, so they're a lot snappier. My work is usually comedic, absurd, and about things I struggle with. I recently had a job at a software

company where I worked with sixteen people named Matt. [*Laughs.*] I did customer support on the phone and I sort of transformed that into a play about the Internet and tech companies.

How was working in customer service?

It was hard but it was honestly more positive than I had thought. The minority of people are terrible. Most people just want to be helped. I realized that when somebody yelled at me because they couldn't connect a subdomain they weren't actually mad at me. They might have marital problems. I think I'm very good at deescalation now, and I feel confident in turning a situation around.

47th–50th Streets/Rockefeller Center station
Manhattan, 2019

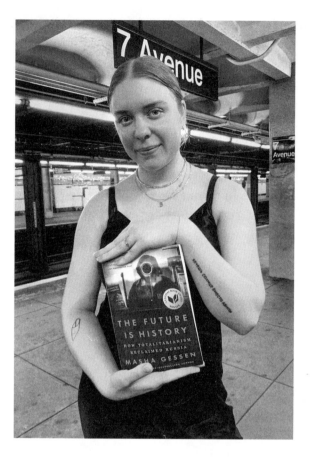

Bogdana Ferguson

The Future Is History: How Totalitarianism
Reclaimed Russia by Masha Gessen

P eople still don't quite understand that Ukraine, which is where I'm from, is a separate country from Russia. It kind of makes sense because throughout history, my country has changed hands a lot. People tend to think we're either exactly the same as Russia or completely different. Neither is quite true. That's why reading *The Future Is History* is amazing. Masha Gessen knows so much about the nuances between these countries.

What do you make of the title of the book, *The Future Is History*?

There's a saying that if we don't know our history we're bound to repeat it. That has been drilled into my head ever since I was a little kid. Gessen connects the dots between dictatorships, the current governing body, and the overall state of affairs in Russia, and although the book is mostly about Russia, you can't help but see similarities in American politics. It's interesting how people can hold so much power over others so shamelessly and irresponsibly. I'm fascinated with dictatorships and I love reading about religious cults.

Cults and their inner workings are fascinating.

Humans have the beautiful ability to believe in ideas, but sometimes that interferes with our basic instinct for survival. When a cult leader tells people to drink poison, the followers believe in that fantasy so deeply they actually do it. No animal ever kills itself because of an ideology.

Do you know the song "Wind of Change" by the Scorpions?

Yes, I know the song [*laughs*] and I've also listened to the podcast *Wind of Change*. It's crazy and talks about the role of cynicism and how it can be used to push certain ideologies. For many people, cynicism is the survival mode in modern-day Russia. The majority of the population can't fight anymore because they have no more hope. The podcast is inspired by the song and makes an interesting point that everything in culture is propaganda and that propaganda is made by all artists who are projecting an idea. It definitely gave me a lot to think about.

7th Avenue station
Brooklyn, 2020

Ralph Bavaro

Photography: The 50 Most Influential
Photographers of All Time by Chris Dickie

M y twin brother, who is the older one by three minutes, and I watched *Saturday Night Live* religiously every weekend, and we grew up with the *SNL* cast. My first internship in college was at *SNL* and it was crazy to walk into studio 8H for the first time. I worked in the photography department under Mary Ellen Matthews, the lead photographer, and Will

Heath. I was there for two years and it was a surreal experience. The studio is a lot smaller in person than it looks on TV, but it was the experience of a lifetime.

Do you have a favorite photographer?

My favorite photographer is Richard Avedon. He was one of the greatest fashion and portrait photographers of all time, if not *the* greatest. You should totally check out his book *In the American West*. This book, *Photography* by Chris Dickie, features many other photographers I look to for inspiration, like Annie Leibovitz, Robert Mapplethorpe, and William Eggleston. They think outside the box and inspire me to set myself apart from others.

Do you remember the last photography exhibit that blew your mind?

The last exhibit I remember seeing was about Vivian Maier. She was a nanny and also secretly a street photographer—and an amazing one at that. She would roam the streets with a medium-format camera and use "normal lenses," which made me realize how close she got to her subjects. She also only got ten to twelve shots on a roll of film. Hearing about her background and seeing how she worked really puts things into perspective.

Old Town station
Staten Island, 2020

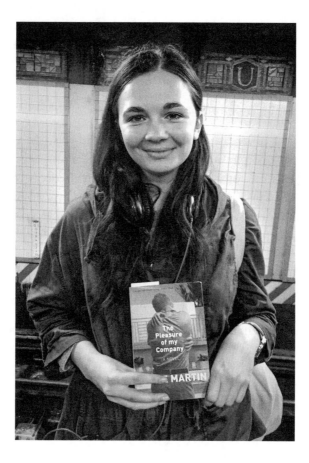

Amanda Degelmann

The Pleasure of My Company
by Steve Martin

I was skeptical of a book that's written by an actor, but Steve Martin is funny, so I went for it. The main character is in his thirties, unemployed, and talks to his therapist every week because he's afraid of curbsides. I relate to some of his social anxieties, like dealing with people.

What makes someone hard to deal with?

If someone is unwilling to listen, that makes someone very hard to deal with, and I feel like a lot of people are not listening right now. The more I think about it, the more it makes sense that I'm reading this book. [*Laughs.*] I empathize with the main character retreating from society.

14th Street–Union Square station
Manhattan, 2017

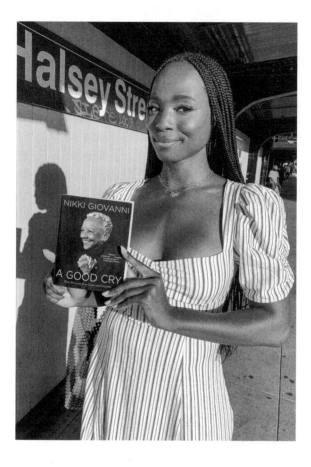

Sydnee Washington

*A Good Cry: What We Learn from Tears
and Laughter* by Nikki Giovanni

Time goes by so fast when you're not making money. I've been a performer and a comedian in New York for eight years. Before the pandemic, I was always on the go and everything was spontaneous—as a performer I know that any street corner can be my stage. But I recently transitioned into adulthood and was like, "Okay girl, you're thirty-five, you need to know how to make pasta that's not in a cup." I wanted to get myself

the tools to be an adult. That said, it's second nature for me to be as chaotic in the kitchen as I am in other parts of my life.

This year everything has been majorly chaotic. How do you deal with it?

Oh honey, we're all just two minutes away from having a good cry. Sometimes you cry and it's situational, but having a *good* cry means you're getting all the things out that have piled up inside of you. Afterward you're like, "I don't need to cry until next year! I hit my mark!" That's a good cry, when you've cried so hard that it's fulfilling. Nikki Giovanni is a legendary poet and writer. This book is about her interactions with the city and the many tensions we are feeling. It is refreshing to sit with her.

Do you remember the last time you had a good cry?

I was watching *Up* on a plane, and from beginning to end, that movie is a tsunami. We all have emotions and feelings, but sometimes it's not good to take them so literal. When you're depressed, every day feels like the worst day of your life. You have to realize that it's only a feeling. It is not *actually* the worst day ever. I used to put my mental health by the wayside, but now it's in my top three. You can't do anything if you are not mentally stable, and often you just need a few words to gather yourself. That's what Nikki Giovanni helps me to remember. Everything is a ball of Play-Doh that you can move around and shift into what it needs to be.

Gorgeous. Any closing thoughts on 2020?

2020 took me out. I have to smile with purpose now, especially at my age. If I am going to get a line by the mouth, it's got to be top-tier laughs.

Halsey Street station
Brooklyn, 2020

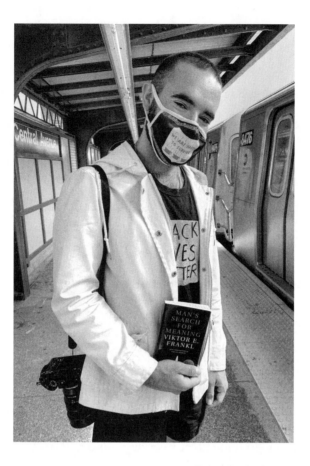

Jeremy Cohen

Man's Search for Meaning
by Viktor E. Frankl

I'm an emotional person, but I don't cry often. I think it's because we grow up seeing macho men and tough guys on TV and I feel like there's a psychological thing going on where my body doesn't let me cry. I'm a photographer and the last time I cried was when one of my photos was printed in *New York* magazine. I laid on the floor and cried for at least

fifteen minutes. It was very cathartic. A lot of New Yorkers work hard and we forget to give ourselves a little pat on the back. It felt really good to be proud of myself.

Did this book have you in tears?

I definitely got emotional reading *Man's Search for Meaning.* We all go through stuff, but Viktor Frankl went through the worst of the worst. He had an amazing career as a psychiatrist, he had a beautiful wife, all of these friends, and then all of a sudden the Holocaust happened. He ended up in multiple concentration camps, unaware if his family was even alive. It's extremely morbid and bleak, yet this man knew how powerful our minds can be. He realized all he could do was to control his reactions to things. That's how his mind stayed strong and that's how he survived an impossible situation. That's just phenomenal to me. I love the idea of being such an optimist that you can see the silver lining in any situation.

How did you and Viktor Frankl find each other?

When I was younger, I had no Jewish friends and was always a little embarrassed to be Jewish, because no one else was. I wanted to become more comfortable with myself and first picked up this book around the same time I went to Israel. It was magical to see the Dead Sea, Jerusalem, and Tel Aviv. The combination of going on that trip and reading this book helped me realize that I have a special connection with other Jewish people. By the way, did you know that the *M* in the M train stands for matzoh-ball soup? I'm just kidding [*laughs*], it doesn't. But wouldn't that be so cool?

Central Avenue station
Brooklyn, 2020

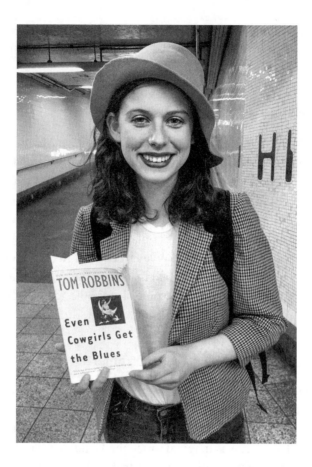

Frances Weisberg

*Even Cowgirls Get
the Blues* by Tom Robbins

T his story is about a woman named Sissy Hankshaw who is born with two extra-large thumbs. She takes that as a sign that she should become a hitchhiker. I'm from California and I'm used to being in nature and moving around in open spaces. This might be my third time reading this book. It reminds me to be adventurous and the descriptive imagery and Robbins's

Barnes & Noble Booksellers #2088
335 Russell Street
Hadley, MA 01035
413-584-2558

:2088 REG:003 TRN:5571 CSHR:Olivia D

ween the Lines: Stories from the Unde
781982145675 T1
1 @ 24.99) 24.99

total 24.99
es Tax T1 (6.250%) 1.56
AL 26.55
A DEBIT 26.55
ard#: XXXXXXXXXXXX7781

pplication Label: US DEBIT
ID: a0000000980840
IN Verified
VR: 8080048000
SI: 6800

EMBER WOULD HAVE SAVED 2.50

Thanks for shopping at
Barnes & Noble

.04G 07/28/2022 02:08PM

CUSTOMER COPY

purchased as part of the offer are returned, in which
items are available for a refund (in 30 days). Exchanges of the
sold at no cost are available only for items of equal or lesser
than the original cost of such item.

Opened music CDs, DVDs, vinyl records, electronics, toys/ga
and audio books may not be returned, and can be excha
only for the same product and only if defective. NO
purchased from other retailers or sellers are returnable or
the retailer or seller from which they were purchased purs
to such retailer's or seller's return policy. Maga
newspapers, eBooks, digital downloads, and used book:
not returnable or exchangeable. Defective NOOKs ma
exchanged at the store in accordance with the applic
warranty.

Returns or exchanges will not be permitted (i) after 30 da
without receipt or (ii) for product not carried by Barn
Noble.com, (iii) for purchases made with a check less th
days prior to the date of return.

Policy on receipt may appear in two sections.

Return Policy

With a sales receipt or Barnes & Noble.com packing s
a full refund in the original form of payment will be issued f
any Barnes & Noble Booksellers store for returns of new
unread books, and unopened and undamaged music
DVDs, vinyl records, electronics, toys/games and audio be
made within 30 days of purchase from a Barnes & No
Booksellers store or Barnes & Noble.com with the be
exceptions:

Undamaged NOOKs purchased from any Barnes & Noble Books
store or from Barnes & Noble.com may be returned within 14
when accompanied with a sales receipt or with a Barnes & Noble
packing slip or may be exchanged within 30 days with a gift receip

A store credit for the purchase price will be issued (i) when
receipt is presented within 60 days of purchase, (ii) for all textk
returns and exchanges, or (iii) when the original tender is PayP

Items purchased as part of a Buy One Get One or Buy Two
Third Free offer are available for exchange only, unless all
purchased as part of the offer are returned, in which case
items are available for a refund (in 30 days). Exchanges of the
sold at no cost are available only for items of equal or lesser

prose are so beautiful. It's an escape from my surroundings and it hits me right in the heart. I guess I'm drawn to this book over and over again because it's about a person I would like to be: someone who lives on her own terms.

Metropolitan Avenue/Lorimer Street station
Brooklyn, 2015

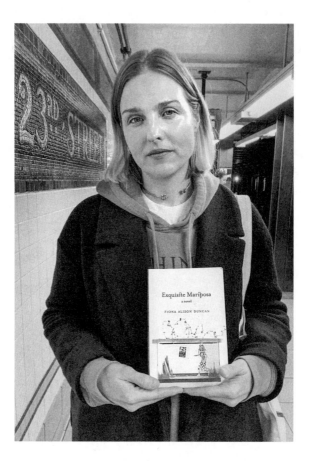

Katja Blichfeld

Exquisite Mariposa
by Fiona Alison Duncan

A good character is the most interesting thing to me. I could watch hours of TV about people's lives, and this book feels a little bit like that. It rambles on and there aren't a bunch of journeys that conclude in some satisfying way. I like that—and I was obviously attracted to this cover. There's some sort of tea beverage, a doll dressed like an artistic millennial, and the kind of grass that comes inside a sushi package. It begs a second look.

La mariposa is the butterfly. Is it a transformational story?

It's a meditation on "the Real," which is something I think a lot of us are eager to tap into since we're living online in "the Unreal." The narrator sublets an apartment in LA with several people who are younger than her. Their building is called La Mariposa, and she is fascinated with her room-mates and feels like she really *sees* them. The concept of words not always being enough resonates with me. Sometimes you can't reduce your life to a caption on social media, but it has definitely become second nature for us to document life this way.

What is "the Real" for you personally?

For me, the realest moments happen when I have a true connection with another person. I'm really hungry to get to a place where I'm not bound by convention or the influence of social media. I don't know if I'll ever get there, but as I get older, I'm becoming more aware of how subjective reality is. I'm constantly negotiating and questioning how my experience squares up with other people's experiences. That should never stop, I think. Especially since I'm someone who portrays other people's lives.

Is there a specific type of New York character you love?

I've lived in New York for sixteen years and it's getting harder to say what makes someone a real New Yorker. I guess this is where language fails me, because it comes down to a feeling and an intuition. The other day, I saw a woman on the subway and secretly snapped a photo of her so I could send it to my friend, who I knew would appreciate her. Both of us agreed that she was a true New Yorker. She was probably in her late fifties and had a hairdo that was developed decades ago. I am certain that she has a standing hair and nail appointment. She was probably going to her job at an office, because she was wearing boots with her hosiery. I could imagine her work shoes lined up under her desk, ready for her to slip on as they have been for all of time. I didn't even hear her speak, but she epitomized New York City to me.

**23rd Street station
Manhattan, 2020**

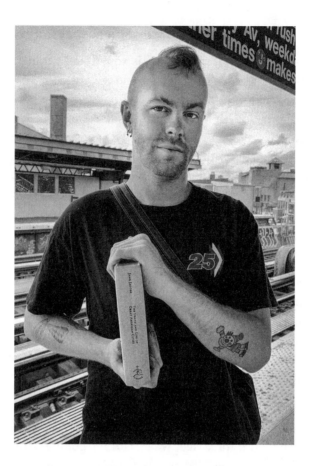

Sean Michael Bennett

*The Death and Life of Great
American Cities* by Jane Jacobs

D on't you love it when someone does your hair and they're flicking it around to show you all the ways it can be styled and you're seeing yourself for the first time again? I'm a hairstylist and I think hair can be ordinary in terms of shape, color, style, and texture, but hair can also be a free-form object that exists outside the box and raises questions. How old is this person? What music do they listen to? Do they like the forest?

Maybe that's just New York hair, though. [*Laughs.*] Here we have gender-nonconforming hair, there is corona hair, protest hair, going-to-work hair, statement hair—our hair is solidified in our uniqueness, as it should be.

Do you have a favorite place to do hair in New York?

I have done hair everywhere! That's why I carry this fifty-pound suitcase with me. I've done hair on the street, in studios, hotels, parks, on the beach, outside of clubs, and inside my favorite restaurants. I have cut hair at Le Bain, which is very froufrou, very chic, and it's the place you go to be seen. I love to deconstruct the idea of what a space is meant to be. It's good to ask, "What are we doing here? What does it mean to go to a leather bar?"

Wait, a leather bar. Are you into BDSM leather culture?

Yes, I am. It's very different than what people imagine it to be. How I explain it is that the BDSM elders put me in a box and show me that being gay or queer isn't necessarily about the box but rather about an idea and a construct. The elders show me what my box looks like, what shape it is, and how to work with that shape. It's not about being beaten. It's about new possibilities.

Is it true that when you come to New York, your old self first has to die?

Completely, it's all about reincarnation! The phoenix rising! The molting of the skin! The city's dirty air gives you a microdermabrasion and you have a newfound, raw sense of self! This book, *The Death and Life of American Cities*, made me understand New York's muscle memory, its beating heart. It came to me at a point when I was recontextualizing myself, and I think it's really interesting that Jane Jacobs put "death" first in the title, because it highlights that death is necessary for a revolving cycle. The chicken or the egg. Coming back from the tomb to the womb. There was a daddy who once told me that New York City is a play that is always happening. It's the same play over and over again, but with new characters every time.

Gates Avenue station
Brooklyn, 2020

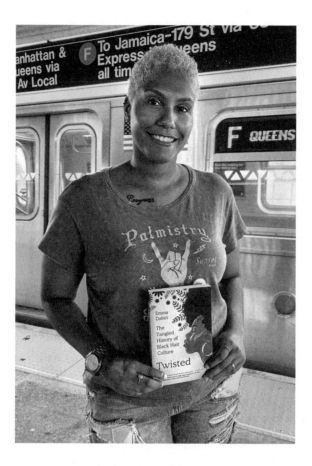

Sheri Cheatwood

Twisted: The Tangled History of
Black Hair Culture by Emma Dabiri

When I started reading *Twisted* by Emma Dabiri, I cut off all my hair. Before that, I had medium-length hair, and my hair is naturally curly, so I would straighten it every day. No one had ever really seen my natural hair before I got this cut, and I don't think I ever found beauty in my hair before, especially when I was younger. In middle school, boys would make comments and tease me. Only recently has mainstream culture

started to accept that Black hair *is* beautiful, in whatever style we want to wear it. My hair has always been tied to my Blackness and being a woman. When I went on a job interview, my hair had to be straight. This summer, I was like, "I'm so over it. I'm tired of trying to live up to someone else's standard."

When you're asked to change your hair, are you also asked to change yourself?

I think so. I tried to make myself and my hair "acceptable" to society. I love that this book talks about how hair connects us to our culture and history. The Afro was a revolutionary act and for Black women hair is a big part of our identity. The problem is that most beauty standards are imposed by white, mainstream media. Tiffany Haddish recently went bald and Viola Davis wears her hair natural all the time. I'd love to see that on TV! It's an honest version of different types of beauty, and we really need young Black kids to know that their hair is beautiful. There doesn't have to be a "better than" or "less than" type of hair. Books like this one make me realize that I want a lot of fresh starts in life.

**Avenue P station
Brooklyn, 2020**

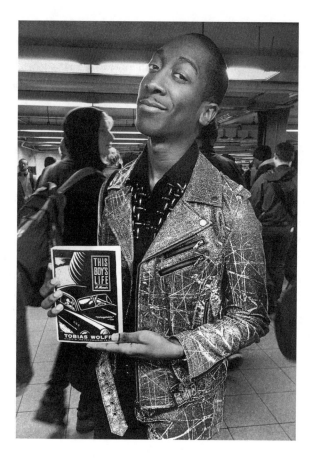

Barrington Roberts

This Boy's Life by Tobias Wolff

I believe in alter egos. Beyoncé has Sasha Fierce and Onika has Nicki Minaj. My name is Barrington, but I go by Barri Yoko. Barrington is professional, he is always suited and tied. Barri Yoko is wild, courageous, and his spirit is free. He loves flamboyant, stylish clothing and he likes to wear Mickey Mouse ears. When people ask why I'm wearing them, I tell them the truth. I say, "This is a crown. It represents royalty and I'm wearing it because I'm a king."

Do you remember when you first discovered Barri Yoko?

Barri Yoko is someone I was born with. Sometimes we hold ourselves back because we are afraid of judgment, but that's not me. I'm very confident, and if there's a moment in my life where I want to wear a skirt and heels, I'm going to do so. I want to love who I am. Even if Barri's shoes are uncomfortable, he still walks in them and doesn't let anything bring him down. But thank god for Barrington. Someone has to pay the rent!

Who is reading *This Boy's Life*? Barri or Barrington?

Barrington is reading this book, he is a nerd. [*Laughs.*] This story is so creative and so beautiful. It's about a boy and his mom who is in an abusive relationship and how they transition out of it. He is a pretty bad boy actually. He wants to be a tough guy and show off. He needs a better father figure in his life. [*Laughs.*] I'm reading the book because Obama awarded the author a National Medal of the Arts. I miss Obama so much.

14th Street–Union Square station
Manhattan, 2017

Zoe Cho

Girl in Pieces
by Kathleen Glasgow

Right now, I want to read books that really mean something and aren't superficial. This is about a seventeen-year-old girl who harms herself. She finds a way to stop but that creates new problems with her family. It's deep and it touches your soul. I'm about to start high school, and books give me a place to have thoughts without being openly judged. There's so much stigma around having a perfect image, but that's not real life. With a book, you can experience all the emotions and feelings regardless of what anyone else might think. I'm excited to start high school. I love that almost anything can be explained through science, math, and literature.

Hoyt–Schermerhorn Streets station
Brooklyn, 2017

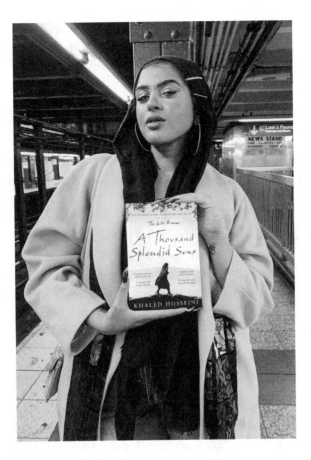

Amani al-Khatahtbeh

A Thousand Splendid Suns
by Khaled Hosseini

I'm an author, activist, and entrepreneur. I was born and raised in Jersey and being in close proximity to New York has always defined my life, especially after 9/11. As a Muslim woman, I was directly impacted by its aftershocks, but it also made me feel connected to the city. Brooklyn became the home base for my company, Muslim Girl, which I started as a teenager because I wanted to create a safe space for Muslim women

where we could have conversations about our everyday lives that the media couldn't hijack. That's how the blog I started in high school became the first Muslim company on *Forbes* 30 Under 30.

Has the narrative the media attaches to Muslim women changed over the years?

Yes, I think the narrative is changing and I'm very proud of the progress we've made. When I was younger, conversations weren't centered on Muslim women or led by Muslim women. When I started speaking about this misrepresentation at conferences, I always asked the audience to google "Muslim women" on image search and to take a moment to observe the results. Page after page, people saw images of Muslim women who were submissive, violent, miserable, oppressed, or silent. Until I thought, "Why am I still using these images? I need to change this." So I partnered with Getty Images and created stock photos that were taken and modeled by Muslim women.

You're creating an additive image. You're widening the lens.

Exactly. As Muslim women, we intimately know what happens when there is a singular image and a blanket representation of a whole group of people. It is often dehumanizing. We have to ask through whose gaze an image is created. Who gets to hold the pen? Who gets to be behind the lens? Imagery has to be individualistic rather than homogenous. Muslim women exist on a spectrum of empowered badasses! [*Laughs.*]

Is there a particular author who means a lot to you?

I never felt seen in movies or magazines, and there were no reflections of me in the media. I felt invisible. Khaled Hosseini's arrival on the literary scene was revolutionary. I poured myself into his books and I adore the way he tells stories about people, not identities. We were in the middle of the Afghanistan War and at the height of the War on Terror when *A Thousand Splendid Suns* was published. Hosseini opened a portal into a world that

was an escape from all this rampant hate, Islamophobia, and xenophobia. He really informed my love for storytelling by showing me the power of how we depict and see one another. My work is about speaking truth to power, and that's all we can do: Be honest and don't soften your edges to satisfy other people.

34th Street—Penn Station
Manhattan, 2020

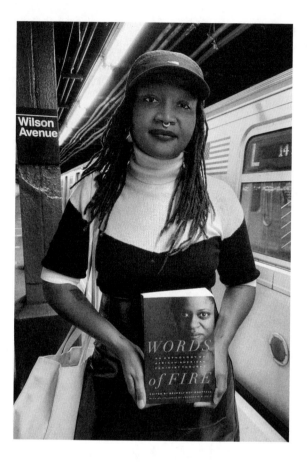

Kimberly Drew

Words of Fire: An Anthology of African-American Feminist Thought edited by Beverly Guy-Sheftall

B ack in 2015, I was hired as a social media assistant at the Metropolitan Museum of Art, a museum I had visited throughout my entire life. My job at the Met was a crash course in building content that would reach a global audience. I didn't necessarily go there with a big intention to revolutionize things. I think that the call to "revolutionize" is often placed on marginalized people and not those already in power, which is unfortunate. I wanted to

work at a large institution to learn skill sets I could apply in the world beyond the museum.

Do you have a practice that helps you to immerse yourself in the arts?

For any practice to grow, it's important to read and it's important to write. I relate to artists who I know read some of the same books as me or have similar life experiences. In some of Jean-Michel Basquiat's paintings, I see the references of the scientific journals he read, and how he reappropriates those diagrams in his work is really interesting. The best thing for myself as a viewer is when I see a clear entry point.

Does a book cover give you that kind of entry point?

I am as much of an aesthetic book buyer as I am a hard-core book nerd, and I do judge a book by its cover, I feel no shame about that. Morgan Parker's *There Are More Beautiful Things Than Beyoncé* has Carrie Mae Weems's artwork on the cover and bell hooks's *Sisters of the Yam* has a work by Lorna Simpson on it. When those intersections happen, I'm really thrilled to see it. It's a beautiful thing that I want to own, engage with, and add to my shelf.

Is there something specific that drew you to *Words of Fire*?

Words of Fire is one of my favorite anthologies. I first made contact with it in college, when I was taking a Black feminism course with Dr. Paula Giddings. I love this book because it's a century of Black women writers articulating the world as they see it, politics as they see it, power as they see it, modes of survival as they see it. I really needed someone to articulate these things for me. It's one of those books you read with your highlighter in hand.

What do you think an anthology gives to its readers?

An anthology is like a smorgasbord of interpretations of the world. It gives you many different vantage points on a subject or a theme, and I like that, because you might read one essay and be like, "What's going on?" And

then you read another one and you're like, "This is exactly what I needed." All of our brains are wired in unique ways and there is never going to be one catchall.

It's good to hear the individual voice within the collective voice.

Collective work and collective responsibility is essential, but the "I" statement is really powerful, too. You have to own your role in a larger community structure. It's important to be specific about where you're coming from and what you're trying to say. When people speak in "we" sentences I always think, "Who is we? And who is implicated?" A lot is lost when someone over-assumes about connective tissues that are hard-earned. I want to get to the bottom of who is speaking, from where, and why. I want to help people find their unique "I" statement and what their unique vantage point is. Imbuing a sense of dynamism into discourse and finding the people who might complicate a narrative is a thing I'm really passionate about.

Wilson Avenue station
Brooklyn, 2020

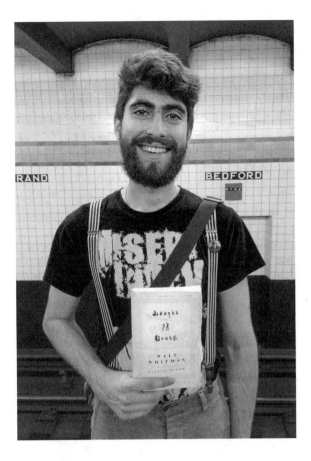

Ashley Levine

Leaves of Grass
by Walt Whitman

This is a difficult experience to describe. I'm reading *Leaves of Grass* for the fourth or fifth time. It feels a little bit like looking at a painting.

Bedford–Nostrand Avenues station
Brooklyn, 2014

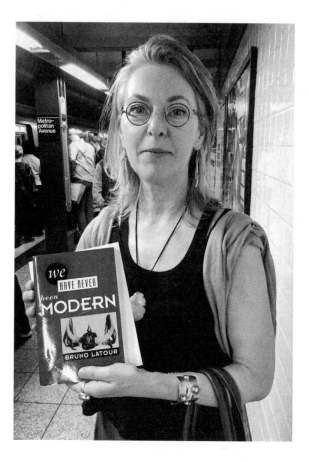

Debra Ramsay

We Have Never Been Modern
by Bruno Latour

I'm in a book club called the Violent Study Club. We read books about spirituality and the occult exclusively. We are all artists, and we are curious about how other artists use spirituality and the occult in their work. Surrealists were especially impacted by it. I'm a painter. My work is quite minimal and I work with systems a lot. Recently, I did a project where I tracked time by watching the change in color on a particular landscape.

I would go to a specific hiking trail and take a photo every 100 steps. That was one of my systems. I don't particularly like this book actually. The last one was kind of a dud as well to be honest, but I remain hopeful.

Metropolitan Avenue/Lorimer Street station
Brooklyn, 2016

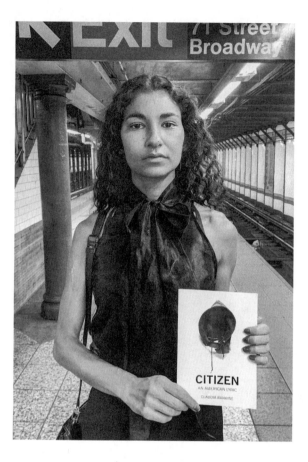

Sarah Dillard

Citizen: An American Lyric by Claudia Rankine

My parents have always encouraged me to project self-assurance, even around my differences. My dad is Black and my mom is from Romania. There was a lot of bias on both sides of the family, so my parents said, "Be exactly who you are. People will love you for that and you don't have to worry about the other stuff." I want to convey that I'm put together and organized and also that I'm creative and a little different through the clothes I'm wearing.

What does it mean to you to be a citizen?

It feels strange to think of myself as an American citizen. Claudia Rankine talks a lot about belonging and experiencing bias. Her descriptions of microaggressions triggered a lot of memories for me. I'm going to be honest, sometimes this book has me in tears, which is why I'm reading it slowly. So often we want to fit into a box of what we think we should be. In *Citizen*, Claudia Rankine says that there isn't one way to be someone, there are a multitude of ways. People are complicated, diverse, and different. We should embrace that, rather than erase it, and we should think about our civil duties and how we want to interact with our fellow citizens.

How do you translate that to what you do in the city?

I'm a writer and I do volunteer work, especially around housing. I feel like you're not truly a part of the New York community if you're not helping the least fortunate. Besides that, I have a job at a clothing store in Flatiron and I'll be going to Columbia University for a degree in social work soon. Sometimes I feel like my fashion side is at odds with my social justice side, but I really love getting dressed in the morning! [*Laughs.*] I care about how I look and feel.

**72nd Street station
Manhattan, 2020**

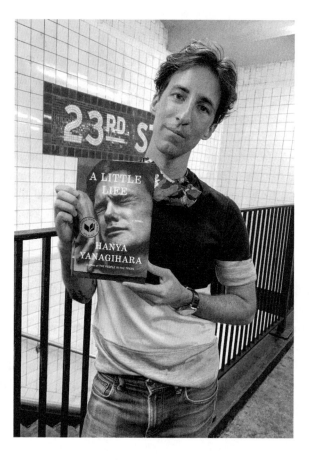

Daniel Vosovic

A Little Life by Hanya Yanagihara

I prefer to feel exhausted and fulfilled at the end of the day rather than half full and comfortable. I've lived in New York for twenty years and I'm the founder and creative director of The Kit. I really wanted to figure out how to change the fashion industry by producing on demand and having no inventory, which is the crux of overconsumption. It also frees me up to say, "What about lime green? What about blue flowers?" It's a very fulfilling journey.

How do you chart a new course when there is no blueprint?

By having the courage to follow my intuition. That meant I had to pull the plug on my original dream, which was hard to do. I went to a community college, took a sewing course on a whim, went on to win *Project Runway* and launched my namesake brand. Everything was built toward having "Daniel Vosovic" written in bright lights. Five years ago, I went to one of my mentors, Malcolm Carfrae at Calvin Klein, to talk about my new idea and he told me: "Think of the fashion industry as a battleship. You are a speedboat and we can capsize you like that. [*Snaps fingers.*] But the reality is, both of us see the glacier on the horizon and you can maneuver a hell of a lot faster than we can." And here we are today. Have you noticed the insane amount of clearance outlets? That's because there is a huge surplus of stuff. The traditional fashion calendar will still exist and some brands will still give us a stomping runway—I mean, the gay boy in me loves a stomping runway—but it doesn't mean that's the *only* way. We really have to think about a solution for people who want to show self-expression but not at the cost of our planet.

Little boat for the win! Let's talk about this book, *A Little Life*.

The word I'd use to describe it is *relentless*. If you want to read something challenging, intimate, and raw, then this is the book for you. If you want a light rom-com page-turner, leave it on the shelf! It's a story about friends who start their lives in New York and grow into adulthood. I found a lot of parallels to my time in the city. While my best friends are from Michigan with similar upbringings, we all followed different paths into the city. New York challenges those friendships and letting go and acknowledging change is hard! It's exhausting! I'm exhausted! People are exhausted reading this! But let's not be too doom and gloom here. At the end of the day, I want to be someone's bright spot. That is how I'd like to spend my days.

23rd Street station
Manhattan, 2020

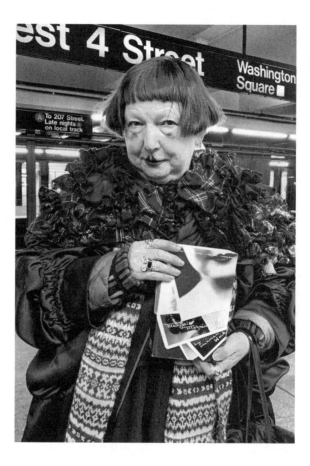

Lynn Yaeger

Marjorie Morningstar by Herman Wouk

I've always loved fashion and defining myself through clothes. I have pieces that are much more expensive and some that are very reasonable. As long as it fits into the picture of how I want to look in Lynn Land, it's for me.

What is Lynn Land and what do you want to look like in it?

Lynn Land is a place with a lot of tulle. I want to look like a fat, clumsy ballet dancer or a broken Victorian doll. [*Laughs.*] At one time in my life, I only wore '20s vintage and went to Europe with six beaded dresses and a velvet coat in my suitcase. But as you get older, the vintage things, which are so charming when slightly torn, start to look shabby. I still have a little bit of vintage in my wardrobe, like my vintage reindeer cardigans. I went crazy and bought a lot of them.

Does *Marjorie Morningstar* have a place in Lynn Land?

Marjorie Morningstar is not a fashion thing for me. At one time, this book was in every Jewish home in America. I first read it as a little girl because I was a grown-up reader at a very young age, although I was a terrible student. It's about the trials and tribulations of a Jewish girl who grows up in the '30s on the Upper West Side and wants to be an actress. She falls madly in love with this sort of sexy, ne'er-do-well Greenwich Village songwriter. I was so young when I read this book, I didn't realize that the sexy guy is actually a jerk. But I was very taken by Marjorie, who goes to Hunter College, which is where my mom went, too. The story ends with her becoming a middle-class housewife, which is very dispiriting, and looking back, this might actually be a terrible book. [*Laughs.*] It's hard to explain why it had such a powerful effect on me. Maybe because it captured the power of New York dreams in a way that really spoke to me when I was young.

Sometimes we need distance to see something in a new light.

Decades of fashion can wash over me without my heart getting involved. I wrote about all sorts of fashion professionally, but the garments that really move and touch me are part of Lynn Land. There's a huge fashion revolution happening right now, and some people argue that we're living through the end of fashion, but people will always want to dress up and decorate themselves. The way clothes are presented, and the way people

buy clothes, all of that is changing, and of course no one really knows what will replace it.

Some say they lost a reason to get dressed when Bill Cunningham passed.

Bill didn't care about people who dressed up for his camera. I feel very firm in saying that. He liked all kinds of people, but not the ones who deliberately tried to get his attention. Sometimes I look at Bill's pictures of me and can't believe what I was wearing. [*Laughs.*] Eleanor Roosevelt, herself a lifelong New Yorker, once said, "Every woman in public life needs to develop skin as tough as rhinoceros hide." The reason why something speaks to you is shrouded in mist. Our taste is one of the great mysteries of human life, and New York is a great place to express fearless experimentation.

West 4th Street–Washington Square station
Manhattan, 2020

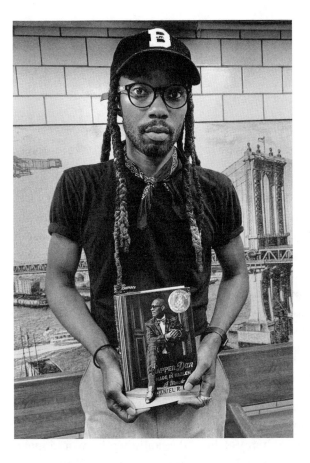

Yahdon Israel

Dapper Dan: Made in Harlem
by Daniel R. Day

A s somebody who grew up in New York City, and as a child of hip-hop culture, I see Dapper Dan's book as a cultural reckoning. Dap influenced culture before we had algorithms that measured impact. That's why his memoir is so important, and to see a pillar of culture tell their story on their terms is beautiful. He gave 5th Avenue the flavor of Harlem and he made ready-to-wear clothing before Louis Vuitton, Fendi, or Gucci ever thought

of it. He took their symbols of luxury and did what he called "Blackinizing" or "knocking up." There are people who have called what he does "knocking off," but a knockoff is a counterfeit or something of lesser quality. Dap used the same quality, if not superior quality, and he showed us how important symbols are and how they can make us feel.

How did Dapper Dan use logos and symbols differently?

Dap created a sartorial language of access. People said, "Oh, it's not just the bag. It's what's on the bag. It's how the bag is worn. It's who's wearing the bag." Dap brought that language of wealth and worth to Harlem, where it belongs. You turn on a hip-hop video today and it's very hard to not see logos. Before Dap, the symbols of privilege and wealth were very hidden. Fashion houses were not thinking about decking someone out from head to toe in a monogram. But for a community of people who historically have not had access to wealth, it's important to say, "I'm somebody who you should take seriously. I'm somebody who you should value."

And he showed people how to make that access their own.

Exactly. When he started doing those pieces—this story is in the book—he would go down to 5th Avenue, buy Gucci garment bags with the Gucci logo printed on them for like $15, and then he would make outfits out of them. It got to the point where he was buying so many garment bags that he had to find a different way, and that's when he got real leather and a printing machine. The ink he used was so powerful that it would never fade. That's what I mean when I say that he "knocked it up." The discourse ascribed to us, as Black people, is that we innovate culture in a way the world takes notice of and seeks to emulate. If we are the arbiters of it, then it's important to know who those people are.

What's your personal relationship with fashion?

My understanding of fashion comes from my mother, who made my clothes for the first ten years of my life. I was very connected to the process, seeing how my pants would fit as my mom tailored the clothes to my body. Love

was literally stitched into every piece of fabric I wore. My connection to clothes is skin-deep. But then I went out into the world with the clothes my mother made, and ironically, I got made fun of because they were not Phat Farm. You learn at a young age that there are arbitrary rules that make people fly or not.

Do you have a take on fashion rules?

What I've learned in my time of dressing up is that when you're following a rule, you're allowing the world to dictate how you should exist in it. You have to ask yourself, "How do I use these principles to my benefit? How do I articulate what I want?" I want to be fly, but not on other people's terms.

York Street station
Brooklyn, 2019

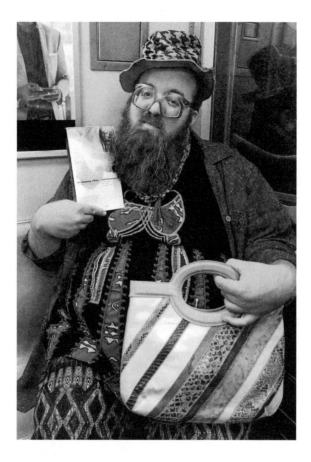

Dusty Childers

The Chronology of Water:
A Memoir by Lidia Yuknavitch

*T*he Chronology of Water is a stream-of-consciousness memoir by a woman who was slated to be an Olympic swimmer, and the theme of water connects with all moments in her life. I found out about the book through her TED Talk about being a misfit. She was afraid to put herself out there, because she thought she would be too different to fit in with everyone else. The idea that no matter how many times you mess up you

can still put forth your art—that idea calms me. Just like she keeps going back to water, I keep going back to fabric. I'm a designer and have been surrounded by fabric my whole life. My family worked in mills in the South. I feel like fabric is in my blood.

F Train
Manhattan, 2016

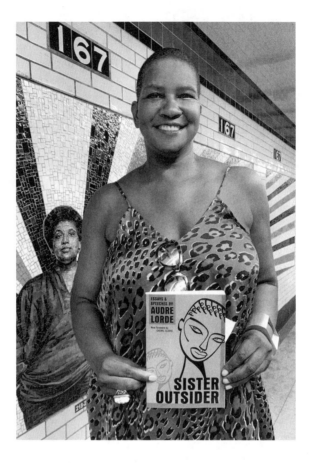

Pamela Sneed

Sister Outsider
by Audre Lorde

I'm a small-town person, but I know I'm a New Yorker, because when people stand in my way I'm ready to do some kung fu on them. [*Laughs.*] Defending your space is a city thing—that and being enraged by politics and places like Century 21 going out of business. I am devastated! That's where I buy all my clothes, like this dress I'm wearing today. I'm over six feet tall! Century 21 is how I stay fashionable and current! People come

from all over the world to go there. I don't consider it a store. I consider it a landmark.

How do you feel standing next to Audre Lorde's mosaic by Rico Gatson?

Sister Outsider is a bible for me and remains a necessity. These are dire times and I believe we need the voice and wisdom of a Black lesbian. Audre Lorde gives us space, hope, license, and courage. I love her mosaic and I hope to be as brave and as bold as her. I feel like our story as LGBTQ people of color has never really been documented. To narrate your story and to name yourself is so powerful. Maybe somebody else can stay alive because of you.

What do you name yourself?

I am a Black lesbian warrior, poet, survivor, mother, politically outspoken interdisciplinary artist, doing my work, coming to ask: Are you doing yours?

167th Street station
Bronx, 2020

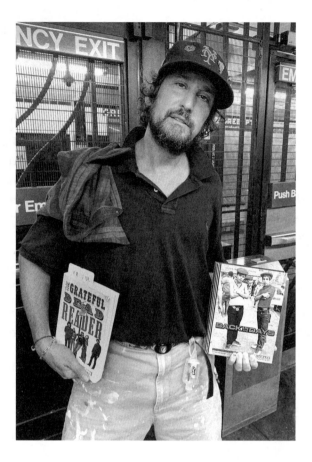

Mordechai Rubinstein

Back in the Days by Jamel Shabazz,
Fab 5 Freddy, Ernie Paniccioli

I t's nice to get a full look. I like to study what people wear and imagine where they might be going. With a postal worker in uniform, obviously you can tell they're a letter carrier. But there are different types of messengers in New York—the walking messenger, the bike messenger—and a lot of them are veterans. People don't know that. Messengers have some of New York's best style along with street vendors. I also love the subway for

looking at people. It's fun to see somebody with a briefcase, a suit and tie, and then, boom: sandals. Where are they going? Is this the new casual Friday?

Subway etiquette is a big thing. I'm breaking it right now.

On the subway, I want to get close, but it might be rush hour. So I act like a tourist and ask for directions even when I know which way is east and west. Someone might tell me to get lost, but most New Yorkers aren't rude. We're actually very nice people. We love to conversate. However, there are a couple of unspoken rules you have to know to break them. Don't talk to somebody in an elevator. I do. I try to be inviting but not everybody is a chatterbox.

You clearly love this city very much.

Everyone thinks I'm a New Yorker and I'm not. I'm a Hasidic Jew from Rhode Island and I've been living in the city most of my life. I wear Mets hats. I wear Yankees hats. I like to represent the city of New York as much as I can, wherever I am. You could say that I'm a fashion consultant and a street photographer. The best subjects are people who don't understand why I want to photograph them. I wish I was a real street photographer who shoots from the hip, because you get things like ice cream dripping out of someone's mouth, but it's not what I do. I want to document the movement of clothes.

New York's street photographers are iconic and important.

Yes, because the city has changed but we don't want to admit it. This book is called *Back in the Days* by photographer Jamel Shabazz, who captured the New York that I miss. But guess what? I wasn't even there for it. [*Laughs.*] Shabazz is still uptown and I'd really like to find him in person. What an archive he must have. I've only been shooting for twenty years. In Shabazz's work, you can tell exactly what year these photos were taken. You can tell this is the '80s. Look at the laces on their Pumas, their low-slung belts, their Kangol hats—these clothes make me think of a time

when New York had more character. Today, everyone is dressed by the Internet. Back then, if someone was in head-to-toe Adidas, you bet they knew every Run-DMC lyric.

Do you thrift and do second-hand?

I do. I like to imagine who owned the item before me. That sweater I saw on eBay, did that come from a JCPenney employee? Was it their uniform? Is it a special edition from their corporate family barbecue? I was raised on second-hand clothes and hated them as a kid. The only new thing I had was my bar mitzvah suit. It's funny, now that I have a couple of dollars, I'm a sucker for second-hand again. It's true, tried, and tested. It's not going to shrink, and it's got the fringes on the shorts ready to go.

What are you wearing today?

What influences me is old men. My father-in-law painted a house in these shorts and you can see paint splatters all over the fabric. I've never painted anything in my life and my polo is three sizes too big, which is great. Today, I wanted to look cool and dress a little nerdy with a tie. Then I looked at the time and said, "Well, there's no time to prepare an outfit." So I'm wearing head to toe what I was wearing yesterday. All I did was shower.

**Greenpoint Avenue station
Brooklyn, 2020**

Sandy Miller

Let Me Be Frank with You
by Richard Ford

R ichard Ford is one of my favorite writers. *Let Me Be Frank with You* is the fourth book in a series that follows a character named Frank Bascombe over four decades. Ford is a neorealist in the vein of John Updike and he also happens to be exactly my age. A lot of his writing is autobiographical so I'm experiencing the same things as his characters at the same time, like retirement, aging, and ailing. [*Laughs.*] *Let Me Be Frank with You* is set after Hurricane Sandy and Ford has a black humor about things like mortality. One of the characters says, "If nothing is funny, then nothing is truly serious." I like that he finds a way to make tough and thought-provoking topics something we can talk about.

Bergen Street station
Brooklyn, 2014

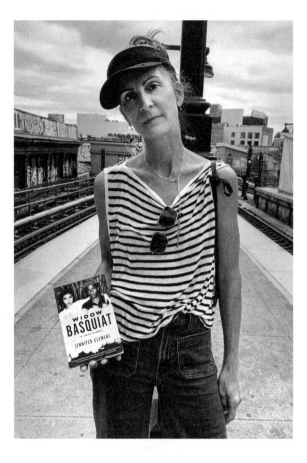

Cheryl Dunn

Widow Basquiat
by Jennifer Clement

I won't tell you the year I came to New York because then you'll know how old I am. [*Laughs.*] Let's say there was graffiti on the trains and the city was the most thrilling and exhilarating place ever because of all the artists who were here. It was heaven.

You made the documentary *Everybody Street*, which I love.

That's how I got to spend a day with street photographer Bruce Davidson. I wanted to shoot him on the subway and there's a station right outside his apartment, so I was like, "Hey, Bruce, you think we could get on?" I was so nervous! I shot on 16-millimeter film and I think my struggle to load it helped to convince him to ride more stops than intended. What you work with helps or hurts you, but it definitely gives people an idea about your seriousness. You have to fail, fail, and fail again, but in between you might get a magic shot.

Is this book magical?

If you love New York, art, and graffiti, you'll love *Widow Basquiat*. I'm reading it while finishing a documentary about Dash Snow, the graffiti writer turned artist who passed away at age twenty-seven, just like Basquiat. What I picked up is that Keith could glamorize graffiti as a gay white man in a way that Jean-Michel could not. Here it says, "They both understood this." Basquiat was a kid from the street who got sucked into the art scene and it destroyed him. He put so much of his life force into his work, and it emanates from it, but if you give away all your life force, you can't exist. People will take it endlessly until there's nothing left.

How do you stay afloat and not get sucked dry?

All of our biggest fear is the fear of the unknown. I was at a concert in Golden Gate Park where Rage Against the Machine and the Beastie Boys were playing for maybe a hundred thousand people. There was a massive push toward the mosh pit and people started falling. Everyone yelled, "Get away! Get out!" But I said, "No, let's go in, to the middle." Outside the center, it was hectic and scary. And in the center, it was calm. Don't succumb to fear, because that's what most people are going to do. With intelligence, go in, and find a better, calmer way.

**Myrtle Avenue–Broadway station
Brooklyn, 2020**

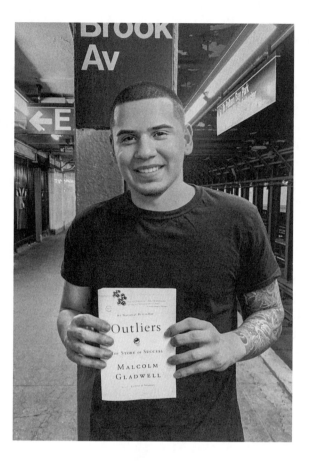

Devon Rodriguez

Outliers by Malcolm Gladwell

I'm an artist. I do drawings and oil paintings, but I got started by doing graffiti here, in the Bronx. That's what all my friends were doing and I thought the colors, the letters, the handwriting, all of it was so sick. Graffiti culture is huge in the Bronx. I remember when my father took me and my sister to do graffiti with him, my sister asked, "Why does everyone do it? I don't get it. No one knows your name." And my father said, "We want to mark our territory, like a dog taking a piss." [*Laughs.*]

Do you want people to know your name?

When I was a kid, I definitely wanted to be famous. Now I just want my work to be famous. I think that has to do with how I grew up. Five of us lived in a tiny one-bedroom on 141st and Willis. Ten people shared the same bathroom and people would constantly walk through our apartment to get to it, like it was an open house. I felt so unspecial, the way I was raised.

How did you get into oil painting?

After I got arrested for doing graffiti, I started to draw people on the subway. The grittiness of New York is embedded in the subway. The clothing, the colors, and the way they interact with the subway lighting is perfect. This book, *Outliers*, made me want to become a master at painting and drawing. I first read it when I was fifteen. I used to google "how to become successful" all the time, and the 10,000-hour rule kept coming up. Supposedly, when you put 10,000 hours into any craft, you become world-class. Malcolm Gladwell made this rule famous with this book. I thought it might be a little self-helpy—like how to take charge of your life—but it wasn't. Gladwell analyzed a bunch of success stories and everything that it takes, like individual merit, where and how you grow up, and how much you practice. Everybody thought Mozart was a child prodigy, but he actually sucked until he put in the time.

Brook Avenue station
Bronx, 2019

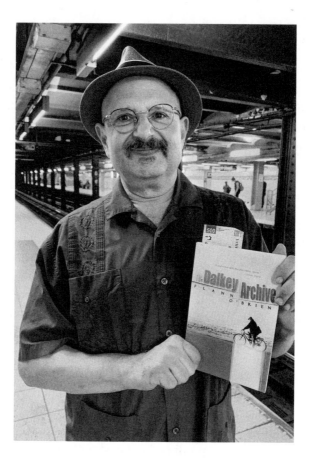

Michael Hashim

The Dalkey Archive
by Flann O'Brien

T he bookmark I'm using is a 500-peso note and this is probably the second or third time I'm reading *The Dalkey Archive*. Flann O'Brien is one of the great Irish novelists, like James Joyce and Samuel Beckett. He is completely indescribable and almost magical.

How did this peso note become your bookmark?

I'm a musician and play jazz with different bands around the city. Some-one must have left it in a tip jar. Frida Kahlo's portrait is on one side and Diego Rivera's on the other. I have no idea how much it's worth, but I think it shows that certain countries value their national artists.

How do you feel about money as an artist in New York?

I keep it pretty casual. [*Laughs.*] I take no particular joy in it, nor do I feel any particular pain by not having it. When I was a kid in a small town upstate, listening to records by great artists of jazz, I wondered if I would ever be like them. And hey, I became a jazz musician and I've played here for over forty years! I'm a lucky guy. New York is jazz. And jazz is New York.

14th Street/8th Avenue station
Manhattan, 2019

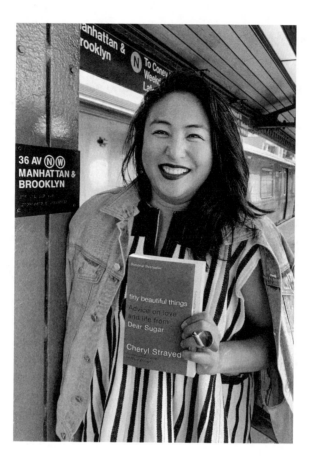

Happy David

Tiny Beautiful Things: Advice on Love and Life
from Dear Sugar by Cheryl Strayed

One of the most memorable places I've lived was when I sublet the apartment of a famous artist's ex-wife for $400 a month. I was a student with two pieces of luggage, living in the heart of Chelsea with signed Yayoi Kusama pieces on the walls. You could do twenty backflips in that place. It was amazing.

Do you have a favorite place in the city?

I'm from Manila in the Philippines, where I had my own jewelry line. People loved it, but in the early 2000s cheap stuff flooded the market and I figured it was time to become a student again. I came to New York for an internship with Alexis Bittar, and they hired me, but also suddenly laid me off. I was shocked and took a random job in the Village, two blocks from Casa Magazines, which became one of my favorite places in the city. It's on 8th Avenue, next to another legendary place called La Bonbonniere. They've been there together for twenty-five years.

Casa Magazines is iconic. What do you love about it?

Someone is always there to talk to you. It's open from 6 a.m. to midnight and it feels permanent in a city where storefronts come and go. When you look inside, all you see are magazines, from the floor to the ceiling. Casa is tiny but somehow it feels like a living room and people come in just to talk about their life or to complain about their kids. [*Laughs.*]

Are little things important to you?

Yes! *Tiny Beautiful Things* reminds me of my own moments of heartbreak, job losses, highs and lows. Cheryl has a great way of saying that all these little things build a great collection of experiences. It's comforting and it makes me laugh. Because of my name, people ask me if I'm always happy, and I try to see beauty in all things, but I've also experienced loss. My real name is Maria Regina Felicitas. My mom loved Happy Rockefeller and I was a terrible crybaby so everybody started calling me Happy. It stuck and I think it worked.

36th Avenue station
Queens, 2020

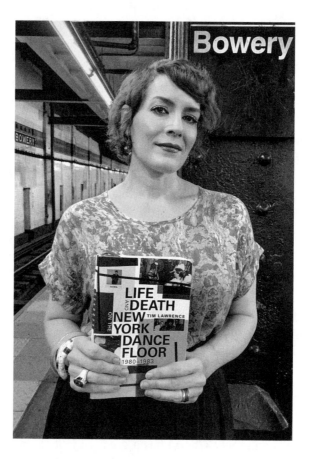

Ana Matronic

Life and Death on the New York
Dance Floor, 1980–1983 by Tim Lawrence

Nothing makes me happier than disco music. It's the mother of dance music, and transformational. Every DJ who spins today can trace their lineage back to people like Nicky Siano of the Gallery and Larry Levan of the Paradise Garage in SoHo. The original disco dancers were under a great deal of stress—the unemployment rate was 80 percent among young Black men in Brooklyn back then—and disco dancers were escaping tension,

oppression, and other woes. Women were getting down and disco was one of the first styles that didn't require a dance partner. I find a great deal of hope and inspiration in the disco era.

I love disco music so much! The music of liberation!

What's not to love! [*Laughs.*] It ranges from the totally sublime to the totally ridiculous and who could ever forget the sound of Donna Summer orgasming on "Love to Love You Baby." This book covers the post-punk, post-disco era, the rise of hip-hop and DJ culture, break-dance parties, and clubs like Area, Danceteria, and the Mudd Club. My musical knowledge grew exponentially after first reading this book, which I love, because the New York City dance floor is where I met some of my best friends and made my career with Scissor Sisters.

What does Bowery Ballroom mean to you as a musician?

I think you don't "arrive" in New York until you sell out Bowery Ballroom, which was punk rock central for a long time. I can't think of another venue where I fully enjoy the sound and the vibe the same way. It's my favorite place to see a show in New York. Wherever you are, it never feels too packed, and you can pretty much get a good view anywhere. It feels like home.

What kind of vibe do you think is important to carry forward?

We are social animals and social creatures. This book drives home that there's no substitute for a night of getting down and sweaty with your friends. [*Laughs.*] Music is the balm that soothes the soul.

Bowery station
Manhattan, 2020

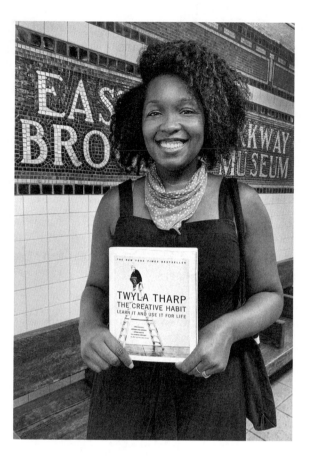

Tiffany Davis

*The Creative Habit: Learn It and
Use It for Life* by Twyla Tharp

You might know Twyla Tharp from the show *Movin' Out*. She is a choreographer, dancer, and the author of *The Creative Habit*. She was also pen pals with Maurice Sendak, which she casually mentions, like, "One thing that brings me delight is my decade-long penpalship with Maurice Sendak." It's one of the many gems in this book.

Maurice is a good name drop! Is the book any good?

It's a great book for anyone who wants to tap into their creative force. I really like the idea that because you are a creation who has experiences, you can also create things. We think creativity is spontaneous and combustible but I'm learning that creativity is a habit and a ritual. This book reminds me to even *call* myself a creative. I think people should honor the creative part of themselves, no matter what their vocation is and no matter how they're paying their bills.

Do you remember when you felt connected to your creativity?

I remember a dance recital when I was five years old and played the Statue of Liberty. There was a crown, ballet slippers, a flowing Grecian robe, and there was shimmer involved—the favorite "color" of little girls. [*Laughs.*] I felt great. I came onto the stage to dance and then it hit me. I had forgotten my torch! I ran backstage, grabbed it, and ran back out. I'm sure little Tiffany was mortified, but when I joined my group again, everyone smiled and clapped and my mom said, "I'm so proud of you for knowing that there was something you needed to do." It's a story I think about often because it's about one of my best qualities. When you're part of a group, sometimes you have to say, "This isn't my best work. Give me a second. I'll be right back." I want to give myself and others that space. I mean, the Statue of Liberty is literally a beacon that reminds us to collaborate. What a great invitation.

Eastern Parkway–Brooklyn Museum station
Brooklyn, 2020

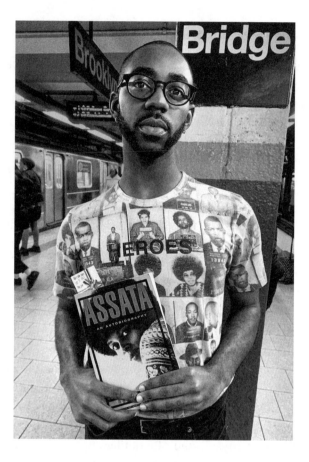

Owen Edwards

Assata: An Autobiography
by Assata Shakur

Ultimately, dance is about being culturally empathetic. I'm a dancer and I first heard about Assata Shakur through the "Assata chant" in Jamila Woods's song "Blk Girl Soldier." The opening phrase of the chant moved me deeply: "It is our duty to fight for our freedom." Those words left a mark on my heart and sparked my interest to read Assata's autobiography. I want to understand the movements and the good troublemakers who came

before me. Assata was a part of the Black Liberation Army, and she was wrongfully accused of murdering a New Jersey state trooper, which put her on the FBI Most Wanted list. Her autobiography follows her journey of activism, to being wrongfully imprisoned and ultimately fleeing to Cuba, where she lives today in political asylum.

What do movements give us?

Movements help us to understand that people who share similar views, values, morals, and beliefs exist. When you think about movements for the liberation of women, Black people, and the LGBTQIA+ community, those are people who once felt voiceless. But together as one, we are courageous and determined. Like Nina Simone said, "I'll tell you what freedom is to me. No fear."

Does dance create freedom for you?

Yes, dance *is* freedom! Our bodies can twirl, jump, slide, sway—the physical possibilities are endless. [*Laughs.*] But the body is also political, especially my Black queer body. Dance helps me to express myself and share my story. When I can't find the words, I am confident that my body will find a way. When I dance, there is a mutual embrace with those surrounding me. When I dance, I am free.

Brooklyn Bridge–City Hall station
Manhattan, 2020

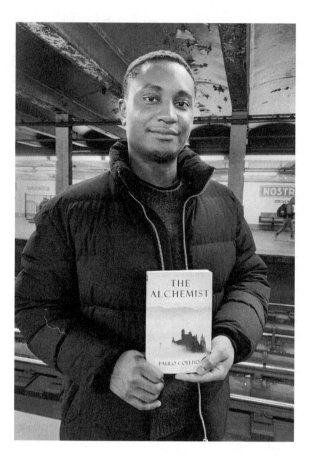

Chi Ossé

The Alchemist
by Paulo Coelho

T he first protest I went to was at Barclays Center after the murder of
George Floyd. I was totally unprepared. I wore shorts and I brought
some water and a ChapStick. [*Laughs.*] Then I got pepper sprayed and
realized there were better ways to prepare for how the police will treat you.
I protested day after day and I started to find my voice. I cofounded Warriors
in the Garden, a collective of activists dedicated to nonviolent protest for

legislative change, and it feels like I've known them forever. You form strong bonds with strangers through traumatic experiences.

What were you doing before the protests?

I was in a weird state. I wasn't working, I didn't feel inspired, and I didn't know where my life was going. I dropped out of college after my dad passed away and I was really depressed. Suddenly this book caught my eye—I have no idea how *The Alchemist* got into my house. I live alone and don't recall buying it. I finally picked it up and I swear my life has changed immensely. Right after reading it, I designed a T-shirt for a New York Nico contest to raise money for mutual aid efforts. Then I started to sell my own T-shirts and donated a portion of the profits to Send Chinatown Love. Next, I'm running for city council in Crown Heights and Bed-Stuy, where I grew up. I think *The Alchemist*'s message is to go with your gut and to do what feels right. My gut is telling me that I have found my calling. I swear, this is a magical book. It honestly brings me to tears, because I never had an experience like that. Everything that happened led me to my personal legend.

Nostrand Avenue station
Brooklyn, 2020

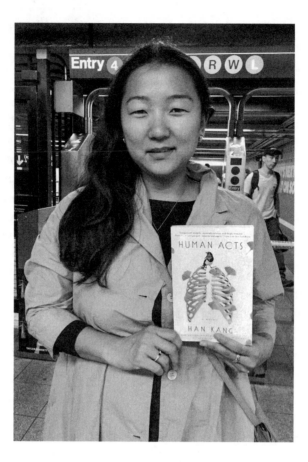

Siheun Song

Human Acts
by Han Kang

*H*uman Acts was on a list of recommended books about human rights. I often ask myself how to move from being comfortable to doing something that requires me to speak up. Stories like this one, which is about the Gwangju Uprising in South Korea, help me to reflect on my personal responsibility. It's painful to read because so much death and trauma unfolds. The reader is addressed as "you," so it's very disorienting

and it blurs the sense of self. It made me wonder where my being ends and begins, and I was reminded that the personal is political. I'm Korean and we're known for being demonstrators and fighting for the underdog. Hundreds of thousands of people went to Seoul every day for six weeks, forcing the president to resign. In 2016, I put 50,000 people on buses to the Women's March on Washington. It was the hardest I've ever worked and also the proudest moment of my life.

14th Street–Union Square station
Manhattan, 2018

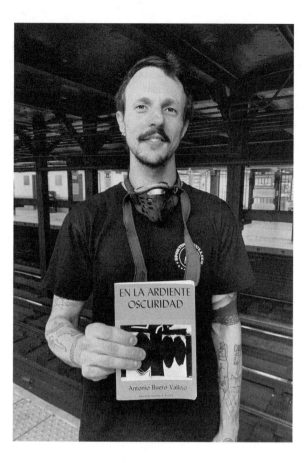

Eli Schewel

En la ardiente oscuridad (*In the Burning Darkness*) by Antonio Buero Vallejo

I'm an arborist for a living and my hobby is rat hunting. Field rats are eaten around the world, but I would not eat a New York rat. Most of them have been poisoned and are somewhere on the trajectory of death. Hunting small game with dogs is something that people have been doing for tens of thousands of years. We haven't always been sitting on the couch with our dogs watching TV. [*Laughs.*]

What about animal rights advocates who say that hunting is cruel?

My dog, Sundrop, delivers a far quicker, safer, and more humane death to the rat than poison. Rat hunting is also about social justice. Respiratory illnesses caused by rat dander are twice as likely in poor communities and communities of color. Recent research even ties respiratory illnesses to the rat poison itself. You can't poison one part of the ecosystem without releasing that poison everywhere else. I think people who are opposed to hunting rats with dogs need to ask themselves whether poisoning the adjacent human population is worth it.

I had to think about it just now. It didn't click as a community service right away.

I like to solve problems for people. What I am doing is giving people a sense of power. Rats are very quick and they evade you. For people dealing with rats in their walls and in their ceilings, it really is the worst. They are completely powerless and there's mental trauma on top of physical trauma. I know what I'm saying is going to rile up animal advocates. But I'm talking about helping people to reclaim their power, not animal cruelty.

I heard that you also make deliveries.

Yes. [*Laughs.*] A lot of problems are caused by the lack of city services and it dawned on me that in this moment of abject political failure we have the ability to agitate the people in power. They slash social services and education budgets while doing nothing to get killer cops off our streets. Every New Yorker should be outraged at that thought. I found it important to make rat deliveries to Mayor Wilhelm de Blasio at Gracie Mansion. I grew up in an area where the police were violent and abusive. I've got nothing good to say about cops and I thought my delivery might be an effective way to communicate my feelings.

What are your feelings about this book you're reading?

It's an incredible book called *En la ardiente oscuridad*, or *In the Burning Darkness*. It uses the metaphor of blindness to explore the human condition

and the struggle for liberation. The main allegory is that we are blind to the future. The characters live in a school for blind children and are given a system that makes them feel safe because they know where everything is. And that's what it's like to be white, which is to be blind to how brutal the world is for other people, particularly Black people. The world is set up to make white people feel safe.

That's incredibly powerful. How can we overcome this blindness?

We all have to "freedom dream." I'm borrowing that term from the activist and filmmaker Tourmaline. We have to push that dream as wide and as far as we can. I first read this book in high school and it makes me so happy to revisit it, during this abolition movement. I'm getting emotional talking about it, because I really need this dream too. I'm an Ashkenazi Jew who was born in '84 to a single lesbian mom in Tennessee, where it was illegal for her to be in possession of the sperm she used to get pregnant with me. As a queer spawn born into a gay family in the South, I have resistance in my DNA. I know that Black liberation is my liberation, too.

Church Avenue station
Brooklyn, 2020

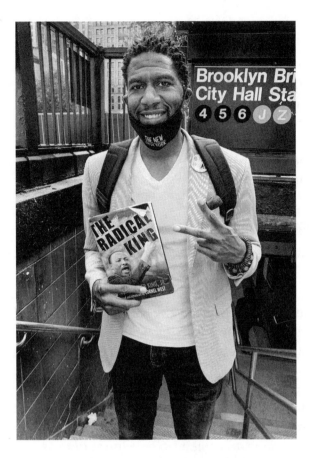

Jumaane Williams

The Radical King by Dr. Martin
Luther King Jr., edited by Cornel West

This book is a bit tattered [*laughs*], I've had it for a long time. Dr. Martin Luther King Jr. is one of my childhood heroes and it's strange to hear people invoke his name to push back on protest when he was much more radical than people who sanitize him let him be. Toward the end of his and Malcolm X's life, they were actually converging in thought, which is pretty amazing.

Why do you think people are so afraid of the word *radical*?

People are afraid of the word *radical* when it's about changing power structures, otherwise they have no problem with it. To me, being radical is necessary. Anything people enjoy about life came into existence through radical and revolutionary means. It amuses me that people pretend that "being radical" is something to fear, when in reality "being radical" has singularly moved the world forward. Nelson Mandela was on America's terrorist list until 2008.

We don't talk about that at all.

Not at all. When I was younger, my heroes were Spider-Man, X-Men, Malcolm X, and MLK. They were all sticking up for the little guy, creating unity through equity and justice. Our current social structure is not based on equity and justice. We pretend it is, but it never has been. Now, hundreds of years later, people are finally atoning and understanding the impact of enslavement. None of us who are alive now are responsible for that system, but we're responsible for the systems we perpetuate. I'm the fifth Public Advocate of New York City. Before me came Letitia James, and before her Bill de Blasio, the current mayor. I think the government often makes decisions "for" the community and not "with" the community. I want to make sure that people who are closest to the problem are heard and represented.

What do you say to the future generation of New York?

People tend to think of New York's hard edge, and yes, we can be a little abrasive [*laughs*], but we got a lot of love. When a New Yorker is hurt, other New Yorkers lift them up. We have to leave this city a little bit better than we found it. We owe it to the next generation to not go backward. And we have to keep our love energy strong.

Brooklyn Bridge–City Hall station
Manhattan, 2020

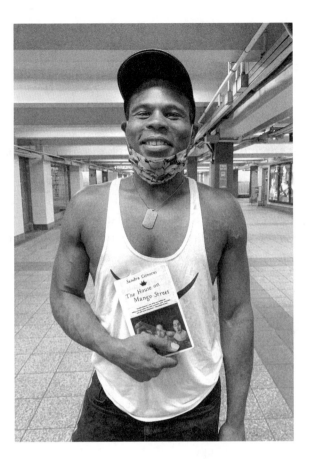

Dwreck Ingram

The House on Mango Street
by Sandra Cisneros

A s a child, I used to be really overweight, and I would drown myself in books—words were my solace. *The House on Mango Street* was one of the first books I ever loved and it felt like a reflection of my neighborhood. It doesn't focus on African American or Black culture, but I know the main character's journey. There's this weird phase in middle school where you're going from childhood to adolescence, and as a person of

color, you go from being adorable, cute, and innocent to being seen as a sexual object if you're a woman, or as a dangerous threat if you're a man. I went through this myself, and I think that it's unique to people of color. We lose our innocence so much earlier. I love and appreciate Sandra for addressing that fact.

Thank you for sharing that. We have to look the truth in the eye.

Funny story, I was just fired from my job last week. I worked for property developers and I had weird feelings about it, knowing that the company I work for is actively removing elderly people in the Bronx so they can build a new high-rise and raise rent. I was in conflict with that, so I brought it up in a board meeting. After that, my boss saw me in the news at a protest talking about gentrification and he fired me. I guess I wasn't a good representative for them anymore [*laughs*], but talking about the oppressive systems in America is something that I love to do and need to do! My generation should be the last generation to struggle with horrible schools, horrible police, horrible sanitation systems, and food deserts.

42nd Street–Bryant Park station
Manhattan, 2020

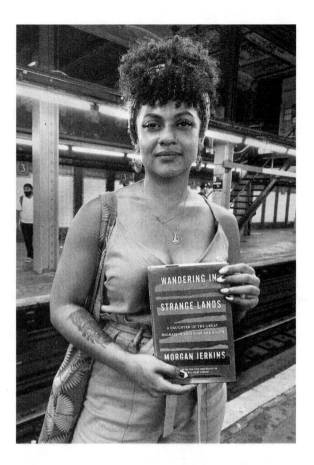

Ora Kemp

*Wandering in Strange Lands: A Daughter of the Great
Migration Reclaims Her Roots* by Morgan Jerkins

My job is to look at food as part of public health. I've always seen the Bronx through the lens of food access. Food quality and food distribution are serious issues here. In areas with a lot of social power, like the Upper West Side, you might have access to a farmers' market every day of the week. Here, we have one grocery store for every twenty-seven bodegas.

Our city is full of invisible lines that change our quality of life from one block to the next.

On my way to the subway, I saw a massive tree that fell over a metal fence into the middle of a basketball court. That means nobody can use it and it's been a week since that storm passed through. I was talking to someone deep in Brooklyn earlier today and they still don't have power. But do you want to hear something really crazy?

I always want to hear something really crazy.

Hunts Point in the Bronx is the largest food distribution center in the world. Not on the East Coast, not in the United States, in the *world*. They fly food across the country, but they won't make sure that people in the Bronx, who take on the burden of all the trucks pummeling their streets, have the food they need. I would love to see a smaller-scale, localized, sustainable system, where we can establish partnerships between local vendors and small businesses so we can have a food stamp–accessible market here in the South Bronx. I believe in my heart that food is a human right.

Does *Wandering in Strange Lands* encourage you in your fight for food access?

Oh, absolutely. Reading Morgan Jerkins reminded me that the system in place has perpetually told us that we don't matter. Of all the work that we, people of color, have to do, the most important thing is to make sure that we know our own history. People say, "You can't know where you're going until you know where you come from." We think we're starting with a blank slate and we're not. We have to command the space we occupy with confidence. I find it beautiful to think that we could have that opportunity. Blacks and Natives fought together for freedom. Blacks and Mexicans fought together for freedom. We are meant to be a collective mosaic of people and establish our entire country and constitution on the power of the king. Well, we are kings, too.

3rd Avenue/138th Street station
Bronx, 2020

Djeison Canuto

Ready Player One
by Ernest Cline

Ready Player One takes place in 2045, when all our resources are depleted. The story follows a kid named Wade and his pursuit of a golden ticket to a new reality called OASIS. He lives in the real world, but like most people, he spends all of his time in a virtual utopia. There are three keys that the players have to find, and the winner gets access to a new virtual world and the inheritance of the billionaire who built OASIS. The whole world searches for these keys, and people are willing to kill to win. The billionaire was born in the '80s, and the virtual world is full of pop culture references, which is a lot of fun. We have some of this virtual reality stuff already, but in the book they're able to create whole new galaxies, there's no poverty, and anyone can go to school.

Would you want to live in a virtual world if you could?

No. At the end of the day, you still have to take your gear off and come back home.

14th Street/8th Avenue station
Manhattan, 2015

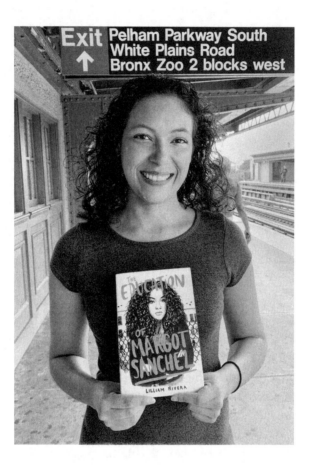

Liana Rodriguez

The Education of Margot Sanchez
by Lilliam Rivera

I didn't start traveling into Manhattan until a few years ago. I was born and raised in the Bronx, went to school in the Bronx, and worked in the Bronx. I started going to Manhattan when I got a job as a personal care assistant for a family who lived in Midtown. Before that, the farthest I went was probably 42nd Street. This book mostly takes place in the South Bronx, and it's great to see places I know intimately in literature.

That is very cool, tell me everything about Margot Sanchez!

Margot Sanchez is on lockdown because she was caught stealing. Her punishment is to work at her father's supermarket for the summer, which she's livid about. She's fifteen, so all she wants to do is impress the popular girls. [*Laughs.*] She's one of the only people of color in her private school, and is dealing with that while trying to fit in. Lilliam Rivera is a Puerto Rican Bronx native. She does an amazing job bringing the themes we actually deal with to life.

You said you worked as a personal caregiver, what was that like?

I assisted a woman with cerebral palsy. She worked and had a full schedule. I would travel around Manhattan to help her physically, with tasks like typing and writing. Emailing took her a really long time but she was fully capable of speaking and had a motorized wheelchair. She made me see the city with completely new eyes. Sidewalks are horrible in New York, but they are exponentially worse for someone like her. A walking person can make sharp turns or hop into the street to get around a big pile of garbage. I also got to see how society views people who have a disability. If we had to go to the DMV to fill out a form, instead of directing questions to her and looking at her, they would look at me and ignore her, as if she couldn't answer them herself.

Did you ever take the subway with her?

Yes, and it was a wild experience. If a station even had an elevator, it was constantly out of service, which would completely derail us. To go anywhere, we'd have to have at least three different routes in place just in case one of them fell through and we'd have to leave four hours earlier than the appointment required. I could not believe what she had to put up with.

Allerton Avenue station
Bronx, 2020

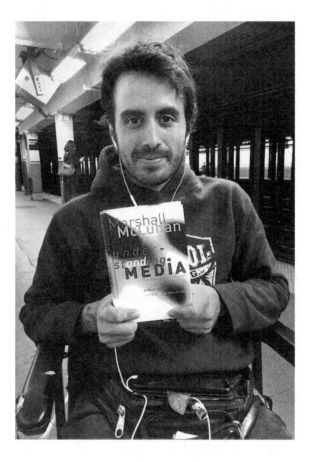

Edgardo Marmol

*Understanding Media: The Extensions
of Man* by Marshall McLuhan

I'm in this wheelchair because I have a cognitive disorder and a neuro-
logical disease that attacks my nervous system. I started to experience
symptoms when I was sixteen. Before that, I had a normal life and mostly
ignored what the future might hold for me. Now my brain doesn't send
proper messages to my body anymore and my muscles don't respond like
they used to. At first, I felt ashamed and I became very shy, but as time

went by, I got used to it and now I feel very proud of myself. My disability really made me want to see the world. I'm from Ecuador and have been in New York for three years. Before that I was in Los Angeles.

Is there a parallel between your disorder and this book you're reading?

I think so. I'm finishing my master's degree and my thesis is a documentary about a dysfunctional family. I want to make movies and teach people how to communicate in a proper way. This book is about media and how we can use it to influence people. I guess in a way my wheelchair is my message. I want to show people that what happened to me does not stop me and that no pain lasts forever.

**Bleecker Street station
Manhattan, 2017**

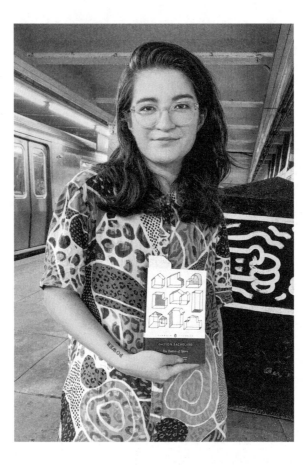

Arabelle Sicardi

The Poetics of Space
by Gaston Bachelard

M y dad was the menswear buyer for a place called Canal Jeans, which was *the* place where all the cool kids, like Chloë Sevigny, used to shop. This was decades ago. I didn't even know about it until I started working in fashion. In retrospect, it explains why my parents had so many cool clothes they never wore and why they never chastised me for wearing something weird to high school. [*Laughs.*] They'd be like, "You can wear

these two different tights at once, but we ask that you change your belt because it does not work."

I'm dying over here! Are your parents no longer in fashion?

No, they retired from fashion before I was born. I was lucky to have pretty much stay-at-home parents, because my dad has a disability. But they were in fashion for years, and they had strong feelings about me not going into it—claiming it was a horrible industry that would chew me up and spit me out. They wanted me to be an engineer or have some sort of job to brag about. [*Laughs.*] The great irony is that all of my cousins are also in creative fields. Our entire family is completely screwed. Just kidding, we're okay.

You write about beauty and technology. How do those two connect?

Beauty is a technology to me. Sometimes I write about actual tech, like QR code–embedded nail art, but right now I'm obsessed with Marie Curie. She died from all of the radioactivity in her research, which she didn't know would happen. When she discovered radioactive materials, it was trendy to use them in literally everything. There were radioactive beauty powders, radioactive matches, radioactive brushes, and even a Broadway play based on radioactivity.

I had no idea radioactivity was a trend! What is *The Poetics of Space* bringing to light for you?

Ocean Vuong recommended *The Poetics of Space* to me when he was visiting New York. I was working on a book and was very frustrated about its structure. Reading this book opened up a new hallway in my brain. It interrogates every aspect of what a home can be. What can a cellar be? A closet? What does a home look like in Paris versus a home in New York? There's a line that says, "You are your home and your home is in you." I really love this book because it helps me to understand that every single thing around me has a memory attached to it and that my relationship to it changes all the time.

Myrtle–Willoughby Avenues station
Brooklyn, 2020

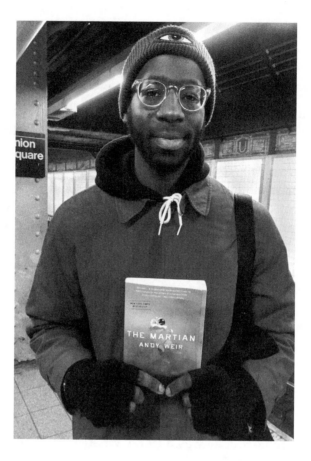

Jerome Bwire

The Martian
by Andy Weir

I'm about forty pages in and I've been captivated since page one. *The Martian* is about an underdog who finds himself in a number of shitty scenarios. For one, he's stranded on Mars. [*Laughs.*] He has nothing to eat and very few tools for survival. His team presumes him dead and leaves him behind. I'm a sci-fi nerd and I guess I'm drawn to bleak situations in space.

If you could, would you travel to Mars?

I think I would go to Mars, but not on the same type of mission. I'd like to pop by for a visit.

14th Street–Union Square station
Manhattan, 2015

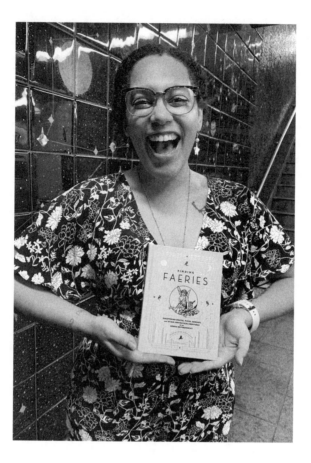

Moiya McTier

Finding Faeries
by Alexandra Rowland

This is my favorite subway station. Look at the beautiful tile mural with all the stars and planets, and right around the corner is the sun. Can you believe that there are hundreds of billions of other solar systems in our Milky Way galaxy? And that our galaxy is one of hundreds of billions of other galaxies? One of the most comforting things about being an astrophysicist is that I regularly deal with numbers that are bigger than the numbers in

Jeff Bezos's bank account, and I don't think a lot of people can say that. [*Laughs.*] The universe has more stuff than Jeff Bezos.

Jeff is shaking right now. Space can be very overwhelming.

I'm still overwhelmed by space sometimes! Space is old! Fourteen billion years is an amount we have trouble wrapping our minds around. As a kid, I had zero interest in space. My mom would try to get me to go stargazing with her, but I wasn't into it. Flash-forward to Harvard University, where I came across a number called the Hubble constant. It describes the expansion of the universe. We used to think the universe would slow down, just stop, or stay at the same speed, but it's not. The expansion of the universe is getting faster and the space between galaxies is stretching. I love the fact that space is so big and that I'm tiny by comparison. In the grand scheme of the universe, my existence and my actions mean nothing, but what I do here on earth still means a lot.

I love that, and that you're reading about faeries.

Both science and space look at fictional world building. Folklore is connected to mythology and I think it pairs beautifully with astrophysics because astronomy was the first science. *Finding Faeries* is about different types of mythological creatures and how they would adapt and react to human activity, like climate change. It feels like a continuation of Neil Gaiman's *American Gods*. I wholeheartedly want faeries to exist, and maybe this will make people take me less seriously as a scientist, but I confess that when I'm in nature I leave out bowls of milk and bread for faeries. I like the idea that there are parts of this world that we don't understand, and I think one of the most powerful things folklore gives us, is to strive for observation.

I have to ask you, is Carl Sagan right and we're all made from stardust?

Yes, because a star is born from a cloud of gas. All planets are made of star materials, and all humans are composed of all the materials that ever existed on our planet. Think about our life and death cycle. That's why we say, "Ashes to ashes, dust to dust." Humans are born, we eat plants or

animals, then we die and decay, and our bodies feed back into the Earth. Everything that's part of space is recycled.

Wait, so every person has been and will be recycled a million times.

Isn't that so cool? You might have an atom from your favorite dead author inside of you. Or maybe there's an atom in your body that used to live in ancient China. I think remembering that we're all recycled backpacks is actually a nice way of remembering how connected we are. It comforts me. Not the fact that I am a backpack [*laughs*], but the fact that everyone always has been and always will be a backpack. We're all space. We're all stardust.

**81st Street–Museum of Natural History station
Manhattan, 2020**

Meg Morton

Let the Great World Spin
by Colum McCann

I found this book at a stoop sale and I've been enjoying it a lot more than I thought I would. I knew the story had to do with the guy who crossed the Twin Towers on a tightrope. The opening scene describes him stepping onto the rope and people's immediate reaction to it. They step out of their world and share the experience of watching him. Usually, in cities especially, people are in their own bubbles, but then there are these moments, like someone walking a tightrope or the pope visiting, and suddenly everyone is aware of each other again, and kinder. Sharing space and experiences really brings out the best in people.

Hoyt–Schermerhorn Streets station
Brooklyn, 2015

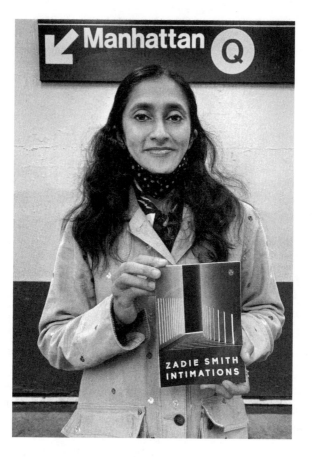

Aparna Nancherla

Intimations
by Zadie Smith

O nce I had the honorable opportunity to open a comedy show for Tig
Notaro at Carnegie Hall, which was never even in my imagination
a place where I would be onstage. As a performer, anytime you're in a
new space, you have to learn it. I was a little worried about Carnegie Hall
because I didn't know how to play it best, but it just gave me a warm
feeling. Some theaters have acoustics where waves of laughter wash over

you. Getting to be a part of that show was surreal from top to bottom. It feels like a lifetime ago, but thankfully stand-up comedy is like the cockroach medium of performing arts. It will always find a way to exist and continue.

As a comedian, are you ever intimating? Are you a person who intimates?

I looked up "intimation" and it means "a hint" or "a way of expressing something without directly expressing it." I think I'm an intimater and that's why this book resonates so much with me. I found it really helpful that Zadie Smith embraces that she's not the type of person who's going to organize the march to get people out into the streets. She's always been a writer, contextualizing things and trying to provide a narrative. You could argue that writers protest in a different way, but she strips you of that romanticism. It's weirdly comforting to know that other people aren't sure how to be helpful. I'm someone who's always trying to people-please. I'm constantly testing the water to see if it's okay for me to express an opinion or to take up space. I don't think that's a great quality, but I think I'm most comfortable waiting for the other person to make the first move.

Where do you think not wanting to make the first move comes from?

I think it comes from—wait, do we want to get into my family history? You're nodding, okay. My sister was the more rebellious one, so I had to use a different strategy. Rebellion seemed like it caused more tension and involved more conflict and confrontation. I thought there had to be a more under-the-radar approach to getting your way. The strategy I came up with is not as exciting. It's a lot of hemming and hawing and hedging. It's a lot of staying on the sidelines and seeing how things go, and, you know, dipping a toe in the water and then getting back out, and waiting some more and then eventually getting in the pool. I've been trying to force myself to be more of a shower and doer, but I think it's also important to acknowledge doubts and to make room for evolution in people.

Parkside Avenue station
Brooklyn, 2020

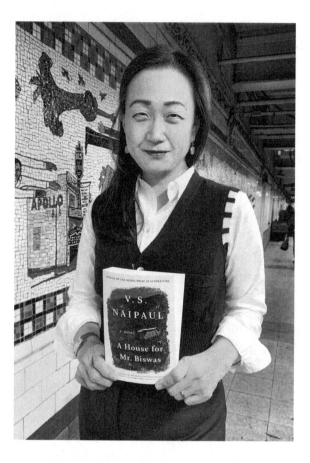

Min Jin Lee

A House for Mr. Biswas
by V. S. Naipaul

The subway stop I lived closest to as a kid was Grand Avenue in Queens, and my parents had a tiny wholesale jewelry business—it measured about 200 square feet—near 34th Street–Herald Square. They started the shop in '77 and they sold costume jewelry to peddlers. Some of the guys would get earrings from my folks for $2 a pair, and they would sell them on the subway for $5 a pair.

I can't get enough of this, and you, a fellow subway lover!

The subway is a miracle and such a special way of moving around in the world. I love it. On the 7 train, you literally see people sitting next to each other who have been at war or ethnically hate each other, and yet on the subway everyone is your neighbor. I remember reading *A House for Mr. Biswas* on the subway, and the moment I finished it, I started to weep.

Do you remember what made you weep?

All Mr. Biswas wants is a house. It means so much to him to have his own space because he lives in a world that keeps erasing him. The entire book is about this man trying to have a bit of dignity. That really connected with me, because at that point in my life, I kept getting rejections and felt diminished as a writer. After reading this novel, it occurred to me that I just didn't care anymore and that I would write about the people I love. For me, the most important people in the world are ordinary people who care deeply about the well-being of others—someone like Whitney Hu, a community organizer I know. A person like that is heroic, because she honors the vitality of all people's lives with the same respect. I can't stand phonies who treat you differently based on your circumstances. Show me something a New Yorker hates more than a phony.

125th Street station
Manhattan, 2020

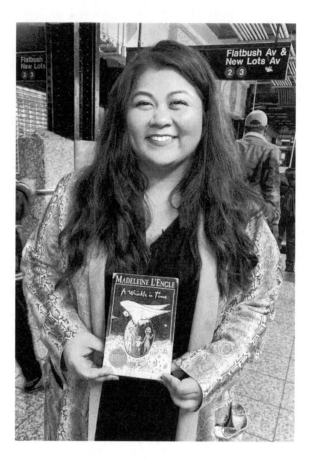

Whitney Hu

A Wrinkle in Time
by Madeleine L'Engle

Time and space are relative. That's a pun on *A Wrinkle in Time*. Okay, but seriously, I love this book. The main character, Meg, is going through puberty, and she feels awkward and gangly, but she's also forced into remarkable circumstances—and she's crushing on a boy, which I identify with because I fall in love twice an hour. [*Laughs.*] In the book, they talk about tesseracts and bending time, and I don't think of myself as sciencey,

but I'm always curious and try to rethink what my reality could be. I really appreciate that Meg openly admits that she's scared, but that she's still brave at the same time. She can hold two truths. I love the reminder that just because I'm scared doesn't mean that I can't act.

When was the last time you had to be brave?

I was at a rezoning hearing in Industry City to testify. I was number fifty and started to feel like the notes I had prepared weren't good enough after I heard what other people had to say. So I threw away my script and spoke from the heart. I was shaky and emotional, but the commissioners who hadn't been paying attention looked up. I made them see me.

As a defender of our realm, do you have any secret weapons?

In the book, there's a character who hangs out with a giant boa constrictor and I think that's so cool. Snakes are a symbol of power and wisdom. I'm half Chinese and that's what snakes represent in the zodiac. When I figured that out, I started to wear snake, like this coat. Obviously, I wear fake snake only. It's a sensual, feminine power. People say, "You're so on trend." I'm like, "No, I've always liked snakes, guys."

Atlantic Avenue–Barclays Center station
Brooklyn, 2020

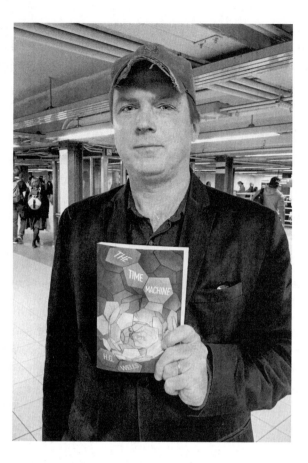

Brixton Doyle

The Time Machine
by H. G. Wells

Coming from a lower-middle-class family, we read anything that we could get our hands on. I first read *The Time Machine* when I was five years old and I've reread it many times since. It was published in 1895 and it's about a time traveler who goes 800,000 years into the future and sees what capitalism has done to humanity. He sees a society that's been split into a leisure class and a working class who exist to feed the rich, who are

becoming more and more lazy. There are modern buildings, but they have fallen into decay. There's an intelligent group of people, but all energy has been drained out of them.

What's your take on leisure time?

When leisure time starts to become your occupation, that's dangerous, because it becomes a vacuum. As people have more time to do "nothing," there is less originality, less thoughtfulness, and more plagiarism. Don't you think we're starting to see the same thing over and over again? I think we are, and that's because people have fewer original experiences.

Where would you go with a time machine?

If I could travel far enough into the future, I'd hope to find an emptier Earth. It would be very lush and green, with many animals, and small cities where highly educated humans live together. People would have become spacefaring and started other colonies, giving Earth a chance to rejuvenate. I want to think optimistically about the future. Otherwise, nothing matters.

**14th Street–Union Square station
Manhattan, 2016**

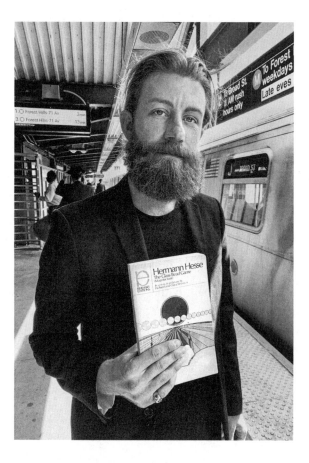

Nicholas Brysiewicz

The Glass Bead Game
by Hermann Hesse

*T*he *Glass Bead Game* is the final book written by Hermann Hesse, and it's the last one I have left to read in his oeuvre. It's a biography of a secular monk, set in the future—call it the year 2500—and the monastery he lives in, where people are perfecting the exchange of ideas through the glass bead game. In a way, it's a book about deep time.

Do you have official business with time?

I work at the Long Now Foundation. We're trying to help people to think differently about time. More specifically, we want people to think about the next and the last 10,000 years of human civilization. Right now, everything from stock trading, to technology, to fashion, to the music industry is short-term focused. Who's holding it down for the long term?

I have so many questions for you. How do you imagine 10,000 years?

For one, we're building a very large clock. Back in '96 we felt that humanity needed an enduring symbol for the future. In the same way that the pyramids at Giza are a symbol for the past, a clock contains the seeds of a distant future right here in the present. So we're building one inside of a mountain in West Texas that is going to keep time for 10,000 years. It's going to chime at solar noon every day for 3.65 million days and the bell toll sequence is composed just for that day. At this point, it's an active construction site and I think it might be open in my lifetime, but I really don't know. We still have 10,000 years to figure it out! Isn't that so freeing?

You have a very chill attitude about this.

There's a lightness of being that comes with seeing yourself in the context of something like the Milky Way, or a mountain range, or 10,000 years, don't you think? I like surfing the edge between smallness and bigness, between agency and determinism. But I'm mostly thinking about how not to constrain future generations. How can I give them everything I possibly can? I also live on the West Coast, and we're usually just a little behind the beat, which is all right by me.

Marcy Avenue station
Brooklyn, 2019

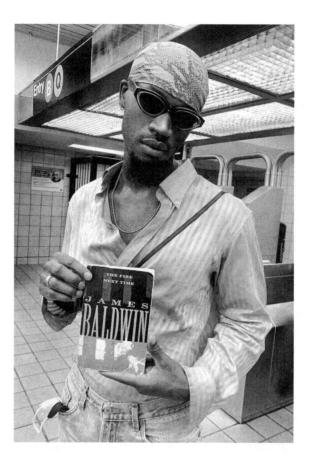

Anthony Prince Leslie

The Fire Next Time by James Baldwin

We're at Church Avenue and East 18th Street, in the heart of Flatbush. This is where people come to make their money, this is where people come to get their hair done, this is where people go to the 99-cent store to get Palmolive to wash their dishes. I get my flowers over there—shout-out to my man for always having great eucalyptus plants that make my bathroom smell good. Everybody looks great and everybody's fire. That's the vibration here.

How long have you lived in this neighborhood?

I've lived in Flatbush for about three years, but I've been coming through since I was a child. My father used to hang out here with his friends, and I remember seeing them in these streets, talking about what's going on in the world. *The Fire Next Time* by James Baldwin feels like a time capsule. I've never read him before, but I've seen *If Beale Street Could Talk*. As a filmmaker, I admire what Barry Jenkins did to make that film poetic and loving. The characters in my films work in salons, delis, and laundromats and are always embedded in real life. Reading this book opens me up to the life of a Black man in the '60s that is still relevant to me today.

It feels like it's meant to be read with *Letter to My Daughter* by Maya Angelou.

I want to read that next, because as a Black man I need to understand Black women. I'm really charged right now because it's been 139 days and Breonna Taylor has not received any justice. And you know what, James Baldwin has seen plenty of that in his time, too. Deciding to show up for somebody else is a choice that ricochets, and we're only going to understand each other if we continue to pass down information so that it can collide, give back, and roll on, like a tidal wave. I feel like I gain so much from this world just by being generous to other people. I might get a smile, or a discount, or a kiss. I like the rewards program in this city.

Do you have a wish for New York's future?

We need a big eucalyptus in Times Square so that it can permeate all five boroughs. Imagine you could smell it forever and ever.

Church Avenue station
Brooklyn, 2020

Emma Straub

The Idiot
by Elif Batuman

In my twenties, I moved near Carroll Street station and started working at BookCourt. It became the point at which my world turned, and it was the center of everything for me. Ten years later, the owners decided to retire, which they certainly deserved after running it for thirty-five years, but that left us without an independent neighborhood bookstore. So my husband, Mike, and I found a space and opened Books Are Magic.

Running a bookstore sounds amazing. You're just hanging out, having a relaxed time . . .

Uli, there's nothing chill about it! [*Laughs.*] It's a common misconception that bookstore owners sit on a stool all day, reading books, which, let me tell you, does not happen. Working in a bookstore is really physical because you're carrying heavy boxes all the time. But Mike and I had always fantasized about having a bookstore and all of a sudden it was upon us—we didn't even pause to think about it. It was just clear as day. I mean, it's ridiculous how lucky we are.

I love you and salute you. What are you reading right now?

I'm reading *The Idiot* by Elif Batuman. It came out a couple of years ago and I think that's the hardest category of book to read. A brand-new book or a classic is easy to pick up. Books that are a couple of years old, you look at them and think, "Well, I should have done it then." We have to overcome that because this book is just so smart and so funny and that's the perfect category to me. It's also such a kick that it's about my generation. People think that I'm a millennial but I was born in 1980.

I was born in '81. We're Cuspers, neither Gen X nor millennials. We should be our own category.

Which makes this a "Cusper book" about being in college and having an email address but being like, "What do I do with my email address?"

Do you even remember life before email?

Yes! When I was in high school, there was a corner on the Upper West Side with a Barnes & Noble, a Burger King, and a pay phone. I had a lot of friends with pagers—somebody was always beeping someone—and we'd call them back on that pay phone, which sounds like the pony express now. You could not cancel plans, it was great. Honestly, I miss it, and what I really miss are all the hours I had to myself where I could just think and write. I used to fill entire notebooks because I was always on time and

my friends were always late. I don't do that anymore. My cell phone has absorbed that time pretty much completely.

Unstructured time is the most exciting thing. When was the last time you had any?

Last week, I went to Nashville for a librarians' conference and I had a slumber party at Ann Patchett's house. What was so great about it—other than Ann Patchett—is that Ann doesn't have a cell phone. So my phone stayed on the kitchen counter. Ann was so cute, and I really wanted to take a picture, but I didn't. It was the most amazing thing because we just had *time* together. Totally endless, limitless time. We sat around, we had breakfast, we talked, and there was no agenda. It felt like being in college and not having email. I miss it, time before responsibilities, time before I was always spoken for.

Bergen Street station
Brooklyn, 2020

Jo Firestone

Time's Arrow
by Martin Amis

I get easily distracted all the time, especially on the subway, and I love a book that sucks me in. I was reading *My Brilliant Friend* and I got stuck mid-puberty. I had to put it down. I asked my friend Colin Elzie and he recommended *Time's Arrow* for a little excitement. He said that it's a real page-turner. He also gave me a spoiler. He spoiled it pretty bad, actually. I'm not going to do that for you right now.

How do you feel about time?

My general feeling about time is that I'm always running out of it. I don't sleep much. I'm always asking myself, "Where am I? Where *should* I be right now?" I think this will be a good book for me.

Clinton–Washington Avenues station
Brooklyn, 2016

Kamau Ware

*Silencing the Past: Power and the
Production of History* by Michel-Rolph Trouillot

I tried to name my son History, but his mom and my mom didn't like that too much. So we gave him seven different names and eventually he landed on Asis when he was a week-old youth. Time and history are personal experiences. I've always liked history and I define it as "the world according to human beings" because it's always told by flawed people, whether it happened a day ago or centuries ago. This book, *Silencing*

the Past, is real meta. Trouillot illustrates so well that history is not one-dimensional. History is the production of what people say happens, and if you've got the right budget, you can make one narrative seem truthful. Some information definitely has a bigger budget.

Which of the many histories are you interested in?

I'm specifically interested in the African diaspora's impact on the world. I look at the public square to see how the diaspora is present or not in our cities. I look at street names, statues, and at media, including digital ads and jumbotrons. You would have little sense that New York City is named after a slave trader and that's a choice as much as it is to not acknowledge the people who built roads like Broadway and Wall Street. The African Burial Ground was discovered in 1991 on Duane Street about two blocks from our current city hall and people were like, "Oh, there are bones here, who knew." Ever since the beginning of this country, New York City has pretended that Black people didn't build the streets we walk on.

Does it all come back to money?

Absolutely. Whether it's a bullet, a book, or a boulevard, it's all about money and power. A lot of academia and established institutions have been supported by people who have made a lot of money with slavery, by financing it. Me studying Black history in New York is personal, but it's also a part of my practice as an artist who became a historian. For the last ten years, I've been doing walking tours to push the conversation into a regular, daily activity.

My aunt Moni firmly believes that you learn a city by walking it.

Yes, when you go for a walk, you're at the source. Anytime you're getting locally grown knowledge from the ground, you're able to braid yourself back into the human narrative. Remember when Michelle Obama mentioned that the White House was built by enslaved people and there was an uproar? She had to pull out the receipts and be like, "I'm sorry, there are these things called facts." Telling a false narrative is the same thing as destroying the truth.

Where are you finding your place in history?

It's one thing to say, "I want to understand the world we live in." It's a whole different thing to pursue that understanding. There's a whole side of my family I didn't know until 2015. People of African descent in this country often can't trace their lineage back to the 1600s. This of course isn't solely a Black thing. People who are adopted often don't know either. In school, when we have to do oral history projects, that is really uncomfortable for many of us. We don't all have equal footing. I'd like to invite people to better understand their pasts so they can heal. Historic healing is putting yourself in the narrative of the world. If you live in the past, the present, and the future at the same time, you have a totally different awareness. I like to think about how I happened in the world and how I will ripple forward.

Fulton Street station
Manhattan, 2019

Linzi Murray

The Slow Regard of Silent Things
by Patrick Rothfuss

When I was seven months old, I was adopted from China. It's illegal to abandon babies in China, so I don't have any records of my birth family. For a whole portion of my life, I tried to come to terms with that. I know I'm from Maoming, which is in the Guangdong province. They speak a mix of Cantonese and Mandarin, but I think I was surrounded by Mandarin because when I hear it, I feel like I'm at home. In America, I was

an only child and grew up in a suburb of Kansas City in a largely white community. My parents would take me to stuff like Chinese New Year celebrations, but they were mostly guessing. I returned to China for the first time on a heritage tour with other girls my age who were adopted. We went to eight different cities in two weeks, and we split off to each of our orphanages. The whole trip was very emotionally taxing.

Wow, that's a lot of ground to cover.

It was surreal. All my life, my adoption story wasn't tied to real places, they only existed in my mind. Going back, everything clicked into place, especially when I saw the government building where I was found at two days old by a police officer. I was told that I was taken to the orphanage, where I lived until I was adopted. *Now* I realize how traumatic that was. There's something really special about *The Slow Regard of Silent Things*, which is part of the Kingkiller Chronicle series, because I can see myself very clearly when reading it. It follows a minor character, her name is Auri, and I think she is my favorite literary character of all time.

What makes Auri your favorite character of all time?

You can tell that she's brilliant but she *knows* something is off with her because of something that's happened to her. She lives underground by herself in a place called the Underthing and makes up her own names for everything. You kind of understand that she knows the true nature of things, and she sees it as her job to right the wrongs in the world. It's never explicitly said, but what I love about her is that she has OCD. I see myself in her and was able to come to terms with the fact that I have OCD.

How does your OCD express itself?

I've had a lot of trauma in my life. OCD is a defense mechanism where you're trying to set up rules for yourself to feel more in control of your surroundings. I think it took me a long time to come to terms with having OCD, because people casually say, "I'm so OCD, I need everything organized by color." But they don't really understand the compulsive part.

I tap three, five, or seven times, depending on what it is, and things have to face a certain way so I feel safe. There are days where Auri can barely get out of bed, but she knows that's the way her world works and that she just has to do her best. She gave me permission to explore my OCD and to know that it's not a flaw. It's just a part of who I am. Many people are not comfortable talking about their mental health, and I've been criticized by people who say that I shouldn't share or express my feelings so much, but I find it to be one of my strengths. Over time I've learned that I am the key and the answer to myself.

Smith–9th Streets station
Brooklyn, 2020

Arti Gollapudi

Bitch Planet
by Kelly Sue DeConnick,
illustrated by Valentine De Landro

*B*itch Planet takes us into a dystopian future that honestly doesn't feel too out of reach from our current reality. In the book, all "unruly" women are deemed noncompliant, and they are sent from Earth to a prison facility on a different planet, which is called Bitch Planet.

Do you consider yourself an unruly woman?

I consider myself unruly, yes. [*Laughs.*] I act on my needs and my desires to make sure I am comfortable. I remember a particular trip in India. My ammama and I were on a bus, traveling to Agra, and we got stuck in traffic for *hours* because of flooding. As cows and goats sloshed by, I started to panic because my tampon had started to leak. I couldn't wait to change it, so I had my ammama wrap one of her saris around me and I changed my tampon on the bus, surrounded by strangers. South Asian women are always portrayed as subdued background characters, when in fact, women in India have always been protesters and fighters. I want history to remember me as someone who is unafraid to cry in public *and* as someone who is unafraid to speak out against injustice. I am a multifaceted woman and I can have it all.

Lafayette Avenue station
Brooklyn, 2020

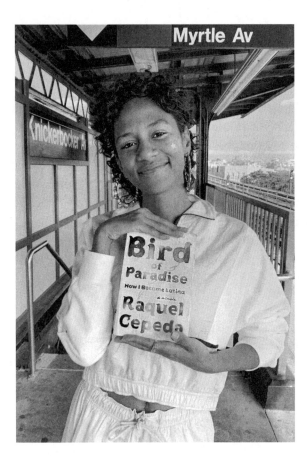

Djali Alessandra Brown-Cepeda

Bird of Paradise
by Raquel Cepeda

A *djali* is a griot, someone who passes down their village's oral history through song, poetry, and prose. I think it's safe to say that I'm pretty much a living embodiment of my name. [*Laughs.*] I'm the founder of Nuevayorkinos, a digital archive dedicated to documenting and preserving

Latinx history and culture in New York City. There are many cultural archival projects out there, like hip-hop and vintage fashion archives, but I felt we needed more Latinx representation, and as a Black Latina in New York City, I want to create a safe space where dialogue is encouraged and decolonization is prioritized.

How can we properly move through history, physically speaking?

Humans are migratory by nature and there's nothing wrong with moving. The problem with gentrification is that it's colonization reincarnated. It's the "I came, I saw, I conquered" spirit, which is perpetuated in all communities of color that fall victim to gentrification. Similar to our ancestors, who saw ships arrive at their shores, when we see white people move into our neighborhoods, it almost feels prophetic. We know we may not be there for much longer.

Let's talk about how we can treat a neighborhood responsibly.

Okay! Step 1: Understand that you're an outsider. Don't expect to be embraced with open arms and know that your presence is often triggering. Step 2: Take accountability for your actions. When you cross a line, own up to it. Step 3: Recognize your privilege. This is something that many white people have difficulty with. Think of ways you can leverage your privilege to amplify, support, and uplift the existing community. Do this out of a genuine desire to sustain a healthy ecosystem, not because of a white savior complex, which is both boring and unhelpful. Step 4: Do the work. Research ways to contribute and meet with community organizers. And stop calling the cops on people playing dominoes because you think you hear gunshots. We are jovial! We're bright! Learn the nuances of the communities that have existed before you and that are not there to exist for you.

Thank you for the best "how to exist" ever. What does this book mean to you?

This is actually a memoir by my mother, Raquel Cepeda. She's been a writer for as long as I can remember, and she even read her work to me when I was a baby. She started out as a music journalist for the *Village*

Voice and then wrote for several publications about uptown in the '80s, the birth of hip-hop, and systemic racism. What I love about this book is that all its heroes, save a handful, are Black, Latinx, and marginalized. That's very rare. Her memoir really helped me to understand my mother as a woman and as Raquel, before becoming my mother. When you learn what people you love have gone through, it can be very difficult, but it also makes you realize they're strong-ass people. My mom taught me to be independent and that I have power within me. I am definitely my mother's daughter. [*Laughs.*]

Bird of Paradise is such a beautiful title.

Bird-of-paradise flowers are gorgeous. They're larger than life. They're exuberant. That's what it means to be Black, what it means to be Latina, what it means to be an immigrant, and what it means to be a New Yorker. My mother found herself through hardships and struggles, but she came out of it beautiful, joyous, brilliant, and ever-reaching, like a bird-of-paradise. That's the message for people who've been taught for generations that we are nothing, for people who have been kept down, for people who have had laws and policies enacted against them, for people who can't breathe in this society. It is important that we always reach up, as it is written on our New York state flag: Excelsior. Ever upward. That's us.

Knickerbocker Avenue station
Brooklyn

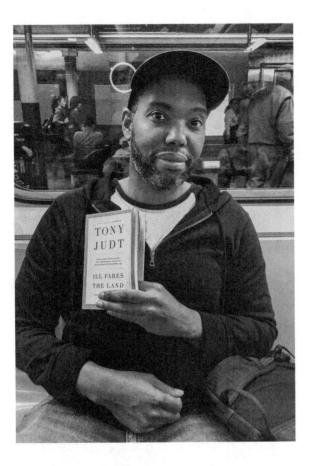

Ta-Nehisi Coates

Ill Fares the Land by Tony Judt

Tony Judt was a historian who died in 2010. He was a huge inspiration to my work, and this is a book of his I haven't read yet. He was not nostalgic about the past. A lot of intellectuals are pushed to find a solution that makes everybody feel good, but Tony didn't soften things for you. There are things he says that I don't agree with, but I really love his searching mind.

6 Train
Manhattan, 2018

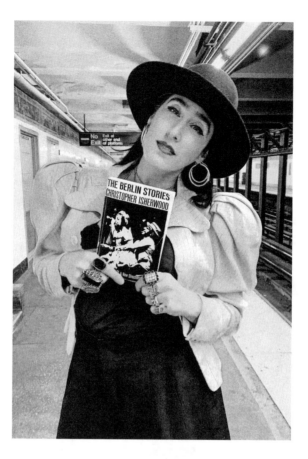

Ladyfag

The Berlin Stories
by Christopher Isherwood

I'm one of the people who keeps New York City dancing. Nightlife is a really important part of cities. I just saw the Studio 54 exhibit at the Brooklyn Museum and it was incredible. Obviously, it's an iconic club, but the memorabilia, costumes, and music were so inspiring. Seeing it was a reminder that nightlife is about freedom. When people go out, they're looking for something. They're looking to celebrate, or to find joy, or to

have a naughty night—either way, people go out to express themselves and to join in sharing collective energy. It's about the vibe.

You're a steward of the vibe! What's the most important thing about keeping the vibe alive?

Maybe I should have a business card that says vibes manager, because that's basically what I do when I throw parties! [*Laughs.*] It's sort of like a scientific experiment, where I throw everything I know into a petri dish, but after that, I can't control what happens. A party isn't a finished product. You're creating it together, in real time. That's part of the magic.

How did this book come into your life?

I first read *The Berlin Stories* when I was much younger and coming out as queer. I wanted to absorb everything about drag and nightlife. The second time I read it was when I moved from Toronto to New York. This is my third time reading it. It's about Berlin in the early '30s, the height of night-life and cabaret culture, and also the time of Hitler's rise to power. With the election coming so close to destroying our country, I felt like reading it again.

When was the last time you were at a really fabulous party?

The last time I really danced and experienced collective joy was the night of the 2020 election, the day Trump got kicked out of office. I was in Washington Square Park and New York was going *off*. Is there any better feeling than dancing with the whole city you love?

Graham Avenue station
Brooklyn, 2020

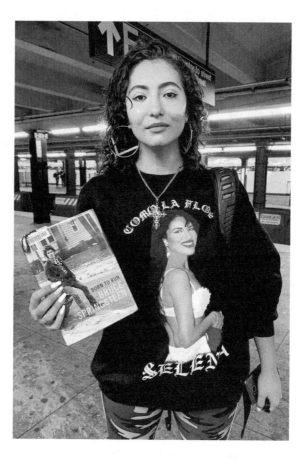

Isabela Martinez

Born to Run
by Bruce Springsteen

I was fifteen when I listened to the album *Born to Run* for the first time and I have absolutely loved it ever since. I was really into VH1, and they played all of those great '80s music specials. I try not to limit myself to one genre or one specific artist. I think it's important to get to know a lot of different musicians. I remember listening to the song "Born to Run" for the first time and I thought that the words were so beautiful—they spoke

to me, it was very touching. Reading about Bruce Springsteen makes me understand how hard he has worked his entire life and that he puts his heart and soul into everything he does. That makes me want to try harder, regardless of what I'm doing. I think life feels totally different when you have passion.

West 4th Street–Washington Square station
Manhattan, 2019

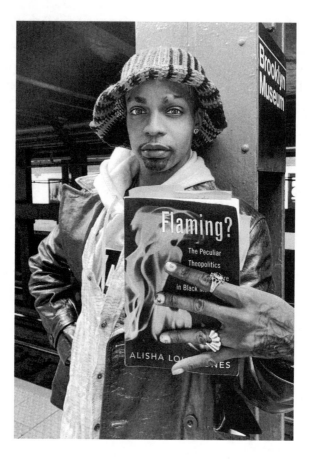

Ian Isiah

*Flaming?: The Peculiar Theopolitics of Fire and Desire
in Black Male Gospel Performance* by Alisha Lola Jones

Hello world! It's Ian Isiah, aka SHUGGA, because I'm street but sweet. I'm hanging out at the Eastern Parkway–Brooklyn Museum station where the 2, 4, and 3 trains come to par-tay. Back in the day, the 3 train would take me all the way to Rockaway Avenue in Brownsville, where my church is, and I would meet up with my family, who is so adamant about being on time that they would take the car instead of waiting on me and

these trains. How I got there didn't matter, because I had a goal: to sing and perform at my church. It's in the middle of the projects and it's a really cool spot. Besides that, I grew up in a house with a bunch of musicians and preachers. By age three I was playing the pots and pans, trying to drum for my grandmother who sang hymns while washing dishes. Two years later, I ended up playing the drums in church, and then I joined the choir, which I eventually led. And it all started with the 3 train. [*Laughs.*]

What kind of universe is New York for you?

New York City is the crazy glue that holds every part of my body together. New York is the attitude of everything and it has taught me everything. I come from my mother, a preacher who had sex with a Rastafarian, and now I'm alive. This book is insane and I swear it's about me. I've never seen a book that is about being a flamboyant homosexual in the Black church before.

Many famous singers and musicians get their start at their church.

Yes, there's a huge culture in the Black church of utilizing and developing homosexuals for their abilities and gifts only to deny them within the church later. You're dying in faith, but you're growing in talent. Still, so many icons come out of the church. Tonéx, who I love so much, Andraé Edward Crouch, and Richard Smallwood, whose family gave us what we now call live gospel, which started in Black churches and was led by homosexuals. I'm very strong and confident in my faith, but I'm also very strong and confident in my sexuality. I realized that my faith didn't have to get diminished because of it. If anything, it grew, because I am learning from my forefathers.

You're perched on the intersection of culture, music, fashion, and design. What do you find there?

Believe it or not, this station is three minutes from my office at Hood By Air, which was founded by Shayne Oliver, my best friend. Shayne, our mother of the house, had a big dream, and he persuaded me to understand

that Hood By Air was more than fashion. It was a culture shift. That's what I live for, culture shifting, culture reviving, and culture enhancement. The challenge is that now many are manifesting without humility, which will lead to their downfall. There is a university within your mind and you have to take many courses to develop as an artist.

Is making music different from being a designer?

Music unifies. The musician's job is to move us forward in unity. We can all sing together and make one sound. Music is no other thing but unity. We don't have control over the weather, or geology, or science. But we're blessed to have control over music.

**Eastern Parkway–Brooklyn Museum station
Brooklyn, 2020**

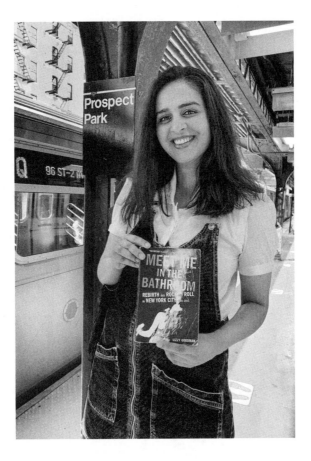

Anupa Otiv

*Meet Me in the Bathroom: Rebirth and Rock and
Roll in New York City 2001–2011* by Lizzy Goodman

The second I got an iPod my older brother Aditya was in charge of it.
The first playlist he made for me had "Airbag" by Radiohead and
"Where Is My Mind" by the Pixies on it. It will come as no surprise that
this book belongs to my brother. [*Laughs.*] I feel like he is metaphorically
updating my iPod once again with *Meet Me in the Bathroom*, which is a
collection of interviews with iconic people in the New York music scene,

like producers, musicians, journalists, and club owners. It's interesting to read about the city right around 9/11. Somehow, through all that chaos, these bands and musicians kept going. It exemplifies the New York spirit of doing the best you can.

Did your brother bestow you with other cultural activities?

I'm a comedy writer and feel like I get that from my brother in some ways. When I was eighteen, he curated a tour of stand-up comedy shows for us and we went to see Marc Maron at Le Poisson Rouge in the Village. Maron was taping his comedy special *Thinky Pain*. Throughout the whole show, you can see my brother and me, with my blunt Bettie Page bangs, sitting in the front row. We're forever preserved in Netflix history looking ridiculous, feeling so cool.

Prospect Park station
Brooklyn, 2020

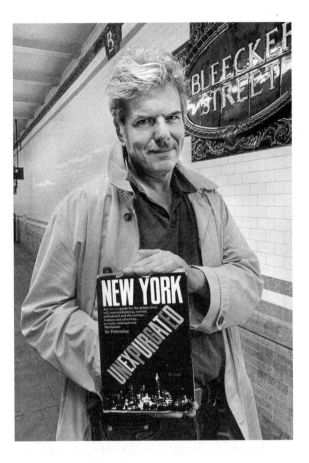

Chris Lombardi

New York Unexpurgated by Petronius

M y brother and I shared a bedroom and we fought all the time. Eventually, my parents moved me into the "library," which was the den with all the books. That's where I found my dad's copy of *New York Unexpurgated*. Being born in Manhattan, my dad was a little bit of a libertine, a little bit pre-hippie, a little bit repressed, but he also liked to find trouble in his own way. [*Laughs.*] *New York Unexpurgated* is a guide that pokes fun at the endless possibilities the city has to offer. It lists coffee shops where you can buy marijuana from waitresses and tells you how to pay off

a cop if you get in trouble for having sex in a bathroom. It made me want to find out what was underneath the city.

What did you find underneath the city?

I grew up during a pretty wild time in New York and I was turned on by music. People were creating art in unconventional ways and were expressing themselves through their emotions and style. It was an in-your-face kind of place. I had a job at a record distributor for a few months and I thought that I could document what was going on in music myself, so I released some 7-inch singles. That turned into signing artists, like Superchunk and the Dustdevils. Next thing I knew, I had a record label and needed a name for it. I had just seen Pedro Almodóvar's movie *Matador* at Film Forum on Watts Street and had picked up a bullfighting music record at the Chelsea flea market for twenty-five cents. I thought Matador Records had a good ring to it.

Is there a moment at Matador Records that you'll remember forever?

I've always loved a good juxtaposition. In the early days we'd go to meetings at Atlantic Records when Ahmet Ertegun was still there. We were twenty-four-year-old kids smoking cigarettes on the thirty-second floor of Rockefeller Center with guys in three-piece suits smoking actual pipes. It was a strange clash visually and it was also strange that the music that we found appealing had become a mainstream commodity.

What made people want to listen to outsiders at that point in time?

Music was homemade then, less produced, and still random in discovery. We were all very fearful of "selling out" back then. Once you succeeded, you were "outside the outside" and your credibility was lost. Now people aspire to sell out, which I don't think is very interesting. I think homemade art is one of the only worthy pursuits of your time and money. You have to go to the source to get the ultimate, unexpurgated experience.

Bleecker Street station
Manhattan, 2020

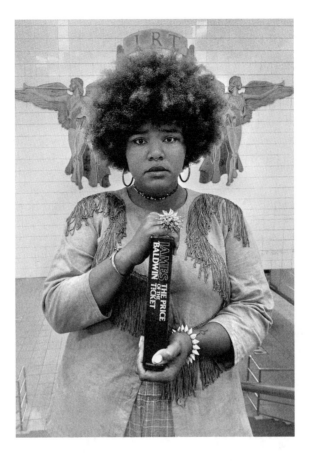

Amyra León

The Price of the Ticket
by James Baldwin

Music is my source of catharsis. I'm a musician, activist, author, educator, and a New York native. I'm building a universe where we can safely look at our wounds and heal together. As a young person, I used to run amok in these streets, writing plays at the piers and putting them up in Midtown. Everything was music, everything was poetry, everything was a stage.

Does New York appeal to your senses in a particular way?

The sonic landscape of New York City is very specific. As a musician, I recognize the synchronicity of the city more than anything. You hear the birds singing, the leaves moving, the train is coming, and you feel your heartbeat. Breeding silence in this city is a personal accountability to oneself. Even at home you still hear the world outside. Everything else in this city may disappear, but the myriad sounds will never be diminished.

This book is called *The Price of the Ticket*. What's in that title for you?

This book means everything to me. It's a reminder to be accountable to my ability to tell stories and to ignite change. James Baldwin was a creator in an era when the boiling point kept rising, and he paints such a clear picture of how his skin was received in the world. You cannot walk into a single James Baldwin experience without being confronted with yourself. It's important to see yourself and also to recognize the people around you, whether you know them personally or not. James, Nina, Billie, Martin, Malcolm, Kwame Ture—they all knew each other, and they're part of my community, too.

What is at the center of all the ways you share your voice?

I follow my words. If the message must be housed in music, then I will sing it. If the message must be consumed in the privacy of your mind, I will write it. If the message must be felt, I will perform a play. If the message must bring you closer to me, I will make a film. I occupy different mediums to help people find their unique entry point. People from all over the world digest my work. They're weeping, they're laughing, and they're healing with me, beyond the limitation of language.

A high level of care always vibrates differently.

Honest emotion can always be felt. Many artists aim to create what they are told people want to hear. That is a disservice to reality. To make a Top 40 hit requires that you create something that purposefully breeds temporary

satisfaction. I pray that will change in our culture because the ephemeral nature of it will leave us constantly dissatisfied.

A "hit" is quick. It hits you and then dissipates.

Yes, I think a certain level of honesty is necessary in creating lasting work and change. If you're looking to understand what's happening now, read the reflections of people who have lived through this before. Baldwin's essays have saved, ignited, and invited me to become a more transparent creator. Dive into the work, y'all.

Grand Army Plaza station
Brooklyn, 2020

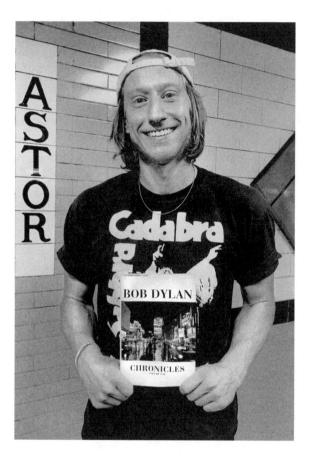

Timothy Goodman

Chronicles: Volume One by Bob Dylan

I'm a Cancer-Gemini cusp, Capricorn rising, Scorpio moon, and all of my favorite artists are Geminis. I think this is easily the fifth time I've read Bob Dylan's *Chronicles*. Bob is of course a Gemini.

How would you describe a typical Gemini?

Being a Gemini means that you get bored easily, so you need stimulation. That's why I draw, write, and conduct social experiments. For me,

the greatest joy about being a designer is to connect with another human through my work. Bob Dylan is in his tenth incarnation as a musician. He had three careers in the '60s alone—folk, electric, and then there was that whole thing where he became the voice of a generation with "Blowing in the Wind." But for a while, he didn't know who he was or what he was doing. He talks about it in this book, which is super esoteric.

Where would you have run into Bob in the city back then?

Oh, we would have met at the West 4th Street basketball court. Living nearby still feels like a dream. I always wonder what it was like in the '60s—how it felt and smelled, and what the food tasted like. I think about the beatniks, the poets, and the musicians. Yes, I romanticize the hell out of it. [*Laughs.*] I like to remember beginnings, like my own, painting homes in Cleveland making $8 an hour, pulling buckets of wallpaper glue up the stairs.

What do you get from revisiting a beginning?

It's humbling. I have a friend named Les who is sixty-eight years old. He's lived here all his life and comes from another world. Les also *is* the world, he's one with everything and a really special guy. Everything and nothing is funny to him, and you can feel all the years in his voice and in his hands. I think I want to be a combination of Les, Bob Dylan, and Quincy Jones when I'm an old man.

**Astor Place station
Manhattan, 2020**

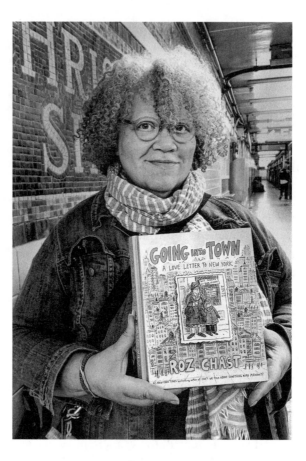

Gail Anderson

*Going Into Town: A Love Letter
to New York* by Roz Chast

There was a spot around the corner from my apartment in the West Village, Hudson Diner, that closed down a few years ago. I had my order—a grilled cheese, fries, and a Coke with ice and no straw—and my favorite booth. It was nice to have a place where someone remembers that you require a little extra ketchup.

How does it feel to be seen among millions?

It makes me feel like I actually cast a shadow. [*Laughs.*] I'm fortunate to have my design work seen in the city where I grew up. When I see my work at a newsstand, or on a marquee in Times Square, or on a subway poster, I feel incredibly lucky to be part of the city in that way.

Do you have a favorite diner anecdote?

I had lunch at a diner with Milton Glaser several times during the last years of his life. He was very sweet to me because we're both from the Bronx. Milton is the design hero behind the *I* ❤ *NY* logo, he was a founder of *New York* magazine, and he is the definition of a legend, period. His passing created a real void, and there isn't a New Yorker who wasn't touched by his genius, unknowingly or knowingly. I mean, who hasn't picked up an *I* ❤ *NY* souvenir? Milton gave that logo to the city and he never made a penny off it. He was the ultimate New Yorker.

Does *Going Into Town* reflect your New York experience?

Oh yes! Roz Chast wrote this book for her kids about the city. It is ha-ha-funny and dead-on accurate. Roz is a cartoonist for the *New Yorker*. Her wit and her humor are everything I love, maybe because we're around the same age. If you have a guest coming to visit, or a child moving to the city, or if you've been here all your life, get a copy to have a chuckle and feel wistful.

What would you say in a love letter to New York?

Dear New York, please—no more mice in my apartment. Thank you for everything else. Love, Gail.

Christopher Street–Sheridan Square station
Manhattan, 2020

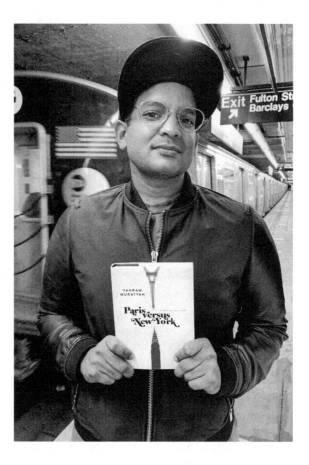

Rajiv Fernandez

Paris versus New York:
A Tally of Two Cities by Vahram Muratyan

As a Brown boy from Nebraska with a funny name, conforming to a single profession is foreign to me. [*Laughs.*] I'm an illustrator, an architect, and a comedian. I love that *Paris versus New York* visually emphasizes how different our cities are, yet there is a commonality among us. The bold imagery playfully compares Paris with its baguettes, the Eiffel Tower, and bobos to New York with its bagels, the Statue of Liberty, and hipsters.

What qualifies something as "good" design?

Good design is not just meant to please the eye. It's meant to spark interesting dialogue. New York is the diversity capital of the world and it shows in the vast array of designers with totally different sensibilities that clash and coexist here, from Times Square to Brooklyn.

Lafayette Avenue station
Brooklyn, 2017

Melissa Braxton

Happy City
by Charles Montgomery

W hat do I think makes a city happy? Diversity of everything! This book is about urban design and I'm an architect, so the topic interests me. *Happy City* shows how little things affect our lives so deeply. For example, commuting in a car versus taking a train has a big effect on our happiness, but a huge amount of money goes into street infrastructure and much less goes to public transportation. I lived in Copenhagen for a while, and they held a town meeting to decide on the design of a manhole. Can you imagine? [*Laughs.*] I don't think that would work in the United States but it's certainly interesting to think about what we could be doing differently here with better design.

**Clinton–Washington Avenues station
Brooklyn, 2015**

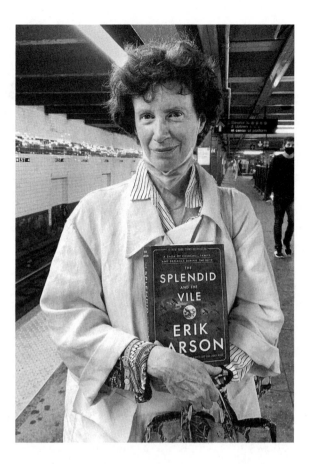

Wendy Goodman

The Splendid and the Vile
by Erik Larson

W hen you go into someone's home, you immediately know a whole number of things about that person. You see their discipline. You know what books they read or that they don't read—a house without books is a very sad place. You understand if they have beautiful things and if they take care of those beautiful things. The most important thing you understand is their passion. As a design editor, I go into many different homes and I'm

very sensitive to smell. I smell if it's fresh, if they burn incense, if they cook. I love the life of places.

Is there a place you'll remember forever because it was so special?

The apartment of photographer Richard Avedon comes to mind. It thrilled me beyond anything. All of the walls were made of bulletin boards and he could stick anything on them with a thumbtack. I thought that was so cool and easy. I also love that his library had a collection of every Proust translation ever done. Avedon was obsessed with Proust.

What a dream. Are you obsessed with this book?

I have not been able to put it down! It's about World War II, specifically the time in England when Churchill was prime minister. The Nazis thought that if they executed a Blitzkrieg, the British would surrender and they could move in. Because Churchill was an extraordinary leader, the British endured. One person can bring about great confidence during a time of great suffering.

Does it give you thoughts on why it's important not to surrender?

Absolutely. It shows that people have much more courage and strength than they give themselves credit for. It's very powerful to endure things you didn't think you could. Right now, we're watching old ways die and we might not know what that new way is yet. The miracle of healing and having the courage to keep going is crucial, however. That's the thing to remember: nothing ventured, nothing gained. Your curiosity will get you everywhere.

West 4th Street–Washington Square station
Manhattan, 2020

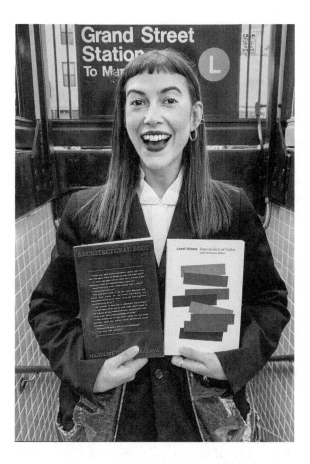

Leta Sobierajski

Architectural Body
by Madeline Gins

My entire life revolves around color. My husband and I are intrigued by a couple called Shusaku Arakawa and Madeline Gins. Arakawa was an architect and Gins was a poet. They thought of the body as a piece of architecture that needs constant stimulation and should be tricked into being uncomfortable. They built these really unusual houses. I went to Long Island to see one a couple of weeks ago and when you walk inside,

the floor is bumpy and all of the walls are different colors. The space makes you feel childlike, alert, and curious. We've added as much color to every surface in our Brooklyn apartment as possible as an homage to this couple.

What did your apartment look like before?

Our home used to be a clean white space, because I was convinced that minimalism was my way of life. But in the last couple of years, I've realized that I don't actually associate with a white room anymore. Now every wall in our apartment is a different color: pink, red, yellow, dark blue, apple green, orange—every hue of the rainbow. We're renters and our landlord is going to be *so* surprised if we ever move out. [*Laughs.*]

That deposit is not coming back. Do we all see color the same way?

Not at all! Color is a very personal experience, and how you see it is influenced by what's around it and what you're juxtaposing next to it. How you see color can even depend on your mood. If you see something as blue and I see it as green, we're both right. Some people say that black and white are not colors, but I don't think that's true because in printing, black has every color in it and white is void of everything.

This is fantastic. If none of us see the same color, what is the purpose of color?

Color is a vessel for joy! Even if we all perceive color differently it still evokes emotion about the world around you. Seeing color is kind of like hearing a song. You might be more attuned to listening to the trumpet, another person might be more into the flute. You each enjoy it for different reasons, but you still have an experience together.

Grand Street station
Brooklyn, 2020

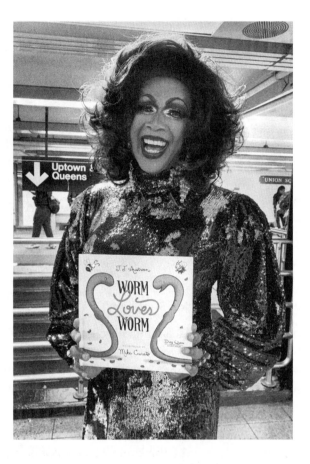

Harmonica Sunbeam

Worm Loves Worm by J. J. Austrian,
illustrated by Mike Curato

When I take the train, I get one of two reactions: a nice compliment or an ugly look. What would make you frown at something so fabulous? I just made your day more interesting, honey! Nothing else was going on until I walked into that subway car. [*Laughs.*]

Where are you going in this fabulous purple sequin gown?

I'm a storyteller for Drag Queen Story Hour. We read books to children to let them know that everybody is different but that we're all special. I always wear something bright and sparkly because if I can't catch their attention with the book at least I give them something to look at. You want your first experience meeting a drag queen something to be remembered. Today, I read at a public school in the East Village, and this is one of my favorite books. It's about two worms who are in love and want to get married. They face obstacles from other animals who say, "You need rings." And the worms say, "We don't have fingers, we can't wear rings." Another animal says, "You should wear the rings as belts!" Someone always tells the worms what to do, but the worms say, "This is how *we* are doing it!" In the end, they get married because love is love.

How did you become Harmonica Sunbeam?

In high school, my name was Macadamia Serendipity because I like macadamia nuts, but that was too lengthy for a marquee, so I went with Tequila Sunrise and eventually that morphed into Harmonica Sunbeam. If you get the chance to make up a name, you really want to be the only one. Like Cher. I did drag for the first time when I was nineteen and got involved with the ballroom scene. The category of my first ball was "Butch Queen First Time in Drag at a Ball." My house members put me together—hair, shoes, nails, makeup—and all I had to do was go out and present. I did, and years later people are still bitter that I won. [*Laughs.*] I was a member of the House of Adonis and eventually became the mother of that house. We were a relatively small house, and we didn't live together, but we would gather often and that's what made us a family. Now I have one daughter and a cat. Even though I'm no longer active in the ballroom scene, it's still a big part of me and it shows in my performances. That's where I got my start, and I will always bring a little bit of ballroom with me.

I bet that a little bit of ballroom makes life much better.

Yes, it does! As drag queens, we have this situation where people fall in love with what they see. I have to tell them that I don't always look this

way. I want you to appreciate what I do, but I want you to love me for who I am. This may be a fantasy for you, but it is not for me. I used to be really shy and I would not parade around halfway ready with my face painted and my boy clothes on. [*Laughs.*] Now I feel confident to say, "I am who I am." We only get one life. We can't live for other people. We have to live for ourselves in order to get the happiness we deserve.

14th Street–Union Square station
Manhattan, 2019

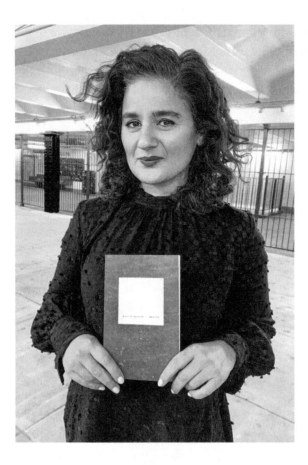

Naz Riahi

Bluets by Maggie Nelson

I always wonder why we ask kids about their favorite color, but not adults. Maybe we associate colors and vibrancy with childhood. I was raised in Iran until I was ten, and I remember the colorfulness of the natural world, starting with our small orchard. We had cherries, peaches, and other kinds of fruit trees. Inside, my mother hung green drapes and our white couches had green leaves on the upholstery. I had sheets with rainbow hearts on them. But black was the chicest color in Iran.

It's a blue day. You hold *Bluets* in your hands.

This is my favorite Maggie Nelson book. It's a memoir about a man she was madly in love with and her love for the color blue, which has come to represent him. It's some of the most stunning, breathtaking prose. I fell in love with someone a few years ago the way Maggie fell in love with this man, and I try to envision him as a color now, but I really can't. One of my favorite sentences in *Bluets* is "Perhaps in time, I will also stop missing you." It's so simple and it runs through my mind over and over again. I did stop missing him. I think. Most of the time. But there is so much else I miss. I miss Iran, that colorful orchard, our house, and everything else that's gone. There's such sadness in no longer missing something you once loved.

Lafayette Avenue station
Brooklyn, 2020

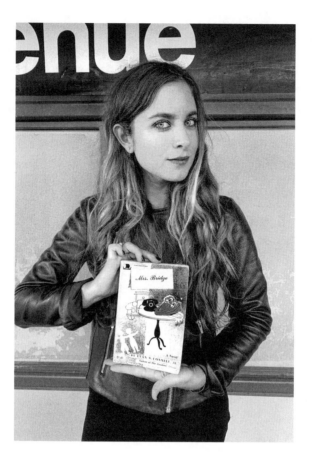

Molly Beth Young

Mrs. Bridge
by Evan S. Connell

T his book reminds me of people who smoke cigarettes and need a pack in all of their favorite places. One in the glove compartment, one on the desk, one on the bedside table. I have multiple copies of *Mrs. Bridge* all over the place and I have reread it every year since 2012. It's about a suburban matron in Kansas City who struggles with a sense of futility and frustration. She represents a particular, somewhat lost, middle-class,

Midwestern person who seems entirely unrelatable, and yet her experiences and feelings are so beautifully, tangibly represented. It makes me think of the time I found a cheap ticket and went to Iceland. There was a cafe in Reykjavík that sold rye bread ice cream and I was like, "That sounds disgusting. I'll have two." It was amazing! This book is composed of ingredients that don't sound promising, and yet when combined they form an unforgettable artifact.

It is immediately apparent that you are a person who really loves words.

Yes [*laughs*], and as a crossword puzzle writer I should really keep a list of words I love. I'm curious if they have anything in common phonetically or letter-wise. My younger brother has synesthesia. It's a condition where different senses overlap. For him, each letter in the alphabet is associated with a specific color and when he opens a book every word is colorful. He told me that *M* is magenta. Vladimir Nabokov and Mary J. Blige have synesthesia, according to Wikipedia. I feel like I have the much less sexy version of it, where I have a concrete sensory affiliation with words. Reading gives me a physical sensation that I'm drawn to, like eating or sleeping. That makes me sound like such a pervert. [*Laughs.*]

You make crossword puzzles. You are definitely a perv.

It's so satisfying to make one! It's like baking a beautiful cake or what I imagine giving birth to a human is like, although less sublime. You get to create something that is a perfect, self-contained entity, works in every direction, has 180-degree rotational symmetry, and can be enjoyed by other people. Like a baby, a crossword puzzle is very satisfying.

Marcy Avenue station
Brooklyn, 2019

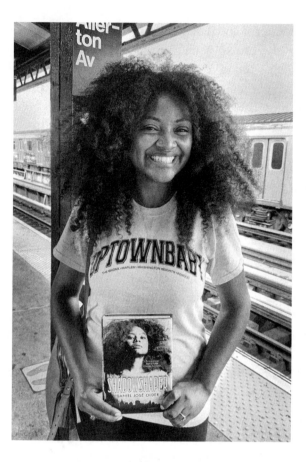

Saraciea Fennell

Shadowshaper by Daniel José Older

I was a total nerd in high school. I definitely rode the train holding a basketball while reading a book. [*Laughs.*] I remember getting off at this station after I had just joined the basketball team at Jane Addams Vocational High School. I played my sophomore and junior year and I wasn't any good, but it was tons of fun. I remember losing a major game the same day my family had moved from the South Bronx to the North Bronx. I was in my feelings because we lost and also about this new chapter in my life—I hadn't even decorated my room yet.

It sounds like you got the best of both worlds in terms of the location.

Definitely. I feel like both places have taught me to be a resilient young Black Latina woman. People see the Bronx as the underdog, but the Bronx has a deep history. We have the Edgar Allan Poe Cottage, Stan Lee went to high school here, Mark Twain lived here for a little bit, and James Baldwin grew up in Harlem, but he would cross the bridge to buy stale bread for his siblings in the Bronx. We have some literary gold mines here. That's why I started The Bronx is Reading, a book festival that honors our literary ancestors and future literary legends.

Speaking of literary ancestors, tell me about the book you're reading.

Shadowshaper is amazing. I have big, bushy, wild curls and this was the first cover I saw with a beautiful Black woman on it who has a head full of hair. The story melts together activism and art while tackling anti-Blackness in the Latinx community. I have a lot of conversations about this with my immediate family because we all have different shades of brown skin and some of us are white passing. There's a part in the book where the aunt of the main character, Sierra, tells her to not go in the sun and that she should strive to be the color of the bottom of her foot. But Sierra doesn't care. I'm a bold person, but I wish I had as much confidence as Sierra when I was a teen. She stands up and says, "I love the person I am."

Do you have thoughts on what it means to belong to a place?

When you belong to a place, you should treat it like you treat your body. You own all of the deepest parts of yourself, you know what you like, you know what you don't like. When you belong to a community, you have to know what's good, what's bad, and then figure out how to enrich it. Nine times out of ten, people from this area didn't like it here, so they left. I'm trying to live up to the ideals that I'm fighting for, and I'm trying to lift up others as I climb. It may take me longer to get to the top, but there will be thousands of my people right behind me.

Allerton Avenue station
Bronx, 2020

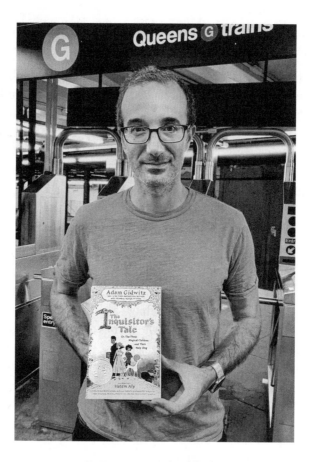

Jad Abumrad

The Inquisitor's Tale
by Adam Gidwitz

Every block is its own universe in New York City and every subway train has a special feeling. I spent the first ten years of my life waiting for the G train. Hearing it leave the station before you got there was the sound of life passing you by—you knew you were stuck in that tunnel for another thirty to forty minutes. One time, I had just swiped my Metro-Card, I heard the train pulling in, and I started sprinting—I'm talking a full

sprint—down the steps, skipping every third step, running toward the train as it slowly pulled away. I happened to have a grapefruit in my hand, and I was so upset, I hurled the grapefruit at the G train. It went splat, right on the conductor's window. He looked at me with a smile on his face as he pulled away and disappeared into the darkness. I think he understood. After that I shifted my allegiance to the C train, which, too, has done nothing for me, but I love it. I think it might be its blue color.

There must be some kind of color theory at play.

I've never thought about it, but I definitely have strong feelings about the red line. If you ever end up on the 1 train, just pray for a bolt of lightning to take you out of your misery. It stops so often you're better off walking. The B, D, F, M trains look a bit burnt and like they have bleak futures—that's what the orange says to me. I love the Q train most. As a new dad, I'd take my kids on the Q train and we'd ride it one way and back. It never stops and suddenly you're in Connecticut, it's amazing. [*Laughs.*] My kids love the subway and its chicken-size rats.

The book you have with you looks like one children would love.

If no one had ever told me it was a kids' book, I still would have enjoyed it deeply without question. It's set in France during the Dark Ages and about an inquisitor who is looking for stories. One by one, people show up at this inn and tell him about three kids who seem to be saints. One of them is a little girl who has seizures and visions of the future, another is a giant Muslim boy from North Africa with superhuman strength, and the third is a young Jewish kid who can heal people. During the pandemic shutdowns, New York felt like it had survived an apocalypse. There were wall-to-wall sirens all day and night long while I reported on the pandemic for *Radiolab*. I was up to my eyeballs in this new plague that seemed so horrible and dark. It was really good to sit with my son at night and read about another dark time that was still full of life and energy.

I immediately think of you as the inquisitor, given your work.

It's true. My job is very much like being the guy at the inn who says, "Come sit at the table and tell me a story." I think the act of reading the story aloud did make me identify with the most flawed character in the book, the inquisitor. His voice was so intoxicating and *so* fun to read. He wants to know everything about these kids, but we don't know why. All we know is that he has bad intentions. But when he starts to engage with the kids, he falls under their spell because they are so pure, unpolluted by dogma and belief. He is reformed by their very presence.

Appreciation of presence is what we need!

I think the antidote to everything wrong in the world is having curiosity about one another. If we shut ourselves off from the questions that allow us to get even a little bit closer to one another, we become trapped in our solitude. What will heal society is asking: "What is it like to be you?" And then we have to keep asking weird and awkward questions, the kind that make you clamp your hand over your mouth like you're a little kid. Those questions will get us there.

**Fulton Street station
Brooklyn, 2020**

Céline Semaan

The Politics of Dispossession
by Edward W. Said

O ftentimes asking questions is seen as nosy or rude. I've always asked a lot of questions. Every child asks, "Why, why, why?" until they are satisfied with the answer, but we tend to brush them aside. Instead, we could say, "I don't know, let's find out." That gesture fosters and nourishes the mind. As a designer, it's my job to ask a lot of questions because without understanding what we are designing, there's no point to it.

We also have to ask ourselves how we want to live.

Absolutely. I work at the intersection of human rights and environmental justice as the executive director and cofounder of Slow Factory, where we offer free programs for unlearning. Today is Indigenous Peoples' Day. I encourage us to acknowledge that this country was founded on stolen land that belonged to Indigenous people since the beginning of time and that it was built with the forced labor of Indigenous Africans who were enslaved by European settlers. Millions of Native people lived here before the Europeans arrived. Meanwhile, Indigenous knowledge allows us to coexist on this planet with harmony, yet how we address climate change and the environment is very much rooted in the idea of colonialism and land dispossession.

Is there a book that connects you to this land?

Growing up as a refugee, I have always struggled with the notion of home and belonging. It was only when I arrived in New York that I felt like I

found my place. I think in a way, New York can belong to everyone. The author that really connects me to this city is Edward W. Said, a scholar, polymath, and literary critic. He taught at Columbia University and died in New York at age sixty-seven. He wrote several books that helped define postcolonialism and the anti-colonial mindset. *The Politics of Dispossession* asks the question, "Where do you come from?"

To start with the end in mind can be a good idea.

Well, if we want to look at the way nature functions, nothing really ends or dies. Everything is regenerated. If a leaf falls on the ground, it gets absorbed by the soil and turns into nutrients. The environment's cycle is nonlinear. The opposite idea can be traced back to white supremacy and to the concept of sitting on top of a triangle, where the world is at your service and everything can be used and discarded. Sustainability is a culture. It's not something you can buy or borrow. It's very much about how you decide to live.

Phone interview, 2020

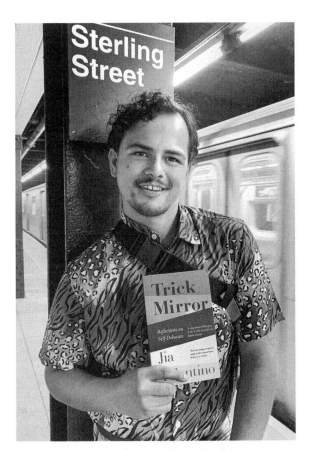

Ron Sese

Trick Mirror: Reflections on
Self-Delusion by Jia Tolentino

A lot of people think that the hood is a dangerous place, and while that may be true, there is also a lot of culture and beauty in our community. It's taken me a long time to realize that and now I appreciate it deeply. I grew up in East Los Angeles, in a town called La Fuente that was a gang-run Chicano barrio. It wasn't always easy. I'm queer and my dad didn't agree with that. He felt like it was a choice. In retrospect, I can say that if

someone thinks sexuality is a choice, they probably feel that way because they haven't asked themselves the right questions about their own sexuality and might be hiding their true self.

Do you feel like you know your true self?

I do. Both parents who raised me are Filipino, and you could say that I'm the product of pro-life propaganda because my dad is not my biological dad. My mom was assaulted at a party and as a result of that I was brought into the world. When my mom first told me, I became really curious about doing a DNA test—you could not have convinced me that I wasn't *only* Filipino and Chicano. [*Laughs.*] My DNA results came back on my thirtieth birthday, and I entered a new decade with a new set of information. Turns out that I'm also Lebanese and Syrian! I think it's really beautiful that there are entirely new cultures I get to explore.

Ron, that's wild. And hard. And amazing.

Isn't it? I've always felt strongly about learning my personal history and choosing my family. Before New York, I moved to San Francisco and worked at an HIV clinic, where I met my late adoptive mother. She was a boisterous, Native Hawaiian trans woman who adopted me informally in the *hānai* tradition. I was nineteen, alone, and couldn't make ends meet. She would invite me over to eat with her and her husband. They tethered me and satisfied a deep desire within me. There's a tradition of queer people looking out for other queer people and I think it's because of the amount of strife that trans people, queer people, and drag queens experience. It gives us compassion and empathy—especially toward each other.

Life is all about bringing awareness to our responsibility for each other.

Yes, make an effort to check yourself. I highly recommend *Trick Mirror* for that—Jia, if you're listening, I really love your book! It's a dissection of the personas and presentations we curate that are not our realized self. As millennials, we've been given the tools and are taught to capitalize on those personas. 2019 was toxic for me because I became obsessed with my

engagement and posting content all the time. I was fighting social media algorithms and shadowbanned for the queer and body focused content I was creating. It was a mess.

Not all algorithms are created equal.

Put that on a shirt. [*Laughs.*] *Trick Mirror* helped me exercise the necessity of contemplating my social media use. It reminded me that online action doesn't equal offline action. This book really offers checks and balances and reminds us to take action in real life.

Did it prompt you to take action in real life?

It did! I started a queer flea market with two friends, Angus and Andy. Hey girl, hey! We've done it in multiple cities nationwide and it's queer-run, with queer vendors. The thing I love so much is that the flea market gives the queer artists a space to meet fans, to have fun, and to create an autonomous financial future. You can't find your chosen family if you don't understand that they are real people out there who are probably looking for you, too.

Sterling Street station
Brooklyn, 2020

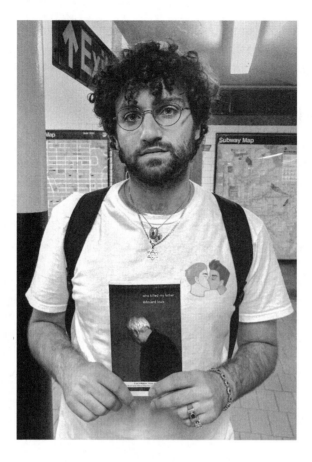

Adam Eli

Who Killed My Father by Édouard Louis

I'm a queer activist, I live in Greenwich Village, this is my subway stop, and it's my belief that queer people anywhere are responsible for queer people everywhere.

What can someone do who's not queer?

The best way to be supportive if you're not queer is to vote and be informed about who and what you're voting for. I absolutely love this book. It's

about Édouard Louis's father, who lived well below the poverty line in rural France—we're talking really dire poverty. Édouard creates a time-line and shows us how government policies directly impact his father. He writes, "I realized when I went to live in Paris, far away from you, that the ruling class may complain about the left-wing government, they may complain about the right-wing government, but no government ever breaks their backs." Then it says, "For the ruling class in general, politics is a question of aesthetics. For us, it was life or death." Certain bodies are more affected by government decisions than others. I think we sometimes fail to see that people's lives are not a news cycle.

Astor Place station
Manhattan, 2019

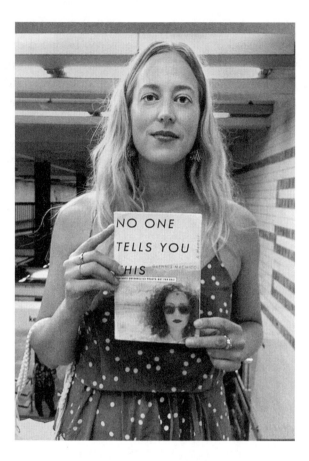

Verena von Pfetten

No One Tells You This: A Memoir
by Glynnis MacNicol

T his book is such a treat. It allows you to see possible paths outside "the
norm"—whatever that is. [*Laughs.*] The author, Glynnis MacNicol,
turns forty and decides to pursue a life without having children or getting
married. It's so heartwarming to read her story. I'm thirty-six and I'm not
sure if I want to have kids. A lot of people say, "Oh, just do it. One day
you'll regret it." But I don't live my life based on the possibility of a future

negative. I think in some ways it's easier to just want what everyone else wants instead of asking yourself what *you* want.

Yes, less peer pressure! More confident decision-making!

It's funny, the thing I'm most grateful for is that I'm not someone who feels a ton of regret. Of course I feel bad if I did something wrong or hurt someone—I'm not a psychopath—and I can be anxious about a million things and overthink everything else, but I hardly ever regret my decisions. I think that fundamentally makes me a very optimistic and happy person.

You've never felt regret about a decision ever?

When I was eighteen, I got a tattoo on my lower back. It's quite literally a tramp stamp of the infinity symbol and I swear I got a new piercing to go with it. [*Laughs.*] I would not walk into a tattoo shop to get it now, but do I regret it? No, definitely not, and I have no plans to remove it. I'm very nostalgic and fond of the person I was back then, and it also makes me laugh. People are complicated beings, but we know ourselves best. We really need to interrogate which decisions we make because of other people, and when it's time to stop second-guessing ourselves. Spend your life however you want! But hopefully if you decide not to have kids, you'll use your extra hours, finances, and emotional bandwidth to do something good and make other contributions. There are plenty of ways to live a meaningful life.

**Broadway–Lafayette Street station
Manhattan, 2018**

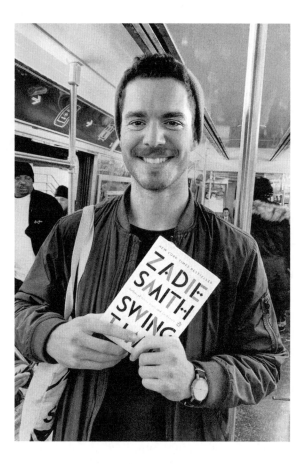

Josh Ross

Swing Time
by Zadie Smith

I'm on page 388 and reaching the climax: Relationships are falling apart, there's conflict around identity, and people are figuring out who they are and where they're going. Zadie Smith has an incredible way of writing her characters. I also love how she inserts beauty and humor into otherwise dark situations. I would say that reading Zadie Smith is life-sustaining.

Where are you headed?

Right now, I'm trying to get back to Brooklyn. In terms of what I am doing with my life, I'm an architect and I do a lot of work for rich people. One of my clients wanted a dumbwaiter in their house, another one bought a pair of Shaquille O'Neal's shoes and wanted a custom glass case to display them in their living room. Stuff like that comes up all the time.

Do you think lots of money makes for a good life?

It's good to have enough money, but I find that people with lots of money often don't know what they want. They don't even know what they *don't* want. [*Laughs.*] I think more money gives you more options, but it doesn't buy you answers, taste, or identity.

D Train
Manhattan, 2020

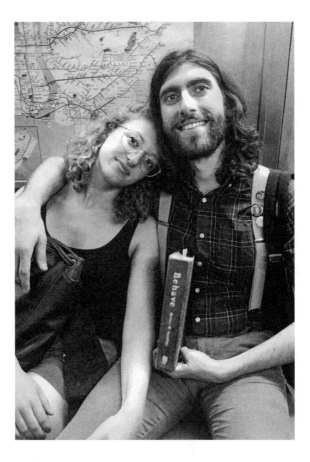

Ashley & Emily Levine

Behave: The Biology of Humans at
Our Best and Worst by Robert M. Sapolsky

Wow, this is crazy! The first time I talked to you about *Leaves of Grass* was in 2014 when I was on my way to meet Emily for a date in Prospect Park! We're married now and just had our two-year wedding anniversary. Today I'm reading *Behave*, and it's a book we both really like. In a nutshell, it looks at humans at our best and our worst and asks why we

do what we do. Sapolsky debunks the myth that our genes determine who we are. Our environment and the culture we're exposed to play a much larger role than we think. It's a very challenging read and very rewarding. It's taking me about as long to read as *Leaves of Grass*. [*Laughs.*]

G Train
Brooklyn, 2017

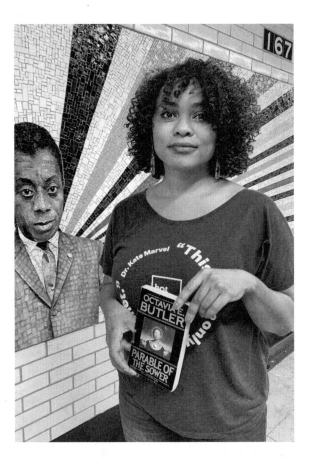

Mary Annaïse Heglar

Parable of the Sower
by Octavia E. Butler

Octavia E. Butler was the Black Nostradamus. It's hard to tell if you're reading a novel or a newspaper when you're reading her books. The beautiful thing she does is propose a very concrete solution to our many questions: empathy. One of the main characters in *Parable of the Sower* has a fictional hyper-empathy syndrome. She sees things happening to other people and literally feels their pain or pleasure. We've had an

unprecedented hurricane season this year, but how much media coverage have you seen about it? People can't take it and we start to look away. In this novel, Butler tells the story of a community that doesn't look away and instead looks after each other. I think the biggest solution is learning how to care for each other.

How can we put empathy front and center?

By keeping the small picture in mind. As a climate justice writer, I'm often asked if I believe the world is ending or beginning, and the thing is, I don't know. But what I *do* know is who I want to be—no matter what happens or who gets elected. Ask yourself who you want to be, accept the consequences, and work on making yourself okay with it.

What's your view on the state of the planet right now?

Climate is colliding with everything, from reproductive rights to racial justice, because it's the landscape on which our lives unfold. If you take the ground underneath us and make it unstable, everything else becomes unstable, too. Some people have a hard time understanding that climate intersects with every issue, and they forget that the environmental movement was started by well-meaning white people with a lot of privilege. Their movement was about clean water, clean air, and other things that were seen as "a white issue." But now we're turning environmentalism into the climate justice movement, which is way more holistic and inclusive.

I keep thinking about Octavia Butler being the Black Nostradamus.

I think she's emblematic of many Black women. Butler wasn't celebrated during her lifetime, and it wasn't until her predictions came true that she got on bestseller lists. Can we stop doing that to Black women? This book was published in '93 and Octavia Butler saw all of it coming. Imagine if we had listened to a Black woman.

167th Street station
Bronx, 2020

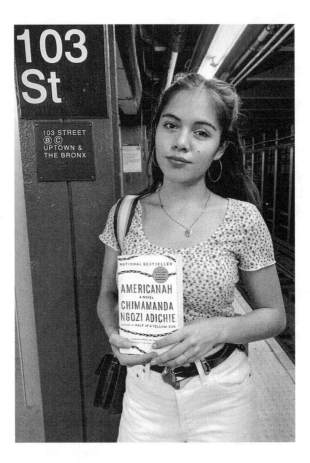

Xiye Bastida

Americanah
by Chimamanda Ngozi Adichie

There's a saying in Indigenous communities, "We don't inherit the land from our ancestors, we borrow it from our children." The philosophy is that we take care of the earth because the earth takes care of us. Why are we destroying our home? The job of every generation is to leave Earth better than you found it. Not the same, not worse. Better.

We need posters of this. How did you become a climate activist?

It started with my parents. My mom is from Chile and my dad is from Mexico. They met at the Earth Summit in Brazil in 1992, then again in Ecuador a year later. They kept running into each other all over the world so frequently that they decided to get married. [*Laughs.*] Both of my parents did a lot of organizing and I learned a lot from them.

What's the climate scoop on New York City?

Right now, the city wants to build a seawall to stop Lower Manhattan from flooding, but really, they just want to protect the Financial District. Where is that water going to go? It's not going to be absorbed by the wall. It's going to go somewhere else and that is sadly where a lot of minority communities live. In New York City, sea levels are projected to rise up to twenty inches by 2050 and six feet by 2100. How old will you be thirty years from now? I'm going to be forty-eight. We'll also experience flooding before 2050 because it's a gradual process. One of the biggest mistakes is saying the climate crisis *will* happen, like it's far away in the future. Psychologically, we're not going to react unless it's immediate. It *is* happening. Now.

What brought your family to New York?

My parents got jobs at the Center for Earth Ethics, which was founded by Karenna Gore. When we arrived in New York, I didn't know that schools here were massively underfunded. Our high school didn't have a science teacher for five months. Other countries glorify the United States and that's why I love authors like Chimamanda Ngozi Adichie so much—she takes you on a journey to face the realities of American life.

It sounds like you can relate on a personal level?

Ifemelu comes from Nigeria, and she helped me recognize my similar culture shock and emotional experiences in America. It was really hard to learn English at age thirteen. At my new high school, I volunteered to be class

president because nobody else wanted to do it. One guy said, "Why is she class president? She can't even speak English." He was right, but it still hurt. When I started learning that communities of color and minorities are more harmed by the climate crisis, I realized that I had to do everything in my power to help—who cares about my English. [*Laughs.*] I joined [Greta Thunberg's] Fridays for Future movement, I organized people to lobby in Albany, I testified at city hall—all without even being a citizen of this country. I think New Yorkers don't fully realize what kind of impact their actions have. What we do here has a huge influence worldwide. It's like a ripple effect. We don't need a thousand new climate activists. We need billions of people doing their very best.

103rd Street station
Manhattan, 2020

Daria Laur

The Worst Journey in the World
by Apsley Cherry-Garrard

I magine going on an expedition to explore a continent without any of the gear or technology we have today. This story is about Robert Falcon Scott's ill-fated journey to the South Pole in 1910. The author was the youngest member of the expedition—he was twenty-four at the time—and his book is full of diary excerpts and anecdotes about human resilience in harsh environments. I'm reading the book in Russian, because I was born in the Republic of Moldova, which used to be part of the USSR, but now it's a small independent country in Eastern Europe. My husband's hobby is mountaineering, and he is currently climbing Mount Rainier in Washington State. While he is there I'm reading this book and I'm trying to imagine how it feels to live in subzero temperatures. We both love seeing beautiful places. When I lived in Moldova, I always had to apply for a visa before I could go anywhere. It was a serious obstacle in seeing the world and meeting new people. Now that I'm a United States citizen, I really appreciate that I can travel more freely. There is so much beauty to see, and I wish it was accessible equally for everybody around the world.

Canal Street station
Manhattan, 2017

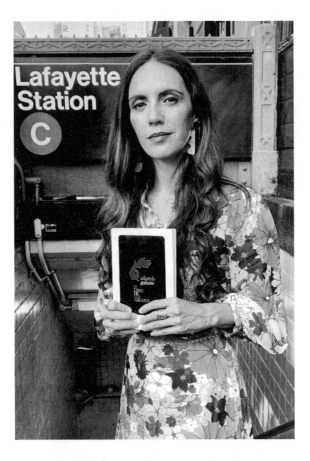

Paola Mendoza

El libro de los abrazos (*The Book of Embraces*) by Eduardo Galeano

This book is a reminder that migration is part of the human experience. I was born in Bogotá, Colombia, and I grew up in California, where I studied acting. I was the only person in my class who left Los Angeles for New York to pursue a career in theater because I didn't want to do what everyone else was doing. [*Laughs.*] *El libro de los abrazos* by Eduardo Galeano is one of my favorite books. It's a collection of poems, thoughts, observations, and short stories. It makes me feel settled, strong, and clear.

Eduardo Galeano was one of the most prolific and important Latin American poets and writers. He died in 2015 and wrote this book in exile.

What kind of experience do you think living in exile is?

Exile is a profound sense of loss. I left my country when I was very young and I've always had this love and longing for Bogotá. I never felt like I was fully accepted by the United States. For some time, I was forced into exile because my uncle was kidnapped at the height of the Colombian Civil War, and I didn't go back for seven or eight years because it wasn't safe. It was a choice, but nonetheless, it was painful. When I finally did go back, I had this overwhelming feeling of gratitude. I could feel my ancestors' bones in the soil and I felt a profound sense of connection to my country.

There are many reasons to migrate, but certain groups are targeted and criminalized for it.

When white people decided to "go explore the world," they were called pioneers. They went to "manifest their destiny," and in their "exploration" they killed and murdered millions of people. As one of my dear friends Jose Antonio Vargas says, "We are here because you were there." That's a critical point to understand. One reason people from the Northern Triangle—Guatemala, El Salvador, and Honduras—come to the United States is because of the drug war that the United States has perpetuated in Central and Latin America. I don't have the answers, but I think we need to accept that migration happens for many reasons.

What kind of neighbor is the United States?

I would not ask the United States for a cup of sugar. [*Laughs.*] I think they would throw me down the stairs, or they would pretend not to be home and never even open the door. [*Laughs.*] A good neighbor is someone who treats the people living next to them the way they would treat their own family. We need to get over our scarcity mindset and think about abundance.

Lafayette Avenue station
Brooklyn, 2020

Dolores Nazario-Ramirez

C-Train and Thirteen Mexicans:
Poems by Jimmy Santiago Baca

W ho am I? I guess I'm someone who likes to help their community. I've been volunteering as a translator with the New York Immigration Coalition for two years. They offer free legal services. I'm Mexican and I know my parents' story of coming to the United States, but I've never really heard other people's stories. We see them on the news, but it's different to see their faces in person. Sometimes they cry and it's hard to not show my emotions.

Why do you feel like you can't show your emotions?

Because I'm there to give them strength and it's often the only chance they get to tell their story. I remember a woman from Guatemala who was seeking asylum. Since she'd had a traumatic childhood experience and the person was still living back home where it happened, the attorney thought that maybe we could use that to make her case. She had her eight-year-old daughter with her and I could tell that it was really tough for her to hear her mother's abuse in detail. Maybe she didn't want her husband to know but she wanted her daughter to know her story. It was intense, but stories like that also affirm my hope to be a criminal defense attorney.

How close are we to that dream?

Thankfully pretty close! I just have to get into law school. A dear family friend was incarcerated because she signed legal papers that had been incorrectly summarized by a translator. I was so upset. The translators in

court often speak Spanish from Spain, but the Spanish we speak in the Latinx community is different. In one case, a judge declared someone guilty just because *one* word was mistranslated. I didn't think about any of this until I interned at the Supreme Court in Brooklyn and saw that there are hardly any attorneys of color present, even though the defendants were largely people of color. I also saw a total lack of Latinx representation on the grand jury, even though most of the defendants were Latinx.

The power of language is real. What is this book about? Please tell me it's about the subway.

I love the subway but *C-Train* stands for "cocaine train." [*Laughs.*] Jimmy Santiago Baca is a screenwriter and a poet. He writes about thirteen Chicanos who struggle with cocaine addiction. Before this book, I never really understood what an addict goes through. The media, especially television, like to suggest that all drugs come from Central America and that all immigrants transport drugs across the Mexican border. That's obviously not true. Most people are searching for education, work, better housing, or an escape from fatal violence. The first story in the book is about a guy named Dream Boy, who has an American dream, which is a big theme throughout the book. A lot of people are longing for that middle-class house in the suburbs with a white picket fence.

Can we be honest? The American dream was pretty much created for white people.

It's sad, but it's the truth. When immigrants come to this country, what they're looking for is hard, if not impossible, to obtain. Society says to strive for that dream, but if you can't get it, you basically have to create your own, and if that makes you unbelievably sad, of course you're more likely to become addicted to something like drugs, and then it's even harder to move past that point. A lot of people say that they don't want us to sit at their table. Well, we don't want to sit at their table anymore. We are going to heal and create our own dreams.

9th Avenue station
Brooklyn, 2020

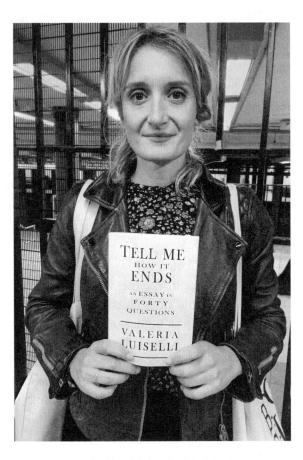

Annalisa Merelli

*Tell Me How It Ends: An Essay in
Forty Questions* by Valeria Luiselli

*T*ell Me How It Ends describes the tragedy of children crossing the
Mexico–United States border by themselves. The author of this book,
Valeria Luiselli, worked as a translator for undocumented children and
she had to ask them the same forty questions about their experience. Her
ultimate question becomes, "What is a human right?"

What do you think is a human right?

One universal human right is the right to free movement, but it's also one of the least protected rights. If you don't have access to food, or are persecuted for being yourself, what would you do? We hear about immigration in the news all the time and think of it as something bureaucratic, but I think we misunderstand a lot of things. The "immigration crisis" is really a refugee crisis, and it's only going to increase because of climate change. It will never go away. I'm an immigrant from Italy and I won a green card in the lottery. I don't know why I came here but I know why I want to stay. This country is broken but it has amazing potential. America is a teenager compared to European countries and—this is a little cliché, but—I see America as a massive social experiment. If you can fix things here, you can fix them anywhere in the world.

Canal Street station
Manhattan, 2018

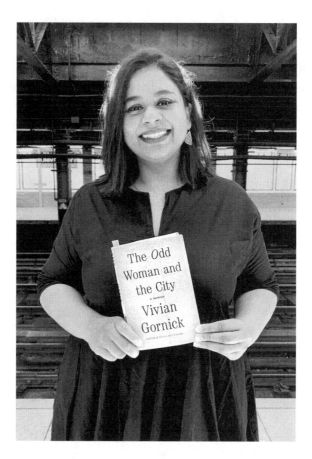

Aishwarya Kondapalli

The Odd Woman and the City
by Vivian Gornick

To quote Vivian Gornick, "The meaning of the city was that it made the loneliness bearable." I love having moments to myself while walking around the city. *The Odd Woman and the City* was made for me. It's about getting lost but never feeling alone.

Are you an odd woman in this city?

Maybe! [*Laughs.*] My husband and I have been married for seven years, but he had to leave New York because of immigration issues and I've been living alone ever since he left. We're both from Southern India. His visa stamp got delayed, and during that time the company he worked for in New York laid him off. When I tell people about it, they cannot understand why I didn't just go back to India with my husband. Coming here was *such* an effort, why would I leave? I finished my degree at Columbia University and got a job. Of course I really miss my husband and I hope he will come back soon, but there are so many things going on in my life.

How long has your husband been gone for?

My husband left two years ago. A lady in my office recently asked me if I was still married because my husband has been gone for so long. Apparently some people still think that women should follow men, but I never felt that way.

What do you think makes a relationship strong?

Being independent. I dine alone, I walk alone, and while I know that doing these things with my husband would be wonderful, it's a different experience and I really enjoy it. I think every person expresses intimacy differently. For me, intimacy means being okay with not sharing *every* moment. I find strength in Vivian Gornick's radical feminist views. It's not that women are greater than men, or that men are greater than women. Everybody has their rightful place. I love that.

116th Street–Columbia University station
Manhattan, 2020

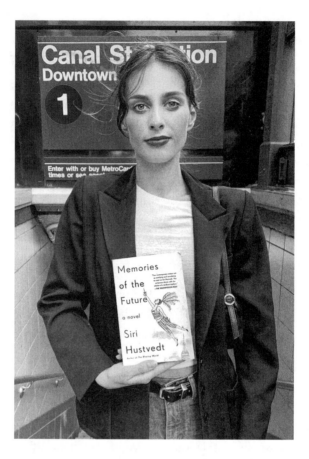

Sophie Auster

Memories of the Future
by Siri Hustvedt

I'm a singer-songwriter and my parents are Paul Auster and Siri Hustvedt. I grew up surrounded by literature, poetry, and films and was basically raised on Jane Austen, Joni Mitchell, and Carole King. I remember winning a national poetry contest when I was ten and I had to get up in front of the whole school to read my poem. I got horribly teased, but hey, what doesn't kill you makes you stronger. [*Laughs.*] I was a sensitive kid and I took

things very seriously. When people meet me, they think I'm from the Midwest, not from New York City.

What is it like to be a person of great sensitivity in this town?

I'm glad I married someone who is as sensitive as I am! You don't get a lot of romantic men in the city anymore, but I found one and one is all I need. [*Laughs.*] I do think of New York as a romantic city. One minute a car splashes you with muddy water and the next minute John Cusack tucks you into a cab, which happened to me once. I was about to climb into a cab and didn't see the man hailing it next to me. He said, "No, no, you take it." Then he smiled and waved goodbye. John Cusack, what a nice man.

Thank you for this life-affirming John Cusack throwback.

Looking back can be useful. *Memories of the Future*, which is admittedly my mother's book, is composed of different diary entries. Her sixty-year-old self looks back at her younger self and fractured memories take all kinds of unexpected left and right turns, which is something I relate to. You get to a certain age when there isn't so much fantasizing about what's next anymore, whereas when you're young, endless future fantasies stretch out in front of you. As for me, I was born in Brooklyn and I'll probably die in Brooklyn, too.

Strange question: Do you have a family plot?

Funny you ask! My parents are going to be buried in Green-Wood Cemetery, which is gorgeous, and they will share a grave. See, romance runs in my family. [*Laughs.*] My parents are very cute with each other. Sometimes, during a party, you can catch them slow dancing together. Anyone is lucky to have parents who love and respect each other. Having a good relationship to aspire to makes you a much more stable person.

**Canal Street station
Manhattan, 2020**

Paul Tudor Owen

Normal People
by Sally Rooney

If you've created a very strong bond with someone, it's not easy to walk away. I'm in a book club with friends from university and we've kept it together for about fifteen years. *Normal People* is the latest book we're reading and I'd describe the style as intense realism. You're absolutely immersed in the lives of Connell and Marianne, two young students in their first years of university, as they get together, break apart, get together, break apart, endlessly. The most I've broken up and gotten back together was maybe two or three times in my thirties. I'm forty now and I wouldn't go back in time if you paid me. [*Laughs.*] I feel much more confident about who I want to be. I work as a journalist for *The Guardian* and recently published my first novel, *The Weighing of the Heart*. If you said to me when I was twenty that I would publish a novel at the age of forty, I would be delighted and probably also ask why it took so long.

Any loving advice you'd give to your twenty-year-old self?

My advice would be to spend less time going out drinking and to focus more on what I'm good at. But it's not always that easy. Some things just take time.

14th Street–Union Square station
Manhattan, 2019

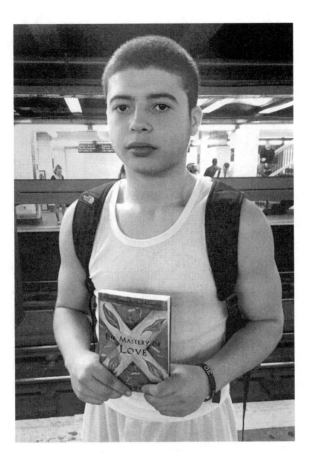

Jason Rosario

The Mastery of Love by Don Miguel Ruiz

My parents think I don't know enough about love. They asked me to read this book because I make mistakes about the person I choose to be with. They say that I have to respect myself first, before I can show my love to another person. This book is actually dope. I'm only fifteen. I'm still new to this type of thing.

Hoyt–Schermerhorn Streets station
Brooklyn, 2016

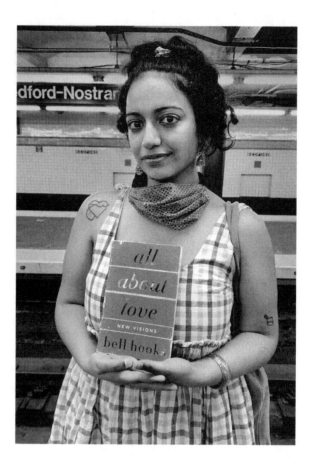

Fareeha Khan

All About Love: New Visions
by bell hooks

I really want to understand love. I want to understand what a real connection is and why people are the way they are. I recently went through a breakup. I thought I had fallen in love but then reality set in. I wanted to work on it and she did not. I feel like I date a lot of people who have cut themselves off from feeling true love because it's too difficult or painful.

How do you define true love?

I think about this a lot and it's why I'm reading bell hooks. She defines true love as the mutual support and the safety to encourage your own and another person's spiritual growth. And she says that there's a heart connection and a soul connection.

What's the difference between a heart and a soul connection?

A heart connection is easier to find. You love someone for who they are. You can see a future with them. You grow together. A heart connection can turn into a romance, a relationship, a friendship, many things. A soul connection is when you meet someone and feel like you've known them forever on an unknowable, deeper level. I think people are cut off from true love because they're terrified of showing who they really are. But getting close with someone always means showing your true self, eventually. It's a crazy good book. Can I read you a crazy good quote from it?

I love a crazy good quote, go for it!

"True love only appears when our hearts are ready." And then it says, "As long as we are afraid to risk, we cannot know love. Hence the truism that love is letting go of fear." I do feel like I've experienced a soul connection before, it just hasn't turned into a long-term relationship yet and bell hooks says that's because it takes work. You have to be willing to do the work to love someone and to be loved in return. So I'm going to read about it. I'm going to make room and space for soulful growth. And I'm going to be an amazing person.

Bedford–Nostrand Avenues station
Brooklyn, 2020

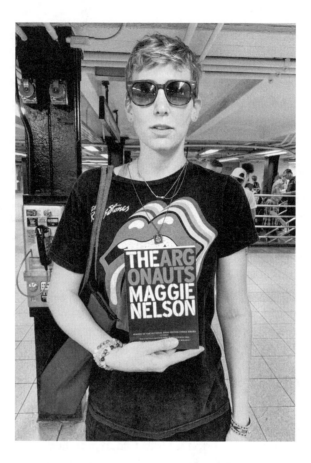

Cat Yezbak

The Argonauts by Maggie Nelson

W hy can't people be free to be all versions of themselves? I've always been interested in gender, desire, sexuality, and how they intersect. Personally speaking, I've never felt just "female." It's only now, approaching forty, that I'm embracing that fact physically. I like short hair and androgynous clothes, and I also want to wear lipstick every now and then. As a society, we are starting to understand the complexities of gender, but many people are still so rigid.

That's an important question we should be asking all the time: Why can't we be free?

Right? In *The Argonauts*, Maggie Nelson shares how she falls in love with another human being, and I'm really interested in Harry, the person she loves. I think Harry might have been born female—I just started the book—and it's refreshing to read about couples who aren't living a cis heteronormative existence. Maggie Nelson also talks about not identifying with any labels and that is something I struggle with, because I've fought so long and hard to call myself a lesbian. Part of my immediate family, which is Syrian, Lebanese, and Irish, still doesn't like the word. I think when you don't get that respect at home, you always feel like you're fighting some kind of war.

What does freedom look like to you?

To me, freedom means being able to hold my girlfriend's hand anywhere in the world without anyone saying a word to us, and without feeling that we might be in harm's way. I'm a real romantic and I'm madly in love with my lady. I like to leave her little notes, I make up ridiculous songs for her, and I love seeing her happy. One of the most important things in a relationship is feeling safe in every way, including the safety to be yourself and to be flawed. A human being falling in love with another human being is the best thing on the planet.

14th Street–Union Square station
Manhattan, 2019

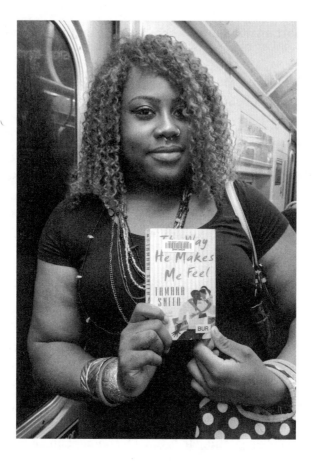

Reyna Boucaud

The Way He Makes Me Feel
by Tamara Sneed

T his story is about a dude who makes a bet that he can make any girl fall in love with him. He's a player and he is doing everything wrong. For the bet, he and his friends pick a girl who used to be a big nerd, but now she's hot and successful. I just read the part where she said, "I love you and I know you love me, too," but the dude hasn't responded yet. This nerd has a better love life than me! [*Laughs.*] I don't relate much to the story, but

I like its approach. First it's about looks, then it's all about personality. If you like the kind of books they sell on the street in Downtown Brooklyn, you'll like this one. Some of their books make me feel naughty. [*Laughs.*] This one is a little more about romance. It's more appropriate train reading.

F Train
Manhattan, 2014

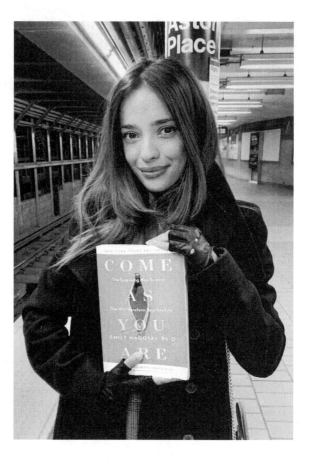

Arina Ahmed

Come as You Are by Emily Nagoski

People push for marriage, but they're afraid to talk about sex. People push for having babies, but they're afraid to talk about sex. How can you not talk about the very thing that brings you to life? When I first picked up *Come as You Are*, I was in a sexual rut and didn't even realize it. I was stressed out about my social life, school, work, and my sex life was suffering. I'm so glad I found this book, because it's unlike anything I've read before. Emily Nagoski is Malcolm Gladwell for sex.

Do you remember who first talked to you about sex?

My family is from Bangladesh, and even to this day, my mom can't openly talk about sex. The sex educators in my American high school told us that abstinence is the best form of birth control and that was it. Naturally, when you go into the real world, you are confused, because people expect you to have sexual intelligence as early as your teens, when people want to lose their virginity and have the kind of sex they've seen in porn. To read a book about sex that's written by a woman is so important to me. All people deserve pleasure, but for women there is often unnecessary guilt and shame attached.

Do we have more pressure around sex than before the Internet?

Today there's so much more pressure on women, period. We need to have the best job, the best partner, and the best life. Right now, I'm unemployed, so I have all this time on my hands, and I realized that I've always tied my self-worth to what I'm doing for a living, which is something I'm unpacking with my therapist. I'm allowed to enjoy sex without having a job!

Anything you found out about sex you didn't know before?

I'm not afraid of my body, but this book pushed me to look beyond the surface and made me understand that my sexuality, my mind, and my personality aren't separate things. They're all one thing: me. I grew up having to please everyone around me, but not necessarily myself. It takes a lot of courage for a woman to unlearn everything she knows. But the more you learn about yourself, the more you can express how you want to feel pleasure in all areas of your life.

Astor Place station
Manhattan, 2020

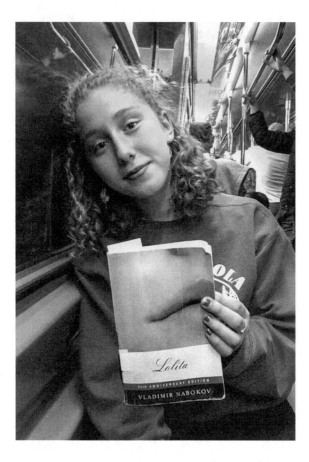

Lea Elton

Lolita
by Vladimir Nabokov

I just met Lolita. She seems innocent, but I've only gotten to know her from Humbert Humbert's point of view. I want to get to know her as a character outside of their relationship. The fact that an older man is this possessive of a much younger girl is scary. A lot of my friends are terrified of that kind of relationship. I've always wanted to read *Lolita* and finally picked it up, although my parents don't really want me to read it yet. There

are themes in it that are hard to digest as a teenage girl, but I believe in exposure. It's not good to have a limited view of the world, especially when you're a young person. This story makes me aware of what it feels like to be in Lolita's position. It will make me recognize it and understand it more in the real world, too.

G Train
Brooklyn, 2018

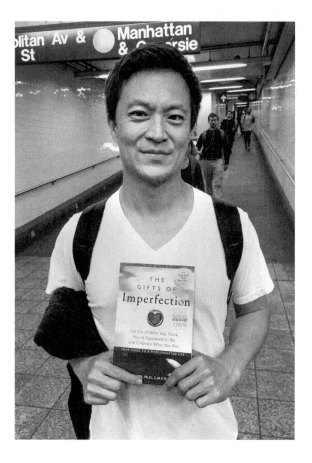

Roger Chang

The Gifts of Imperfection by Brené Brown

B rené Brown tells stories about shame, and her experiences give me the courage to face difficult things in my own life. I don't know why we're always so afraid. [*Laughs.*]

Do you have a secret that's connected to shame?

I haven't shared this with many people, but I will tell you because I think it's important. Ever since I was a kid, my hands have been sweating. I recently

had surgery to fix it, but now the problem has shifted and is occurring on other parts of my body, like my chest and my back. I realize now that the sweating isn't only a physical thing. If I hadn't felt so ashamed about it, I might have asked more questions before the surgery and might have found a different solution. Shame is perpetuated by secrecy. If you can find someone you trust and talk to them, you can break shame down. Talking to you about it makes me feel like I'm on the right path.

Metropolitan Avenue/Lorimer Street station
Brooklyn, 2015

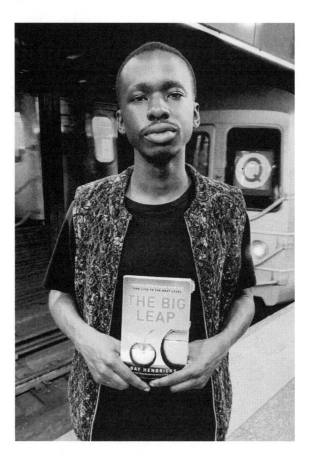

Jeffrey Zie

The Big Leap by Gay Hendricks

One day, I was working in the lobby of the Ace Hotel and started talking to the girl next to me. Her name is Linea. She is dope and told me about this book. *The Big Leap* is some deep shit.

What's behind *The Big Leap*?

It says that we all have an inner thermostat that measures how much success, happiness, and love we're used to experiencing. When we reach a

level that we're not used to, we find a way to subconsciously self-sabotage ourselves back to our comfort zone. For example, when you find yourself procrastinating on a good opportunity, you have to talk to yourself about what you feel you deserve. Words are powerful. I remember when I was three, I said a reckless curse word, which was the last straw for my parents. They moved us out of Queens and to North Carolina. [*Laughs.*]

How was living in North Carolina after growing up in Queens?

I got started with photography, and while I was doing that, I also sold weed on the side. In Concord, it was hard for me to get a job, and this lady fired me for something stupid. I had been in trouble with weed before and had to figure out how to pay my court fees, so I went back to selling weed again. That day, I had an ounce on me and they locked me up because it was my third time getting caught. They say three strikes and you're out. It was really scary.

An ounce of weed is not that much. It's like a small sandwich bag full?

That's right. I did six months in prison for that. In the third month, I ended up in the hole, in solitary confinement. During that time, I was lucid dreaming a lot—that's when you control your dreams—and I had some really cool lucid dreams with Rihanna. [*Laughs.*] But I never knew when I'd be let out of solitary. Three days go by, I'm still in there. A week goes by, I'm still there. Every morning they brought me food through the door but they never opened it to let me out. In one dream, my sister was with me and she shook me awake and said, "It's okay, Jeff, it's just a dream." And while she was shaking me I heard a knock on the door and someone told me that I was getting out of solitary. That was day twenty-eight. I literally woke up in tears.

Can you describe what solitary confinement is like?

One of the craziest parts is the shower situation. They let you take a shower two or three times a week, and when it's your turn, they come to your door and you have to kneel down by a small rectangular hole in the door so they

can cuff you. You come out and the bathroom itself is like a damn cell. You take a shower for ten minutes and then wait about an hour before someone picks you up. You're just standing there, getting ashy as hell. It's wild.

You're completely stripped down and deprived of everything.

Yeah. And some people have been in there for years. The guy in the cell next to me would sometimes talk to me through a crack in the wall. He was in solitary confinement for months. I still think about him. Being in prison makes you realize who your real people are. Anytime you get a letter from somebody it feels like Christmas. I had a couple of friends who sent letters and to this day I'm like, damn. Because that's what helps you escape, you know? Books, letters, and dreaming.

34th Street–Herald Square station
Manhattan, 2020

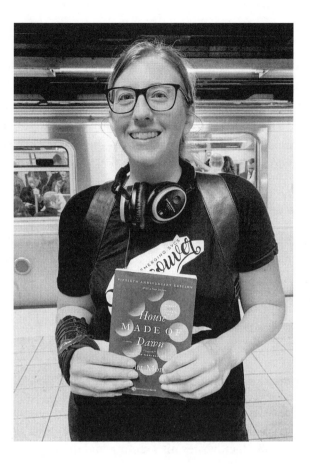

Rebecca Evanhoe

House Made of Dawn
by N. Scott Momaday

I'm part of a program where people read books and write letters about them with prisoners in a maximum-security prison in the South. Right now, my pen pal and I are reading *House Made of Dawn*. We've been writing to each other for about a year and so far we've read thirty-eight different books together. It's a relationship like no other.

What defines your relationship?

I've never had a relationship with someone that's only focused on ideas based on books. When we first started, our letters were mostly about themes, stories, and characters, but now we write more about our beliefs and opinions. When we read *The Watchmen* we had a lot of fun talking about good and evil. Our relationship is completely devoid of the day-to-day, but I feel like I could guess which stories he likes, which feels intimate.

Can you share what you know about your pen pal?

He's been in prison for fourteen years and I think he is in prison for life. I don't know what he's in for and I don't want to know, because the prison system is messed up and it doesn't feel relevant to what he and I are doing. I know that he's been in prison since he was a teenager and that he's a different person now that he's in his twenties. Mostly I just feel happy to know him.

How do you pick the books you read together?

He picks books from the prison library and it's one of the only choices he gets to make in his life. Once he writes me, I have three weeks to write him back. He usually handwrites his greeting and then writes the rest on an old-school typewriter. There are never a lot of typos, so he's either really careful or really good at it. He picked *House Made of Dawn* because he's into Native writers and likes to read about spirituality.

Has anything changed for you since you have known him?

Our correspondence has emphasized how much agency I have in this world. I often have to fly for work and I'll literally write him a letter from the sky.

Jay Street–MetroTech station
Brooklyn, 2019

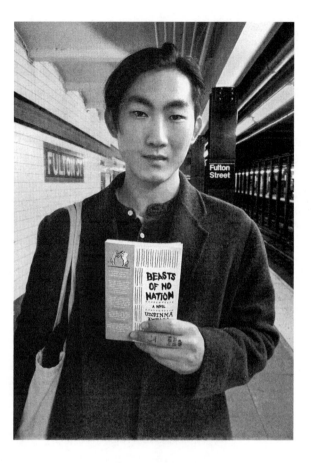

Yizhi Wang

Beasts of No Nation by Uzodinma Iweala

I opened the first page and read: "For those who have suffered." I was moved by these words, I'm not sure why. One day, I hope I can do something big for people. Now I do what I can, even if it's a small act, like buying people on the street pizza or fried chicken.

Fulton Street station
Brooklyn, 2016

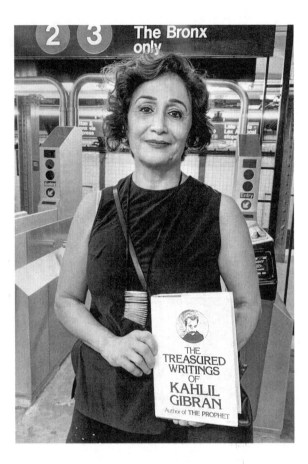

Nasim Alikhani

*The Treasured Writings
of Kahlil Gibran*

I've been different things at different times of my life. Right now, I'm a chef at my restaurant, Sofreh, and I'm also a mother, wife, sister, friend, and a charity worker—I cook for shelters and volunteer. When I cook, I don't just make a dish. I'm practicing my culture, my heritage, my identity, my knowledge, and most importantly my love for other people.

Is New York City your home?

New York City is my second home. I came here when I was twenty-three and now I'm sixty. I'm Persian and grew up in Isfahan, a gorgeous, historical town that also has lots of restrictions and limitations, like all old places. New York gave me my voice and a way to express myself, which I probably couldn't have done in Isfahan. I go back and forth between the two and, as for any immigrant, home and roots are a long conversation.

Can roots ever be fully replanted?

No, but they can develop, extend, and regrow. Humans can do anything. We can reinvent ourselves and re-create our history, but I do not believe that we can separate ourselves from our pasts. It's like when you start a sauce. You begin with your base ingredients, then you start to season it and add flavor to develop it. That takes time, and the same is true for roots.

Is feeding yourself and others a compassionate act?

I think so. Taking care of myself, others, and the environment is what I've learned from Kahlil Gibran, who is a poet, a philosopher, and a political activist. His book is about the philosophy of being easy on yourself and others, and he questions how to find his place in the world, but his thinking isn't black and white. I treat Kahlil Gibran like Rumi or Hafez. A world without these people and their words would be nothing. We would just be a bunch of animals who sleep, eat, and copulate. They are the ones who show us the light. Some are ready, some are not, but the light is always there.

Can we see which message the book wants to send us for the future?

Yes, let's see. I let the pages run through my fingers like this and ask the book to give us a message. Wow, look! The chapter I landed on is called "A Glance at the Future." I'm getting goosebumps. It says, "From behind the Future I saw multitudes worshipping on the bosom of Nature, their faces turned toward the East and awaiting the inundation of the morning

light—the morning of Truth. I saw the city in ruins and nothing remaining to tell man of the defeat of Ignorance and the triumph of Light."

That's stunning. Do you have a wish for New York City's future?

When I came to New York in the '80s, it was exciting and inclusive. I hope rent will come down so the artists and the immigrants can return. I also wish for a strong subway system, because the subway is what created New York and this broken, smelly, hot, dysfunctional subway is what allows life to continue. It's funny, the subway passes under my restaurant and under my apartment. I live on the ninth floor, but on a quiet night, I can feel the vibration of the trains. I love the subway. It's loud, cranky, and just like New York, it's very special.

**Bergen Street station
Brooklyn, 2020**

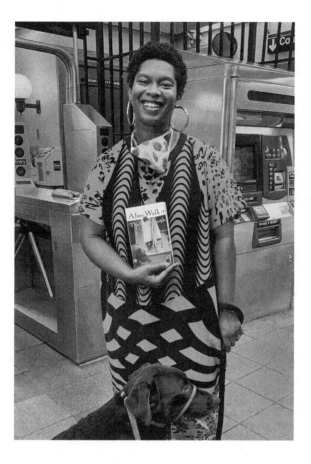

Ashley C. Ford

The Color Purple by Alice Walker

I'm a really serious homebody. I spend a lot of time at home with my husband and my dog, the two people I love. They both are so loving and it's so clear that they want my company. I'm most likely addicted to it, to be perfectly honest. [*Laughs.*]

I love that. Feeling welcome isn't always a given outside of our homes.

The world is a big, wonderful place, and it's worth that risk. When I return home at the end of the day, I'm simply coming to a place where I shed the

anxieties and insecurities I have about the ways the world judges me as a Black woman. Judgment comes very naturally to people, and some people don't even see me, they see some kind of avatar. I'm rereading *The Color Purple* and it reminds me how beautifully complicated human beings are, how resilient we are, that pain is inevitable, and that suffering is a choice. It really soothes me. This is my tenth time reading it.

That's incredible. I'm not a big rereader. I will admit that right now.

When I was a kid, I didn't own a whole lot of books. I'm the oldest of four children and there was always the chance that one of my siblings would destroy or lose one of my books. [*Laughs.*] I used to memorize my books so that if they were gone, I'd still have them in my head.

How do you find compassion these days?

This time around, *The Color Purple* reminds me that people are a product of their environment. I have to search in myself to have empathy for certain people, and I would never want to force my sense of compassion for all living things onto someone else, but this book really helps me to find compassion for the wounded who act out by causing great harm. Light and shadow exist everywhere. Part of our problem is that we want to believe that something that hurts us is all bad and something that is a gift must be all good. That's not how the world works.

I read the best Maya Angelou quote yesterday: "Do the best you can until you know better. Then, when you know better, do better." That's my new anchor.

I love that quote. My current anchor is that no person can be summed up by the best or worst thing they've ever done.

Beverley Road station
Brooklyn, 2020

Ed Pollio

The 50th Law
by Robert Greene

That dilapidated building right behind the train station is ours. [*Laughs.*] My wife, Angelica, and I are the proud owners of 5050 Skatepark on Staten Island. Every landlord was terrified of liability issues, but one person was willing to take a chance on us. That was eight years ago. Before that, me and my friends built skateparks in the woods, and every time the city found out, they'd tear them down.

Who skates here and has the Wu-Tang Clan come by?

Method Man and Redman actually just shot their music video for "Straight Gutta" here and it has twenty million views. We're more than a skatepark.

What about 50 Cent? You have his book in your hands.

First, I have to say that we did not name our place after 50 Cent. [*Laughs.*] It's named after the 50-50 trick, which many different riders can do. Robert Greene is an awesome author and I love how relentless 50 Cent is, how he got out of the streets, and how he became successful. In the book, he talks about his mother being a drug addict, which I relate to because my parents were addicted to drugs. Every day I wake up, I'm super proud of who I am. One of my best friends grew up the same way as me. He saved me but couldn't save himself.

Thank you for sharing that. It's important to hear about forks in the road.

Yeah, I think so, too. The thing is, our landlord is just waiting for the right number and we're a placeholder until he sells the building. But we're not going to give up. We'll find another space. Angelica is jokingly called the skatepark den mother. We have hundreds of kids who come by and end up being raised here. Sometimes they live with us for a while and I'll help them get into welding and construction by working at the skatepark. Kids don't need more shopping centers. They need places to play and hang out.

Stapleton station
Staten Island, 2020

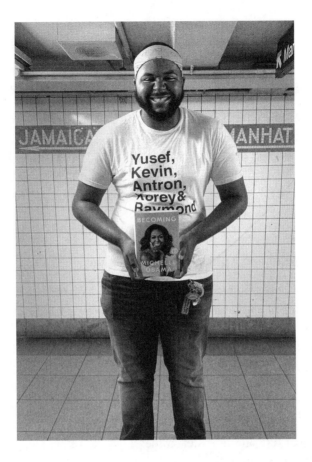

Larry Malcolm Smith Jr.

Becoming
by Michelle Obama

I come from the neighborhood where Sean Bell was shot at fifty times and the cops were acquitted of all charges after they killed him. Since then, I've met Trayvon Martin's mom, Alton Sterling's mom, Stephon Clark's mom, and Tamir Rice's sister. We all lost our family in different ways. I'm a foster kid, and Queens is so important to me as a home. My entire foster home experience took place here and it's where I became an

activist at a young age. I love artists and activists who come out of Queens. I'm like, "Yo, if they can do it, I can do it, too!"

Is there a specific artist you love who came out of Queens?

I really love Nicki Minaj, and I say that with a lot of energy because I love Nas and 50 Cent, too, but Nicki is an assertive Black woman and I love that she did exactly what she wanted to do. She sold her CDs and mixtapes at nail salons and out of the back of her truck to get her music career going. I remember this because her truck was parked in front of our building in South Jamaica, Queens.

We love a determined woman who gets her way.

That's why I'm obsessed with Michelle Obama! Women have always been at the forefront of movements but many of them go unrecognized while risking their lives for us. Black women—let's really unpack it—have been fighting injustice for over 400 years. When I read *Becoming*, I was speechless because Michelle shows that after you fall down, you get back up, and she writes very honestly about her life—I mean, the first lady talks about smoking pot! I thought it was really amazing that she didn't create a fake image. As a foster child, I've done some wrong things too. I was a runaway because I never felt safe in foster homes. I would rather sleep in New York City parks or on trains.

Can you tell me about your foster home experience?

I come from a broken home. My mother was addicted to drugs and alcohol, and she would leave me in a house by myself at age two. That's when I was taken into foster care and given up for adoption. I've been in twenty-three foster homes and people really don't understand what it's like. Foster kids are sexually assaulted and neglected, we have eating disorders, and we attempt suicide. I've never had a family who loved me the way I wanted to be loved, and I really struggle with abandonment. I was adopted into a home when I was four, but my foster mother died of old age by the time I was eleven. You constantly lose and you have to get back up. Why aren't

our elected officials asking us what we need? Why isn't there a food pantry in our shelter? Why does no one care about foster kids when we're not cute babies anymore?

It sounds like these systems are designed to fail. No one can be that thoughtless.

That's absolutely right. When I aged out of the foster care system, all I was given was a MetroCard with two rides on it. That was it. It meant that I was homeless during the winter and nobody cared. I feel like if it wasn't for my activism, I would really lose myself. This shouldn't be my story, or anyone else's. It matters how we spend our precious time. *Becoming* reminds me that nobody is free until we all are free. My liberation doesn't last a minute, an hour, or a month. My liberation is a destination and it lasts forever.

Court Square–23rd Street station
Queens, 2020

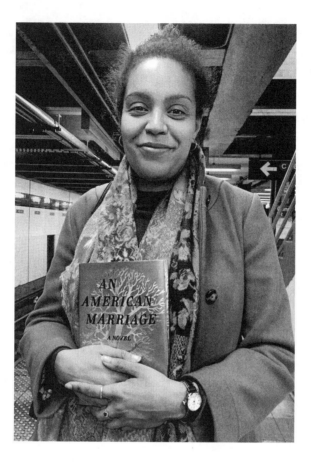

Maya Marie Clark

An American Marriage
by Tayari Jones

I'm a social worker and teenagers are my specialty. They are often deeply neglected sweethearts that nobody gave their time to. I've done this work for a decade, and I'm currently taking a break because it's emotionally taxing.

Today is Valentine's Day and you're reading *An American Marriage*.

An American Marriage is really good. It's about a young, married Black couple. They are starry-eyed, but a year into the marriage the husband is accused of rape and sentenced to twelve years in jail. It completely throws off their marriage and the story unfolds from there. I picked it up because I was going through a big breakup. I was so sad and broken. We were fully in love, we lived together, we shared our lives, and then—the day before Christmas—he just fell through solid ground and disappeared.

That sounds horrible! Did that change how you feel about people?

Being from Michigan, where everyone marries their high school sweetheart, I was quite hard on myself for having a "failed relationship" and I blamed myself. But then I realized that you can love someone in many different ways. The best example for that is Cozette, a ninety-two-year-old woman who I met on a park bench on Spring Street shortly after my breakup. We were the only two people who were not staring at our phones, so we started chatting. We meet up at our bench every weekend and spend holidays together. Cozette never had children and her husband passed away ten years ago. He was her only family so I brought her into mine.

This is everything. Cozette and you are everything.

Cozette is one of my best friends and one of my favorite people to be around even though she's sixty years older. She is funny and kind and she really knows herself, which is what I needed when I met her—I needed to see a woman who was unafraid to be herself. Everyone always says how lucky she is to have me, but Cozette really saved me. She reminded me of how strong I am and how much love I have to give. I did start a family, just not in the way everyone else expected.

West 4th Street–Washington Square station
Manhattan, 2019

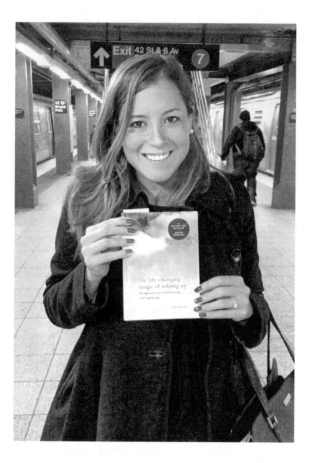

Jessica Escobar

*The Life-Changing Magic of
Tidying Up* by Marie Kondo

My husband moved in with me a couple of months ago and we just got married two weeks ago. My sister gave me this book in preparation. [*Laughs.*] I'm excited about it because I want to make room for him and create new space for myself. The book isn't just about your home either—it's about cleaning up your whole life at once. I'm a drastic person, so that appeals to me. I'm in real estate, and the number one thing I hear from

my clients is that they have too much stuff. Now I'm thinking more about function and if something really brings me joy. Marie Kondo doesn't want people to just get rid of things. She wants to bring more focus to what you actually love, because when you're in a space of joy, you create more of what makes you happy.

42nd Street–Bryant Park station
Manhattan, 2016

Zahra Hankir

The Quarter
by Naguib Mahfouz

This is a beautiful collection of vignettes that transport you to a quarter in Cairo. A quarter is like a souk, a cluster of homes that are very close to one another, usually in a smaller neighborhood that's filled with alleyways. Mahfouz takes you to the Arab streets, and his stories are about the locals—a group of workers who suddenly start weeping, a woman who disappears and returns one year later with a baby—and how they all

relate to one another. It's a treasure trove, and Naguib Mahfouz, who is an Egyptian author, is often referred to as the "Tolstoy of the Arab world," but he is a master in his own right.

Where is home for you?

I'm Lebanese and British by nationality. My parents fled Lebanon during the civil war, and I was born in the UK in the '80s. I was aware at a really young age that I saw my home through the lens of Western journalists in the news and on TV. Those foreign reporters were the only connection my parents and I had with our homeland—we couldn't speak to our family there because of the war—but we knew we weren't getting the whole story. Whenever I read a story or a book by an Arab writer, I feel like I'm no longer sitting on the subway or in my flat. I am back in the Arab world smelling bread being made, listening to the music wafting through the air. I can see the Mediterranean, the *shisha* smoke, my grandma, and my aunt.

That sounds beautiful. Is there a character in the book you feel especially close with?

Someone I'm really drawn to is a woman who doesn't age with time. It's a reflection of beauty, what it means, and how it interacts with an intelligent, worldly woman. Beauty isn't touched by loss, grief, or war, at least on the surface. I think women who artfully do their makeup, who dress beauti- fully, who use perfume even in times of societal instability reflect a quiet power. I don't think it's superficial at all. My friends know that if I'm not wearing eyeliner, I've lost all hope. [*Laughs.*]

Vernon Boulevard–Jackson Avenue station
Queens, 2019

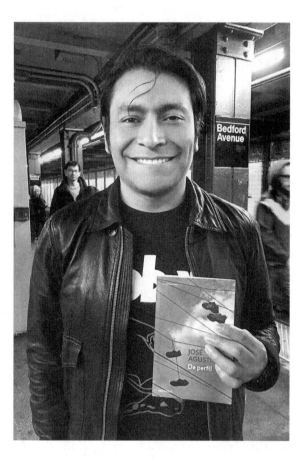

Emmanuel Muñoz Maldonado

De perfil (*In Profile*) by José Agustín

Reading this story feels like having chicken soup in the winter. It feels lovely. The book is based on real events and is set in Mexico City during the '60s, when an important revolution took place because people realized that their democracy was fake. A young man tries to figure out who he is while all of this takes place. I think that is still relevant today, asking who we are and why we separate ourselves from others. Alone we can go faster, but together we can go farther, no?

Where is home for you?

Everyone has their own definition of home. I come from a little town called Tlaxcala in Mexico. It's very quiet, humble, traditional. My parents had the idea to move to New York and I wanted to stay in Mexico, but I needed to help them start their business. I think a place becomes your home when you realize that home doesn't have to be a building or a house that guards and protects you. Being Mexican, I don't exactly feel welcome in America. People who don't even know me say that this is not my home, even though I've lived here for twenty years. I think home is a feeling that I carry inside of me and it's going to be with me wherever I go.

**Metropolitan Avenue/Lorimer Street station
Brooklyn, 2017**

Jacques Aboaf

Ryszard Kapuściński: A Life
by Artur Domosławski

I just came from the library. I'm writing a science-fiction novel and picked up a lot of books for inspiration. Ryszard Kapuściński is one of my heroes. He was a lonely spirit and more at home in other countries than his own. He wrote a lot about Africa. The character in my novel lives in a place that's very different from their home. I saved up money and made a list of countries I want to visit. Since today is New Year's Eve, I spun a

globe and landed on Rwanda. I'm actually on my way home to buy the plane ticket before I chicken out.

Amazing! Are you making any New Year's resolutions?

My resolution for the New Year is to get out of my comfort zone and to keep pushing!

**Hoyt–Schermerhorn Streets station
Brooklyn, 2015**

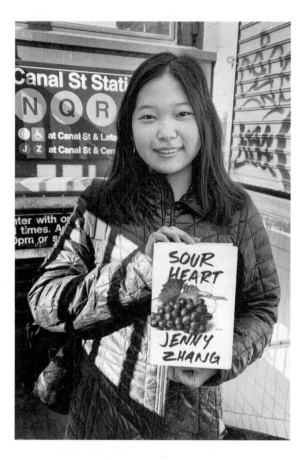

K-Ming Chang

Sour Heart: Stories by Jenny Zhang

Chinatown is often associated with restaurants and tourism, and that's prominent, but Chinatown doesn't just exist for consumption. It's also a place where people live, work, exercise, and spend time with their families. You can see opera performances by elders in the park and the whole sonic landscape of Chinatown is amazing. Someone will speak in Mandarin and the other person will respond in Cantonese. It's really fluid and flexible.

Have you ever overheard a secret on the street?

I was drinking a hot soy milk at the Fay Da Bakery on Mott Street. Two European tourists came in and a local woman sat down across from me. The tourists had just bought a counterfeit purse from a street vendor and they were discussing it. The local woman looked straight at me and said in Shanghainese, which I understand because of my grandfather, "That purse is so ugly and fake. These tourists are so easy to scam." I burst out laughing and sprayed hot soy milk all over myself. The tourists probably thought I was nuts, but I couldn't stop laughing. It was great and definitely reminded me of Jenny Zhang. She writes about living in Queens as the daughter of Chinese immigrants, and all her stories revolve around girls in the city. We often see cliché immigrant narratives where someone is running away from their family, but this book is about a domestic space you don't have to run from. Jenny writes fearlessly and shamelessly. *Sour Heart* reminds me of my own uncanny but joyous memories.

What do you think affects our memories and how real they feel?

It's such a mystery. It's almost like things in the present are clues that unwind a treasure map into our memory. As a child I told myself, "I'm never going to forget this," and of course eventually I forgot, but there are some moments when I suddenly remember, and I'm so appreciative of my past self. Mei Lum, the director of the W.O.W. Project, recently told me, "Don't try to reinvent the wheel—just unbury the wheel, it's already there."

Canal Street station
Manhattan, 2020

Olivia Lindsay Aylmer

Água viva (*The Stream of Life*) by Clarice Lispector

M emory is a central force of longevity. I have memories of being at my great-grandmother Theresa's house in Queens, listening to her stories about decades of life in New York while sitting at her feet. I was raised among three generations of powerful New York women, and my memories are very local. I gained a deep appreciation for the process of memory caretaking through my mom, Laura, who recorded my great-grandmother and my great-aunt Marian telling their New York stories. It made me interested in why we save memories, what's valuable about them, and how they can serve as time capsules.

What have three generations of women taught you about preservation and impermanence?

That culture is an active vessel we can use to shift the ways we think about ourselves and other people in this ever-changing world. I often ask myself if anything we're producing and sharing now will impact future genera-tions. I guess time will tell and we might not be here to find out. Clarice Lispector is a perfect example of how long it can take to find an audience that truly appreciates your work. *Água viva*, or *The Stream of Life*, is an experimental novella, framed as an unsent letter to an ambiguous recipient. It's a kaleidoscopic reflection on how we organize our thoughts and how we choose important memories. Beyond that, it's hard to say. It's like when you hear a really good joke—overexplaining it would ruin it.

Hoyt–Schermerhorn Streets station
Brooklyn, 2020

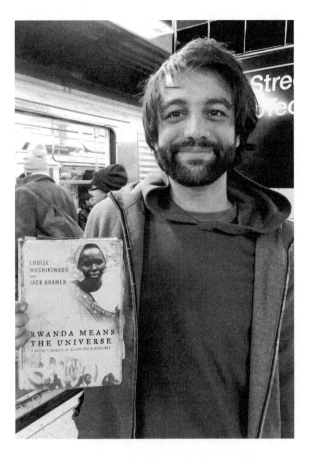

Jacques Aboaf

Rwanda Means the Universe by Louise Mushikiwabo

It is crazy to run into you again! Guess what, I booked that plane ticket right after we talked on New Year's Eve! I'm going to Rwanda in February for six weeks. I guess our conversation was the final motivation I needed. [*Laughs.*] I was kind of like, "Wow, did I really just do that?" but I'm very glad that I'm going and have started to learn some basic Kinyarwanda. It's a language from the Bantu family that's just a little harder than French.

Jay Street–MetroTech station
Brooklyn, 2016

Jeremy O. Harris

From the Mixed-Up Files of Mrs. Basil E.
Frankweiler by E. L. Konigsburg

I am a playwright and a performer, but mainly I'm a nerd who got lucky. [*Laughs.*] New York City has lived in my psyche for longer than I have lived in it and it populated my reading lists when I was a kid. *From the Mixed-Up Files of Mrs. Basil E. Frankweiler* was my favorite book in third grade. It's about siblings who run away from home and stay in the Metropolitan Museum of Art, and there is something magical about kids taking life into their own hands. Meanwhile, I grew up in Virginia in a really small town, but I feel like I was raised culturally as a New Yorker. For one, I got a subscription to the *New Yorker* when I was twelve. [*Laughs.*]

Have you always been an ambitious reader?

Oh, I was obsessed with books. In third grade, I found out that you could win prizes for Accelerated Reader points and that reaching a certain level won you a pizza party. It's messed up and deeply merit-based, but I'm competitive and thought it seemed like an easy game to play. No one could pass you if you read *Don Quixote* [*laughs*], so I went to the library and I was like, "I want *Don Quixote* and *Doctor Doolittle*." I took the AR tests, collected a ton of points, got a $100 gift certificate to Walmart, and bought my first *Sims* game! At one point, I was the number one Accelerated Reader in Henry County, Virginia.

I imagine that very much affected the kind of playwright you are.

I definitely developed an encyclopedic memory of books. Because of that—and because I had a therapist who asked me to write down traumatic events I witnessed as a child in dialogue—I have a verbal memory. I close my eyes and I can remember almost everything that was said verbatim, especially rhythms of speech.

Is there a memory you want to keep in a special place forever?

The events of late 2019 into early 2020. That's when I put on *Slave Play*, *Daddy*, *Water Sports; Or Insignificant White Boys*, *Yell*, and *Black Exhibition*. It was a whirlwind! I remember Machel Ross, the director of *Black Exhibition*, said to me, "It's a lot. You need to take stock. No, you *really* need to take stock." I remember that because she spoke in meter.

What qualities does a modern-day playwright possess?

I think a modern playwright has to have both, a sense of theatricality and a real excitement about film. Then there's someone like Aleshea Harris, who is the great seer of literary implications. One of my favorite stage directions is hers in *Is God Is* because it's an adventure in typography. The way lines are spoken changes based on their font and how they play across the page, which is so Oulipo in the '30s—that French society of writers who were workshopping new forms of text.

How do you want to be remembered?

I want to be remembered as an artistic polymath and as someone who helped bring people back to the theater in a dynamic way. I don't need to be remembered as the best—I want to be thought of as someone who touched many aspects of culture. Life is too short to not try your hand at many different things.

Phone interview, 2020

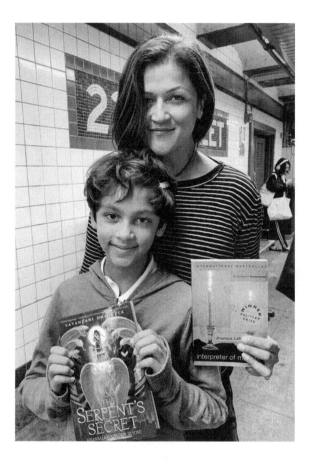

Anjali Kumar

Interpreter of Maladies
by Jhumpa Lahiri

One day, a girl in my French class said that her mom, a children's book illustrator, was looking to draw an Indian girl for a book cover. She asked if I was willing to model for it and said that she would pay me $20. It was kind of random, but I was also psyched because I was sixteen and could use the money. [*Laughs.*] Her mom picked me up after school and we drove out to a nearby farm. On the drive over, she started to ask me all

these questions, like what tribe I belonged to. I told her I was Indian from India, and she said, "Oh, we'll make it work." Then she took a picture of me next to a horse and we drove back home. A year and a half later, I was home during my first year of college, and the woman came by to give me a copy of the book. Sure enough I'm on the cover of *Dawn Rider* as a Native woman named Kit Fox who is going to save her tribe. I've never read it and I forgot about it until literally just now. It is the most absurd thing, yet it somehow perfectly sums up my childhood.

That is bananas. Did your family celebrate being Indian growing up?

Oh, all the time, but those experiences were intentionally created by my parents. We ate Indian food, honored religious holidays, spoke Hindu at home, and my mom wore saris to parties. The books we were reading in school were definitely not reflective of our lives, and it wasn't until I started picking up books like *Interpreter of Maladies* or *A Suitable Boy* as an adult that I thought, "Hey, my stories exist!" My daughter, Zia, came back from school the other day and told me that a character in one of her library books had my name, Anjali. I was blown away and she was unfazed. [*Laughs.*] To her, it was totally normal.

23rd Street station
Manhattan, 2019

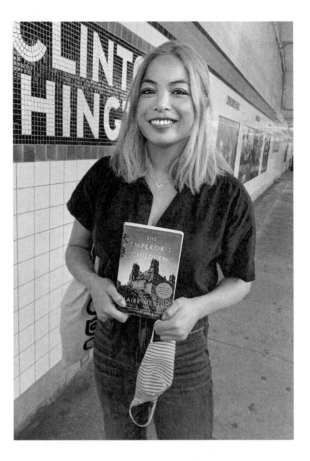

Jia Tolentino

The Emperor's Children
by Claire Messud

Lately, I look around my living room and remember how this used to be a place for parties with kegs where everyone was constantly fighting, breaking up, making up, staying up until five in the morning. Now I'm up at five in the morning but it's because of a new baby. [*Laughs.*] I guess our lives change more than I tend to recognize. *The Emperor's Children* is a pure pleasure and I reread it every summer. It's about three friends on

the cusp of their thirties in a privileged echelon of New York. Their lives are buoyed by youth and they come upon a moment where they're each wrestling with an identity crisis. It also happens to be a phenomenal 9/11 novel, capturing a state of innocence in New York before that cataclysmic morning. Sincere aspiration changes after 9/11 for the characters in the book, and it feels like sincere aspiration has gone the way of the fax machine in the last twenty years in real life.

Does New York make us better people?

One of the things I like about New York is that it asks you to stay open while developing toughness. But people come here because they have that openness and that native toughness already somewhere within them, right? New York keeps you alive at those two poles of human existence. I was born in Canada and grew up in Texas. The first time I came to New York was when we stopped here on a family road trip on the Fourth of July in 2001. I remember taking the ferry to Staten Island to watch the fireworks over the Statue of Liberty and dragging my dad all over the city to get a fake Kate Spade purse in Chinatown. I remember the lions in front of the public library at Bryant Park. I remember the loudness of everything, and this big oceanic sense of life right on the surface. It seemed like a much more fantastic version of what a city could be.

Are memory and aspiration connected?

I think so. When you remember pleasure, you hope to have it again. Remember when we could all meet up in person? That memory is sustaining us in a bittersweet way. It reminds us that it will be possible to do that again. It'll be just as good. No, actually, it will be better.

Clinton–Washington Avenues station
Brooklyn, 2020

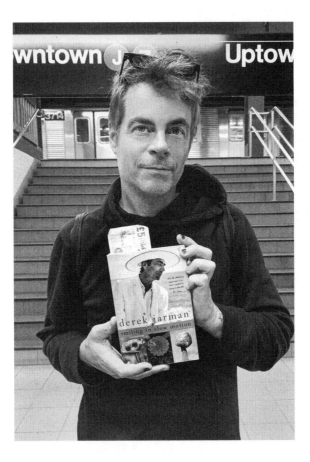

Rob Roth

Smiling in Slow Motion
by Derek Jarman

My grandfather owned a funeral home in Queens that my spinster aunt lived above. As a kid I would run around her apartment, but I was never allowed to enter the basement, where the embalming was done. Regardless, I tend to dwell in the metaphysical. [*Laughs.*] I'm a multidisciplinary artist, but you could also just say that I'm underground. I embrace that, because the underground is where everything begins.

What was the underground like back then?

During that time, getting in at Jackie 60 was the goal for everyone. It was a party in the Meatpacking District that happened every Tuesday for exactly ten years. That's where I met Debbie Harry, Chi Chi Valenti, Genesis P-Orridge, Anohni, and Kitty Boots, the door person. One night, Donatella Versace and Kate Moss walked up to the velvet ropes and the MC said, "Kitty, that's Donatella Versace and Kate Moss." And Kitty said, "Oh, I know. They came in a limousine. I'm making them wait for half an hour." Can you imagine that today? Never! Around 2010, people literally went from clubs in the basement to the rooftops of hotels. It became all about being seen. If you look at the architecture of New York in the last fifteen years, it's all glass, like an Instagram house where everyone can see your sofa. We used to keep things hidden to make them special.

Where do we go from here? Any clues in this book?

My dear friend Chris Miller, a former go-go boy who lives in London, gave me this book by Derek Jarman—Derek gave us Tilda Swinton, by the way—who lived through the plague and eventually died of AIDS. There's no border to Derek, he just is. Gardening was as important to him as film-making. Tilda Swinton said, "That was Derek, he would make something grow where it couldn't." That's the beauty of being an artist. It's in the way you treat other people and in the way you plant a garden. That is the loving reassurance of this book.

Delancey Street/Essex Street station
Manhattan, 2020

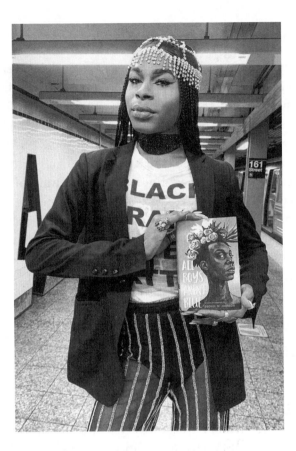

B. Hawk Snipes

All Boys Aren't Blue: A Memoir-Manifesto
by George M. Johnson

I am a native New Yorker—half the Bronx, half Manhattan. I'm a little
bougie and a little ghetto, depending on the situation. My pronouns are
they/them and she/her. I am an entity of many different energies, but some-
times that femme power comes through and I let her do what she needs to
do. We all have masculine and feminine energies in us from birth. It's up to
us as individuals to figure out the balance as we evolve. I grew up thinking

that gender was assigned by a hospital, but as soon as I started to do more research, my mind was blown. I didn't really stand in my ownership of who I am until three years ago and I'm about to be thirty-three. It took me a minute to realize that gender really is a social construct.

Is this book serving up a good, mind-blowing moment?

All Boys Aren't Blue is about being bold, brave, Black, queer and owning all dimensions of who you are. It is *such* an inspiring read. George takes us on a journey of history and freedom while encouraging us to have important conversations with our friends and family. I felt a sense of relief reading these pages and I hope that lots of young people read this book.

There are always waves of people who remind us to be whole.

Yes, I think of *Pose*, because it shows that New York wouldn't be what it is without Black trans magic. I'm an actor, and my role on *Pose* helped me to see myself more clearly. I think of Marsha P. Johnson and the ballroom community that gave New York its vibrancy and excitement. Many of us are shunned into the darkness, but we continue to turn that darkness into light and I think we are riding a magical wave. But there are some icebergs called white supremacy in the ocean that are messing up our flow, so we have to melt them down. If white supremacy doesn't shift, then we will continue to be in big trouble. Knowing our history outside of whiteness, telling our own stories, like George M. Johnson does, will help us through.

Does magic play a big role in your life?

Magic comes and goes in waves, but it always lives within me. There are moments of negative energy when I feel like I want to scream, but then I come out of it and realize I have survived—because magic is a powerful force. I think about my Black ancestors and know I can do anything. It's in my blood to push forward.

161st Street–Yankee Stadium station
Bronx, 2020

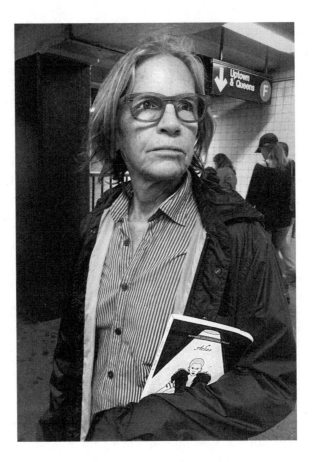

Eileen Myles

Acker
by Douglas A. Martin

T his morning I finished reading *Acker* by Douglas A. Martin, which is
a writerly accomplishment. Kathy Acker is a writer of the '70s, '80s,
and '90s. She sprang out of the poetry world and her work deals with porn,
prestige, privilege, and the political condition of being in a female body.
She rode the glamour train and did it with a shaved head and piercings.
Acker is an amazing person to read about because you get a great swath

of history through her story. She's been dead for twenty years, but Kathy stands as a monument to herself. Waves come back.

Which other waves do you see returning?

We live in a dying resurgence of the patriarchy, and while we're winning, we desperately need people to counter this resurgence. We have these bursts, these revelations—they get some traction and become part of what we know, but then we're over it pretty quickly too. Change happens in a cumulative way and in these waves of language, awareness, acceptance, and mass action. I came to New York in the '70s, and I think the changes we are expecting now, people were very literally expecting to take place then. We're talking about the anti-war movement, feminism, the Black power movement—many of those movements were actively undermined by our government and taken down as best they could. There was a gradual destruction of the very things that were exploding and coming into view in the '60s that seemed so awesome and hopeful. By the '80s, the worm really started to turn and suddenly gender was getting more stratified again, women were suddenly called girls, and there were big shoulders, big suspenders, and big spenders.

Is there a glimmer of hope that it will be different this time?

I believe in the value of human presence. People in the public space seem to be making the most change. We need to keep sharing information and remember that it's all related. The '80s might have gone differently if we all understood who the Black Panthers were and why the American police state felt compelled to assassinate them. I had a messy, wonderful, "radical" time in the '70s, but I didn't entirely get that when anybody lost their rights, I lost mine, too. Now I think that everybody's disasters are my disasters, too.

**2nd Avenue station
Manhattan, 2017**

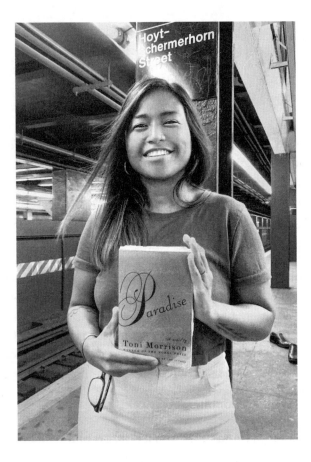

Ica Sadagat

Paradise
by Toni Morrison

Surfing has kept me alive and helps me to reclaim my body. On the ocean my heart rate changes and flows with the water's undulations. I dive and hold my breath, knowing that I could drown at any moment. Surfing is 95 percent struggle and I feel that's what life is like. It's all about paddling, holding your breath, and waiting—all for a few seconds of slide.

Is *Paradise* connected to the sentiment of water?

Absolutely. Toni Morrison resided by the Hudson River, and all of her books have a watery element in them. *Paradise* was originally titled *War*. I think that's so fitting, because to me this book is about abolition. There are two opposing settings in *Paradise*: Ruby, a town that's supposed to be a Black utopia, and a converted convent that houses women who seek refuge. In Ruby, there are no jails or cemeteries and it seems perfect, but there is tension because the community is built on absence and eradication. Unlike Ruby, the converted convent represents the presence of care.

How do we reach paradise and the presence of care?

This book reminds me that paradise is not somewhere you go. Paradise, much like abolition, much like healing, is something you do here, now. It's an act. It's something that you create and carry with you. Toni Morrison said, "We do language. That may be the measure of our lives." What matters is love, the presence of care for each other's plights and joys, and the presence of restoration. All of that exists beyond the heavy-hitting waters.

Do you remember the day of Toni Morrison's passing?

Before I even heard about it, I posted the last page of *Paradise* that morning. The last line reads, "Now they will rest before shouldering the endless work they were created to do down here in paradise." Telling us how we can live, even in her death, is Toni Morrison's gift. I was flummoxed and held at the same time, enraptured by her perfect language. I dropped everything and walked to the ocean. I realized I was already down here in paradise. Isn't it great how she put it? Not up there, in heaven. Down here, in paradise.

Hoyt–Schermerhorn Streets station
Brooklyn, 2020

Jamel Shabazz

A Choice of Weapons
by Gordon Parks

I was born and raised in 1960 in Red Hook, which was a rich community at the time. We had an Olympic-size pool, beautiful parks and trees, and a great sense of community. I went into the military at seventeen. The war in Vietnam had just ended two years prior and my parents had divorced. I didn't want to be a burden to my mother, who I lived with, so I made the difficult decision to enlist. I served three years in West Germany, which transformed my life and gave me an opportunity to see the world beyond New York. It also allowed me to better understand war and those who fought wars. I remember the very first movie my father took me to see as a child was *The Green Berets* with John Wayne, which really traumatized me. My father and I never talked about it. The only conversation we had about war was when I decided to join the military and my father was totally against it. I didn't understand why until I came back home.

Was there a place you really wanted to see when you came home?

I always thought about returning to New York as a photographer, because I never wanted to be without memory again. One of the first places I revisited was my former school, the Samuel J. Tilden High School, because I wanted to talk to young people as I photographed them. I also documented home-lessness, mental illness, and prostitution on the streets and on the subway as the AIDS and crack epidemics were on the horizon. I spent a lot of time in Prospect Park for balance. I yearned for the Black Forest and for being

in a wooded area, around nature. I've documented that park for about forty years. There's something spiritual about those 526 acres.

Which emotions did you find on the subway?

On the subway, there's a wide range of emotions. In the beginning I focused on high school kids and with them I found joy, energy, and style. Friendship is a key component in my work and I look for it always. I would ride all hours with no fear and just record my world and my people. Never a dull moment. [*Laughs.*] When I started to document youth culture, I was mostly concerned with their well-being, because a lot of young people were dying at the hands of each other. The camera allowed me to talk to them and the photograph became the evidence of our conversation. We talked about loving each other, respecting the community, eating right, and having goals. My camera gave me a voice and there was something magical about it. Mind you, at the same time, I was a correction officer on Rikers Island.

Wait, you worked at Rikers Island?

Yeah, I worked a rotating shift and I had my camera with me on Rikers Island, too. It was one thing to interact with people on the street, but to witness Rikers Island's brutality and hateful atmosphere was something else. Jail is a horrible place. It is modern slavery and you are never the same after you endure that hardship. I spent ten years working in the mental-health unit and what I saw troubled me deeply. I played jazz and classical music to get people balanced. I encouraged people to read. I burned incense and tried to bring them healthy foods because they were on a horrible diet. A lot of young men were misled to believe that going to Rikers was some rite of passage and that part of manhood was surviving it. I had to work with great diligence on the streets to convince young men that Rikers was not the way to go.

It sounds like you practice magic as much as photography.

Yes, I see myself as an alchemist who freezes time and emotions. I don't even like the term "photographer" anymore. I think that my mission in life is

to contribute to the preservation of history and culture and my purpose is to serve as a documentarian, but also as a healer and a guide. My work is vision medicine and I hope it makes people feel good. The book that sits very close to me is *A Choice of Weapons* by Gordon Parks. His writing has really informed my practice and it has taught me empathy. Gordon lost his mother at a young age and his life was full of conflict. For him, photography was bigger than simply capturing a moment or getting an award. It was about meeting people and realizing that he met them for a reason. The title of the book is about using his camera to fight the things that he despised, like racism and poverty. My camera is a time machine, a compass, and a weapon. The only other weapon we need is love. Love is the key.

Phone interview, 2020

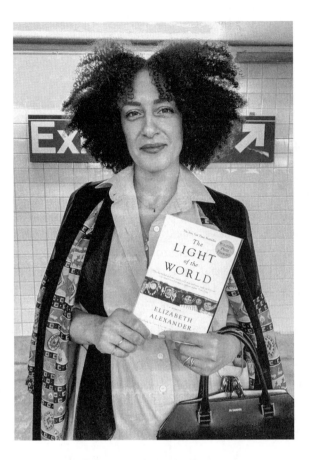

Deana Haggag

The Light of the World: A Memoir
by Elizabeth Alexander

These days, many artists are barely hanging on. I work with painters, poets, architects, filmmakers, and fashion designers, and I help them to take care of their lives financially. I've been trying to process that our artists are barely surviving and it made me want to reread the *Light of the World*. Elizabeth wrote this book right after her husband, a prolific painter and chef named Ficre Ghebreyesus, died unexpectedly at age fifty. The

whole book is raw and beautiful and none of it is neat or straightforward. On page 172 is a meditation on leaving and also a spicy red lentil curry recipe. Everything about it reminds me that life is not linear. Elizabeth says that when she wrote it, she felt like she was putting her hand on the earth, to remember that she was here.

What is the light of the world?

The light of the world is art. It's what makes us fall in love with other people. Artists make me feel like I belong to other people, other times, other countries, and other generations. I fight for art because I love future generations who I will never meet and I want them to know what it was like to be alive today. I want them to know that we didn't sit back and that many courageous people put up a tremendous fight. I am a very spiritual person—I'm Egyptian and a Muslim, and devout in my beliefs. The best shot we have is to honor those who fought for the rights of others. We might not know all of their names, but they were here. I want a record of their existence because they are part of a lineage, from Audre Lorde to a young writer in Brooklyn. Historians work for a nation. Artists work for the people. They tell the truth.

What is a great, artistic, loving community built on?

Interdependence. I had cancer and have a disability now. I was in my midtwenties when I was sick and couldn't do anything. I had to depend on other people, which is counterintuitive to how we are raised. The disability community celebrates interdependence. It's not independence and it's not codependence. It's this idea that we care because we are together. We are interdependent on one another's successes and on one another's livelihoods, and that orientation toward the world has changed my life.

Clinton–Washington Avenues station
Brooklyn, 2020

Emily Cavanagh

Invisible Cities
by Italo Calvino

I enjoy *Invisible Cities* a lot. I feel like I need to read it quickly so I can give it to a friend of mine. [*Laughs.*] Marco Polo and Kublai Khan describe cities they have visited to each other from their unique perspectives. They describe entirely different details and landscapes, socially and architecturally, but it turns out that they are talking about the exact same places. I was just in an argument with the friend who I want to give this book to because it's the perfect representation of what we argued about: the subjectivity of the world. Nothing is as it seems, because everything lies in the eye of the beholder.

West 4th Street–Washington Square station
Manhattan, 2015

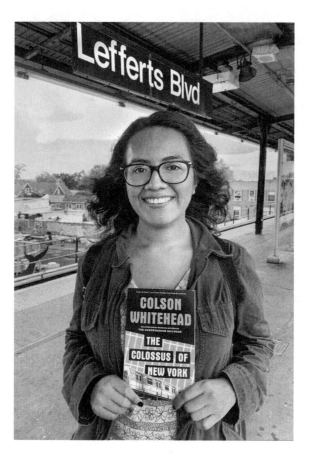

Jessica Mendieta

The Colossus of New York
by Colson Whitehead

This is the last stop on the A train, Lefferts Boulevard, Ozone Park, also known as Little Guyana. I was born and raised in Queens, and run into a lot of people around here. It's a nice feeling to be remembered. I moved away for a while and wasn't sure if I was ever going to come back. It seemed like reading a book about the city would let me know how I feel.

The Colossus of New York is one of my all-time favorites. Did it help?

I read it on the bus as I was leaving New York and the last chapter really got me. It says, "It's time to go. Take a moment to look back and regret all the things you didn't get to do, the places you didn't get to visit. What you did not see. Promise yourself, maybe next time. Assuming it will still be here when you finally return."

It's so good! It has me in tears.

It had me in tears, too. I thought of all the things I didn't want to disappear. The bakery I go to in Astoria, the taco stand I love in the East Village, the halal cart outside the laundromat I use, the bodega on the corner near my house. Sometimes I'm scared to check if my favorite places are still here. You read a headline and brace yourself to say goodbye. Change is part of life here but that doesn't mean I'm indifferent to it. You have to feel the changes that are happening in New York. I was becoming numb to it and that's why I had to leave for a while. This city has to mean something to you if you want to call yourself a New Yorker.

When did you come back?

I got back three weeks ago and realized that I never want to spend this much time apart from my family again. We take the people in our life and what they mean to us for granted. I just started to look for a job again and learned how to bike around the city. That was a fun accomplishment! My next plan is to ride from Lefferts Boulevard to Flushing Meadows Park. I want to get to know the city all over again.

Ozone Park–Lefferts Boulevard station
Queens, 2020

All the People,
All the Books

Arrivals

Julie Helquist, *Just Kids* by Patti Smith
Jazmine Hughes, *We Live for the We* by Dani McClain
Poph Kanchanavasutha, *The Greatest Salesman in the World* by Og Mandino
Douglas Ross, *The Rise and Fall of a Theater Geek* by Seth Rudetsky
Diana Schlossberg, *Orlando* by Virginia Woolf

Trees

Glynnis MacNicol, *The Overstory* by Richard Powers
Ijendu Obasi, *Sacred Instructions* by Sherri Mitchell
Macon McGinnis, *Herbal Remedies* by Andrew Chevallier
LaTonya Yvette, *Braiding Sweetgrass* by Robin Wall Kimmerer
Shea Vassar, *Crooked Hallelujah* by Kelli Jo Ford

Matriarchs

Qween Jean, *Homegoing* by Yaa Gyasi
Samuel María Gómez, *Women Who Run with the Wolves*
 by Clarissa Pinkola Estés
Mary Rhymer, *Asymmetry* by Lisa Halliday
Brittany Saisselin, *Yes Please* by Amy Poehler
Marz Lovejoy, *Rabbit* by Patricia Williams with Jeannine Amber
Leah McSweeney, *The Red Tent* by Anita Diamant
Margaret McInerny, *So Long, See You Tomorrow* by William Maxwell

Legacy

Ellie Musgrave, *M Train* by Patti Smith

Gregory Anderson, *Lamidi Ọlọnade Fakẹyẹ: A Retrospective Exhibition and Autobiography*

Maayan Zilberman, *My Sweet Mexico* by Fany Gerson

Nicolas Heller, *Every Person in New York* by Jason Polan

Marc Anthony Butcher, *Positive Messages* by Marc Anthony Butcher

Debbie Millman, *Dot for Short* by Frieda Friedman

Roxane Gay, *The Age of Innocence* by Edith Wharton

Nancy Bass Wyden, *Hunger* by Roxane Gay

Food

Marguerite Zabar Mariscal, *Rules of Civility* by Amor Towles

Coralie Kwok, *Provence, 1970* by Luke Barr

Christa Beutter, *Di Palo's Guide to the Essential Foods of Italy* by Lou Di Palo with Rachel Wharton

Jody Scaravella, *Kitchen Confidential* by Anthony Bourdain

Laurie Woolever, *Working* by Studs Terkel

Marquis Williams, *The Wine Bible* by Karen MacNeil

Britta Plug, *When Watched* by Leopoldine Core

Camille Becerra, *Save Me the Plums* by Ruth Reichl

Power

Samhita Mukhopadhyay, *Bengali Harlem* by Vivek Bald

Naydeline Mejia, *Eloquent Rage* by Brittney Cooper

Natalie Falcon, *Quiet* by Susan Cain

Dontàe Lewis, *The Power of Now* by Eckhart Tolle

Lakshmi Subramanian, *The Folded Clock* by Heidi Julavits

Mitchell S. Jackson, *There There* by Tommy Orange

Regan de Loggans, *The Young Lords* by Johanna Fernández

Saima Afrin, *They Say, I Say* by Gerald Graff and Cathy Birkenstein

Reality

Alex Zafran, *Severance* by Ling Ma

Kelie Bowman, *1Q84* by Haruki Murakami

Kareem Rahma, *How to Do Nothing* by Jenny Odell

John Donohue, *How to Change Your Mind* by Michael Pollan

Daphne Always, *Her Body and Other Parties* by Carmen Maria Machado

Waris Ahluwalia, *The Wisdom of Insecurity* by Alan Watts

Nora Lynch, *Authority* by Jeff VanderMeer

Big Brother

Eva Munz, *Happiness, as Such* by Natalia Ginzburg

Kristin Vita LaFlare, *1984* by George Orwell

Elise Wien, *Do Not Say We Have Nothing* by Madeleine Thien

Bogdana Ferguson, *The Future Is History* by Masha Gessen

Ralph Bavaro, *Photography* by Chris Dickie

Character

Amanda Degelmann, *The Pleasure of My Company* by Steve Martin

Sydnee Washington, *A Good Cry* by Nikki Giovanni

Jeremy Cohen, *Man's Search for Meaning* by Viktor E. Frankl

Frances Weisberg, *Even Cowgirls Get the Blues* by Tom Robbins

Katja Blichfeld, *Exquisite Mariposa* by Fiona Alison Duncan

Sean Michael Bennett, *The Death and Life of Great American Cities* by Jane Jacobs

Sheri Cheatwood, *Twisted* by Emma Dabiri

Image

Barrington Roberts, *This Boy's Life* by Tobias Wolff

Zoe Cho, *Girl in Pieces* by Kathleen Glasgow

Amani al-Khatahtbeh, *A Thousand Splendid Suns* by Khaled Hosseini

Kimberly Drew, *Words of Fire* edited by Beverly Guy-Sheftall

Ashley Levine, *Leaves of Grass* by Walt Whitman

Debra Ramsay, *We Have Never Been Modern* by Bruno Latour

Fabric

Sarah Dillard, *Citizen* by Claudia Rankine

Daniel Vosovic, *A Little Life* by Hanya Yanagihara

Lynn Yaeger, *Marjorie Morningstar* by Herman Wouk

Yahdon Israel, *Dapper Dan* by Daniel R. Day

Dusty Childers, *The Chronology of Water* by Lidia Yuknavitch

Pamela Sneed, *Sister Outsider* by Audre Lorde

Mordechai Rubinstein, *Back in the Days* by Jamel Shabazz,
 Fab 5 Freddy, Ernie Paniccioli

Old New York

Sandy Miller, *Let Me Be Frank with You* by Richard Ford

Cheryl Dunn, *Widow Basquiat* by Jennifer Clement

Devon Rodriguez, *Outliers* by Malcolm Gladwell

Michael Hashim, *The Dalkey Archive* by Flann O'Brien

Happy David, *Tiny, Beautiful Things* by Cheryl Strayed

Ana Matronic, *Life and Death on the New York Dance Floor, 1980–1983*
 by Tim Lawrence

Movement

Tiffany Davis, *The Creative Habit* by Twyla Tharp

Owen Edwards, *Assata* by Assata Shakur

Chi Ossé, *The Alchemist* by Paulo Coelho

Siheun Song, *Human Acts* by Han Kang

Eli Schewel, *En la ardiente oscuridad* (*In the Burning Darkness*)
 by Antonio Buero Vallejo

Jumaane Williams, *The Radical King* by Dr. Martin Luther King Jr.,
 edited by Cornel West

Access

Dwreck Ingram, *The House on Mango Street* by Sandra Cisneros

Ora Kemp, *Wandering in Strange Lands* by Morgan Jerkins

Djeison Canuto, *Ready Player One* by Ernest Cline

Liana Rodriguez, *The Education of Margot Sanchez* by Lilliam Rivera

Edgardo Marmol, *Understanding Media* by Marshall McLuhan

Arabelle Sicardi, *The Poetics of Space* by Gaston Bachelard

Space

Jerome Bwire, *The Martian* by Andy Weir

Moiya McTier, *Finding Faeries* by Alexandra Rowland

Meg Morton, *Let the Great World Spin* by Colum McCann

Aparna Nancherla, *Intimations* by Zadie Smith

Min Jin Lee, *A House for Mr. Biswas* by V. S. Naipaul

Whitney Hu, *A Wrinkle in Time* by Madeleine L'Engle

Time

Brixton Doyle, *The Time Machine* by H. G. Wells

Nicholas Brysiewicz, *The Glass Bead Game* by Hermann Hesse

Anthony Prince Leslie, *The Fire Next Time* by James Baldwin

Emma Straub, *The Idiot* by Elif Batuman

Jo Firestone, *Time's Arrow* by Martin Amis

History

Kamau Ware, *Silencing the Past* by Michel-Rolph Trouillot

Linzi Murray, *The Slow Regard of Silent Things*
 by Patrick Rothfuss

Arti Gollapudi, *Bitch Planet* by Kelly Sue DeConnick, illustrated by
 Valentine De Landro

Djali Alessandra Brown-Cepeda, *Bird of Paradise* by Raquel Cepeda

Ta-Nehisi Coates, *Ill Fares the Land* by Tony Judt

Music

Ladyfag, *The Berlin Stories* by Christopher Isherwood

Isabela Martinez, *Born to Run* by Bruce Spingsteen

Ian Isiah, *Flaming?* by Alisha Lola Jones

Anupa Otiv, *Meet Me in the Bathroom* by Lizzy Goodman

Chris Lombardi, *New York Unexpurgated* by Petronius

Amyra León, *The Price of the Ticket* by James Baldwin

Design

Timothy Goodman, *Chronicles: Volume One* by Bob Dylan

Gail Anderson, *Going Into Town* by Roz Chast

Rajiv Fernandez, *Paris versus New York* by Vahram Muratyan

Melissa Braxton, *Happy City* by Charles Montgomery

Wendy Goodman, *The Splendid and the Vile* by Erik Larson

Leta Sobierajski, *Architectural Body* by Madeline Gins

(True) Colors

Harmonica Sunbeam, *Worm Loves Worm* by J. J. Austrian, illustrated by Mike Curato
Naz Riahi, *Bluets* by Maggie Nelson
Molly Beth Young, *Mrs. Bridge* by Evan S. Connell
Saraciea Fennell, S*hadowshaper* by Daniel José Older
Jad Abumrad, *The Inquisitor's Tale* by Adam Gidwitz

Questions

Céline Semaan, *The Politics of Dispossession* by Edward W. Said
Ron Sese, *Trick Mirror* by Jia Tolentino
Adam Eli, *Who Killed My Father* by Édouard Louis
Verena von Pfetten, *No One Tells You This* by Glynnis MacNicol
Josh Ross, *Swing Time* by Zadie Smith
Ashley & Emily Levine, *Behave* by Robert M. Sapolsky
Mary Annaïse Heglar, *Parable of the Sower* by Octavia E. Butler

Migration

Xiye Bastida, *Americanah* by Chimamanda Ngozi Adichie
Daria Laur, *The Worst Journey in the World* by Apsley Cherry-Garrard
Paola Mendoza, *El libro de los abrazos* (*The Book of Embraces*)
 by Eduardo Galeano
Dolores Nazario-Ramirez, *C-Train and Thirteen Mexicans* by Jimmy Santiago Baca
Annalisa Merelli, *Tell Me How It Ends* by Valeria Luiselli
Aishwarya Kondapalli, *The Odd Woman and the City* by Vivian Gornick

Love

Sophie Auster, *Memories of the Future* by Siri Hustvedt
Paul Tudor Owen, *Normal People* by Sally Rooney
Jason Rosario, *The Mastery of Love* by Don Miguel Ruiz
Fareeha Khan, *All About Love* by bell hooks
Cat Yezbak, *The Argonauts* by Maggie Nelson
Reyna Boucaud, *The Way He Makes Me Feel* by Tamara Sneed
Arina Ahmed, *Come as You Are* by Emily Nagoski

Compassion

Lea Elton, *Lolita* by Vladimir Nabokov
Roger Chang, *The Gifts of Imperfection* by Bréne Brown

Jeffrey Zie, *The Big Leap* by Gay Hendricks
Rebecca Evanhoe, *House Made of Dawn* by N. Scott Momaday
Yizhi Wang, *Beasts of No Nation* by Uzodinma Iweala
Nasim Alikhani, *The Treasured Writings of Khalil Gibran*

Home

Ashley C. Ford, *The Color Purple* by Alice Walker
Ed Pollio, *The 50th Law* by Robert Greene
Larry Malcolm Smith Jr., *Becoming* by Michelle Obama
Maya Marie Clark, *An American Marriage* by Tayari Jones
Jessica Escobar, *The Life-Changing Magic of Tidying Up* by Marie Kondo
Zahra Hankir, *The Quarter* by Naguib Mahfouz
Emmanuel Muñoz Maldonado, *De perfil* (*In Profile*) by José Agustín
Jacques Aboaf, *Ryszard Kapuściński: A Life* by Artur Domosławski

Memories

K-Ming Chang, *Sour Heart* by Jenny Zhang
Olivia Lindsay Aylmer, *Água viva* (*The Stream of Life*) by Clarice Lispector
Jacques Aboaf, *Rwanda Means the Universe* by Louise Mushikiwabo
Jeremy O. Harris, *From the Mixed-Up Files of Mrs. Basil E. Frankweiler*
 by E. L. Konigsburg
Anjali Kumar, *Interpreter of Maladies* by Jhumpa Lahiri
Jia Tolentino, *The Emperor's Children* by Claire Messud
Rob Roth, *Smiling in Slow Motion* by Derek Jarman

Waves

B. Hawk Snipes, *All Boys Aren't Blue* by George M. Johnson
Eileen Myles, *Acker* by Douglas A. Martin
Ica Sadagat, *Paradise* by Toni Morrison
Jamel Shabazz, *A Choice of Weapons* by Gordon Parks
Deana Haggag, *The Light of the World* by Elizabeth Alexander
Emily Cavanagh, *Invisible Cities* by Italo Calvino

The End of the Line

Jessica Mendieta, *The Colossus of New York* by Colson Whitehead

Afterword

I edited a portion of this book in Provincetown, Massachussetts, in a cozy rental called The Salty Dorothy. I was behind my deadline and in a complicated part of the process where after everything had clicked, nothing seemed to make sense anymore. To get things done and to escape the pre-election energy that was so thick you could cut it with a knife, I left New York for a week in October 2020. Upon my arrival on Cape Cod, the feeling of isolation was immediately unbearable. It was off-season and the pandemic was in full swing, which meant that Provincetown was eerily quiet, which I somehow hadn't figured into my plans. In Brooklyn, there were voices, music, and sirens cutting through the air. There were upstairs neighbors interrupting my day with their footsteps. Here, I was too present with myself, and I had no friends around who could distract me with a walk in Fort Greene Park. During my first day at The Salty Dorothy, after I had rearranged all of the furniture and taken two trips to the grocery store, I wanted to cry. It had been seven years since I had last felt this alone. All of those years that I had lived in New York, I had no reason to confront this kind of loneliness, solitude, and abyss one can sink into when being left utterly alone with their innermost thoughts. Instead of letting myself drown in my sadness, I decided to go for a drive in the car I had borrowed, since I couldn't hop on a subway for a change of scenery, which is what I would have done back home.

At the edge of town and literally at the end of the road, I came upon a narrow pathway made of large boulders that were covered in shells and seaweed. It led straight into the ocean, all the way to the horizon. No one was around, and there were no signs indicating whether it was permitted,

or smart, to walk into the sea on this pathway. I checked my phone and figured that low tide was supposed to start eventually, making it worth a try. As I stepped onto the first few boulders, a strange fear clamped down on me. I should not do this alone. Sure, I could call someone, but there were no actual bystanders around who could save me if I slipped and fell into the ice-cold water. In New York, someone would have surely yelled over by now to ask if I was an idiot or what I was waiting for. That brash voice was so present in my head, it made me laugh. Carefully, I kept walking into the middle of the ocean while surprisingly big waves continued to crash on the boulders and nipped at my feet. Twenty long minutes later, me and the ocean started to calm down. I looked up and could see that the pathway was connected to the shore across the way. I was ecstatic, I would make it! Step by step. Boulder by boulder. The strange fear didn't leave me, but it served a purpose, driving me to find a literal connection in the middle of the sea.

We are here on this planet to make each other feel less adrift and less alone. This gigantic ocean that is our life can feel chaotic, unmanageable, and wild. I hope the stories in this book build a bridge for you, much like the boulders did for me, one by one. When we come together, we can make it to the other side.

Acknowledgments

T his book would not be in your hands today without the generous help of the following people who believed in it, me, and the stories on these pages.

Thank you: Hana Delong, for going first. Heather Karpas and Kristyn Keene Benton at ICM, for making sure I landed with a stellar publishing team. Monica Machado and Caitlin Karna, for working production magic behind the scenes. Karina Castrillo, for transcribing hours and hours of audio files. Alex Daly and Ally Bruschi, for loving and looking out for artists. James Slater, for giving *the* most empathetic legal advice. Caroline Donofrio, Amy Fraser, Éva Goicochea, Erin Allweiss, Alexis Rosenzweig, Allyn Robinson, Adriana Picker, Naz Riahi, Eva Munz, Lindsay Ratowsky, Julia Kirchhoff, and Hana Kim for helping through various growth stages. I owe each of you at least twenty bucks. Glory Edim and Glynnis MacNicol, for encouraging me, and especially for Newburgh. Bridget Badore, for shining up my photography with your excellent editorial eye. Hamish Smyth and Order, for bringing the subway into this book. Lewelin Polanco, Elizabeth Breeden, Christine Calella, Kayley Hoffman, my amazing team at Simon & Schuster, thank you for rocking my world. Zack Knoll, my fabulous editor at Simon & Schuster, for offering your publishing expertise and loving friendship to me tirelessly.

My special thanks go to the communities and people who gave me a new perspective on this journey. The Stadtbibliothek Reutlingen, where my love affair with books began. Saada Ahmed, Elise Peterson, and Josh Slater; without AG there would be no SBR. Kamau Ware and the Black Gotham Experience, who changed my view of the public space. Mark

Oppenheimer and Thread at Yale, where this book was first workshopped. Ruthie Ackerman and Kelly Shetron, who guided my book proposal. Moon Crew and Our Time, thank you for the magic. Team Pool, thank you for the water. To the MTA: you are *wild* but I love you, I really do! To the Subway Book Review contributors: you are the best, may we ride forever. To my chosen family and blood relatives: what a trip! Eric and Bobbie Cohen, Lauren Cohen and Chris Benavides, Charlie and Joel Benavides, Corinne Cohen and HoTeck Kan, Edith and Guntram Schulz, Jon Nastasi and Paula DeRose, Gabe Williams and Lisa Jaeggi, Jamie Pulliam and Meggie Finn, Simmone Taitt and Maurice Bennett, Miles Fletcher and Cosima Juniper Priestley, Adam Henry, Raymond, Eva Kimmerle and Isabel Thompson: You have my whole heart. Thank you for believing in my adventures. My other-other half, Davis Priestley, and my journey sister, Mariah Rich, I love you beyond the beyond. Egon Schöbesch, my guide from another realm, thank you for shining your light on me. Moni Beutter, my patron saint, you saved me more than once and I'm forever grateful. Ulrich and Christa Beutter, there is no me without you. Mumsi, der Apfel fällt zum Glück nicht weit vom Stamm. And to my forever love, Alec Cohen, thank you for finding me again in this lifetime.

Thank you to readers on the New York City subway.

Photo Credits

Original Photography: Uli Beutter Cohen
Photo Editor: Bridget Badore

Typeset

In the early '60s, the New York City Transit Authority wanted to standardize the underground with Helvetica, but it was expensive to ship type plates from Amsterdam and the NYCTA didn't have the money. Instead, they used a "placeholder" font called Standard, also known as Akzidenz-Grotesk. The headline typeface used in this book, NYC Sans, is inspired by Standard and was created by Nick Sherman in 2013. He wanted to digitize the letterforms presented in the *NYCTA Graphics Standards Manual*, which was originally designed by Massimo Vignelli and Bob Noorda in 1970 and reissued by Hamish Smyth and Jesse Reed in 2014. Sherman's goal was not to precisely re-create the original 1970 typeface, but to capture the same spirit of the original subway signage while creating an evolution, which felt like the perfect fit for *Between the Lines*.

Cover Color

Yellow inspires curiosity, hope, and enlightenment. It's associated with the third chakra, the solar plexus, which embodies the power of transformation and invites us to connect to our core identity and individual power. Yellow is a color of miracles and magic.

About the Author

Uli Beutter Cohen is a New York City–based documentarian and artist and the creator of Subway Book Review. Uli's work explores belonging to a time and place through writing and photography and has been featured on TV, in print, and online by *New York* magazine, *Esquire, Vogue, Forbes, O, The Oprah Magazine, Glamour,* the *BBC,* and *The Guardian,* among others. Uli lives in Brooklyn.

@theubc @subwaybookreview
www.subwaybookreview.co